Managing Conservation in Museums

Managing Conservation in Museums

Suzanne Keene

Published in association with:

The National Museum of Science & Industry

Science Museum

Butterworth-Heinemann
Linacre House, Jordan Hill, Oxford OX2 8DP
A division of Reed Educational & Professional Publishing Ltd

℞ A member of the Reed Elsevier plc group

OXFORD BOSTON JOHANNESBURG
MELBOURNE NEW DELHI SINGAPORE

First published 1996

© Suzanne Keene 1996

British Library Cataloguing in Publication Data
Keene, Suzanne
 Managing Conservation in Museums
 I. Title
 069.53068

ISBN 0 7506 2384 5

Library of Congress Cataloguing in Publication Data
Keene, Suzanne
 Managing conservation in museums/Suzanne Keene.
 p. cm.
 Includes index.
 ISBN 0 7506 2384 5
 1. Museum conservation methods – Handbooks, manuals, etc.
 2. Museum techniques – Handbooks, manuals, etc. 3. Material culture –
 Conservation and restoration – Handbooks, manuals, etc. I. Title.
 AM141.K44 95–37486
 069'.53–dc20 CIP

Composition by Genesis Typesetting, Rochester, Kent
Printed and bound in Great Britain by Hartnolls Limited, Bodmin, Cornwall

Contents

Preface

Conservation in museums is evolving. Not many years ago, what conservators mainly did was to carry out practical treatments. But as we have realized the size of the task, with collections often amounting to millions of objects, so it has become apparent to us that success on this scale requires a new view of how we should go about conservation.

The rise in importance of preventive conservation – providing a specified environment, controlling use, ensuring appropriate storage and display conditions – is only part of the answer. Conservators have always been eclectic in hunting out and adopting methods for practical conservation. We need to look now at the techniques used by managers everywhere to organize and control operations. Among them can be found many useful precepts that can be applied in conservation.

This book, then, sets out to open the box labelled 'management' and see what is in it that conservators could use. The use of information is an area that is highly applicable to the problems we face. Conservators are very good at collecting data, but as Poincaré said, 'a list of facts no more constitutes information than a heap of stones does a house.' Conservators always hanker after greater influence in their organizations. One sure way of gaining it is to provide and shrewdly use high level, relevant, management information.

Conservators and museum managers have not really explored this source of inspiration as yet. I hope that this book will supply some useful ideas, and an easy route into what I see as a crucial aspect of conservation in the future.

Suzanne Keene

Acknowledgements

My first debt is to the members of the Conservation Department of the Museum of London. They contributed enormously to every aspect of the work that led to this book. I thank, too, Max Hebditch, Director of the Museum of London, and Valerie Cumming, Deputy Director, for encouraging and, even more important, making use of the work.

A number of people assisted in work on collections condition audits. I particularly thank Louise Bacon of the Horniman Museum, who led the way with surveys there, and Nick Umney of the Victoria and Albert Museum. Velson Horie's work and perceptions also did much to shape thinking on surveys.

At the Institute of Archaeology, Alf Hatton, Elaine Sansom and Liz Pye all gave detailed and constructive assistance and advice. I am very grateful to Clive Orton for a non-alarming approach to statistical method, and to Professor Frank Land, of the LSE, for invaluable discussions about systems.

I also acknowledge the generosity and assistance of the Science Museum, in particular Dr Thomas Wright, Assistant Director, Collections, who gave me very positive encouragement at the many times when this was most needed.

Finally, I am most grateful of all to my family, Derek, Frances and Thomas, for patience, advice and support.

1 Introduction

This book focuses on information. The intention is to give an overview of its role in preserving collections, and to present some information tools from mainstream management. Information for managing conservation, as for any other activity, must satisfy three basic requirements: it must be based on values; it must serve objectives; and it must be useful to the people doing the work.

Museums, conservation and information

Museum collections are held in trust for all. They are assembled by museums as the basis for providing enjoyment and enlightenment, and as a record of past times or different cultures. Conservation is the means by which collections are preserved and cared for. This is a considerable task with many different components: for success, its full scope must be understood, it must be planned and organized, and progress must be monitored. The real extent of the task and the information needs is only just beginning to be appreciated.

Professional management information can be as useful to conservators and other professionals in museums and libraries as is their own specialist expertise. Here the climate in which museums operate today is reviewed, and the most up-to-date and relevant management techniques are described. Through analysing the concepts and systems which underlie museum operations, we can reach a new understanding of the importance and place of collections preservation in museums. The practice and management of conservation are examined, and it is shown how management information techniques can be applied in order to plan, monitor and control conservation work and processes.

The management information methods which are explained and critically reviewed include performance indicators, strategic planning, decision making and priority setting, data analysis and presentation, risk and cost–benefit analysis, and information analysis. These are applied to preventive conservation, work management, and conservation planning.

In this way, a link is established between the world of professional management and the current priorities and preoccupations of conservators. The whole is set in the context of the present climate of museum management.

Museums

Museums are a popular part of life in Britain today. More people are visiting museums in their leisure time (57m in 1977; 80m in 1992). Museums make a major contribution to attracting overseas tourists. Schools make extensive use of them as an adjunct to classroom teaching. What makes a museum a museum is its collections: the basis for its existence and all its activities. Museum objects have a unique power to evoke a response in the visitor. Max Hebditch (1990) has identified firstly, 'the power of relics and symbols contained in museums'; and secondly, 'the unstructured and informal means of transmitting information and experiences by means of the exhibition'. This offers the visitor the opportunity to construct their own experience from what is on offer.

Museums play multiple roles in society. In the present economic circumstances of the UK the tourist and heritage industries are assuming real economic significance. Museums have in the past acted as though managing the care and maintenance of their collections was an optional extra, although paradoxically many people would argue that they also neglected their duties towards visitors. But, as the public sector monitoring bodies have pointed out, museums are accountable for managing the collections effectively, and information is essential to success in this.

Collections

Museum collections are not just assemblages of objects; they are assemblages of *meaningful* objects. Each object is there because of its history, its significance in technological advance, its power to describe the society of its place and day, or indeed its beauty. Each one is thus unique and irreplaceable. It may be drawn on for scholarly research or popular booklet. It may be used in many different displays, telling part of a different story each time. Yet the object remains the same, a true testimony to its origins.

Museums hold collections for three main purposes: as archives of historical evidence; for display; and to demonstrate the function of objects. But for each of these purposes, the object must be maintained in good order, and it must be 'real'. Therefore, every type of museum will require to undertake conservation.

Conservation

It is a primary function of museums to preserve their collections, as a permanent resource that they hold in trust. The work of doing this, museum conservation, is more and more a specialized and professional activity, with its own training schemes, professional bodies, and codes of conduct and ethics. Changing views of the role of collections call for a correspondingly sophisticated approach to their conservation. In the early years of conservation as a separate activity, the objective was to restore the object, sometimes crudely, 'to its former glory', but restoration in museums is now often pejoratively defined as 'to return the object to a supposed earlier state'. Restoration may be all right for objects in private ownership, where a chair must still be a chair (and perhaps also a valuable investment); it may be treated in such a way that it can perform these functions. Once it is in a museum it becomes not a chair but an object. Its function is now not to be sat on or sold, but to be a source of information and inspiration about the context – past or present – that it represents (MacDonald and Alsford, 1991). Therefore, what the museum conservator must do now is conserve: that is preserve the object as far as possible as unimpeachable and original information from its context. This requires a minimalist approach to the work that is done and close cooperation with the other specialists involved – the curators, whose role it is to know what it is important to preserve.

Not everyone dismisses restoration as wrong-headed. Some museum people maintain (particularly of machines and mechanical objects) that museums should preserve the function of the object, not the object itself. But it is increasingly the view (embodied, for example, in the Museums and Galleries Commission's Standards for curation of large objects collections (Paine, 1994)) that the wear and maintenance that objects are subject to if operated can severely compromise them as true representatives of the past. They may still be used to demonstrate function, but not without taking account of the consequences.

The tasks involved in conservation are perhaps uniquely varied. Practical skill is still essential, and most conservators spend most of their time on actively 'treating' objects: removing dirt and deposits that cause damage, strengthening them using physical support or consolidation with resins, removing the chemical products or agents of decay, as in acid paper. But creating the conditions for preservation, rather than curing ills once they become apparent, is assuming ever greater importance in the conservator's role.

The need for and difficulty of this, and the scope of the approach that needs to be adopted to ensure success, is illustrated vividly in the fate of many important collections of ethnography. The objects are mostly made from fragile organic materials, especially vulnerable to decay. Assembled

by scholars and collectors, or by museums themselves, most collections when they reach museums are in good condition. But time after time such collections are discovered to be faded, dirty, crushed by overcrowding, damaged by pests and damp, and lacking documentation and thus a large part of their 'meaning'.

Management information

To preserve such collections successfully takes knowledge of how to diagnose chemical decay and how it can be arrested or reversed, skills in physical treatment, and experience in the recreation of a preservation environment – temperature, humidity, oxygen and gaseous composition, dust exclusion, and light control. But essential though it is, this expertise is useless without the high-level ability to create the organization and the social system of people in it: to plan, monitor and undertake the initial work, and to maintain these conditions indefinitely. This task in turn is impossible without planning, specification, records and monitoring to collect data. Those who wish to preserve collections must take the broadest possible view of the objectives and the strategies which can be used to accomplish them. They must test, by collecting and analysing information about it, whether the real world which they hope to manage is as they envisaged in their plans and concepts, and thus identify the necessary actions.

The wider context

The climate for museums

The national context for museum operations needs to be appreciated. In the UK, various statutory and other government institutions have a hand in museum operations. National museums are established through a variety of Acts of Parliament, the most far-reaching of which is the 1983 Heritage Act. Prior to this, most of the UK national museums were simply departments of the Civil Service. The Act gave them an independent existence, with boards of trustees, as the British Museum has always had. However, since the government is still by far the major source of funds, the independence of these museums is in practice heavily qualified. Local authority museums are run as non-statutory services, meaning that local authorities may provide them, but have no statutory duty to do so. In times of severe financial constraint they are vulnerable.

The Civil Service department responsible for museums is presently the Department of National Heritage (the DNH). As well as the DNH itself, the Museums and Galleries Commission (the MGC) has a prominent role

in museum affairs. The Commission is the channel of government funding for the Area Museum Councils, which provide various subsidized services to museums. The Commission itself is playing an increasingly important part in setting standards for museums. Its museums registration scheme began in 1988 (Museums and Galleries Commission, 1988) and is presently being revised (museums have to meet certain criteria in order to be registered). It is taking an increasing role in standard setting, by publishing a series of Standards in the museum care of collections (Paine, 1992a,b, 1993, 1994). The bodies responsible for monitoring the proper expenditure of public funds also have an effect on museums: the National Audit Office, which reports to the Public Accounts Committee of the House of Commons, and the Audit Commission, which monitors local government. Both bodies have recently produced important reports which continue to influence the policies and priorities of museums (Audit Commission, 1991; Comptroller and Auditor General, 1988).

The context for management in museums has been changing rapidly, from a *laissez-faire* climate in which professional, curatorial objectives dominated, to one in which there are overt pressures for accountability both for the maintenance of the collections and for the use of resources. It is not yet clear whether museums can still be characterized as 'professional bureaucracies' (this is one of the five organizational types described by Mintzberg (1983)), or whether they now belong in a different organizational category.

Management and information

In order to set museum and conservation management in the context of the wider world, the body of general knowledge and understanding of organizations and their management needs to be appreciated. The development of this body of knowledge has been accelerated by the popularity of business schools and educational programmes devoted to its study. There is much literature on the subject, describing approaches that range from the highly analytical and directive (as in scientific management, where people are seen as cogs in a machine) to the inspirational and intuitive (such as work on motivation and leadership), or reviewing a number of different metaphors that can be used to describe organizations (Clutterbuck and Crainer, 1990; Morgan, 1986).

Information lies at the heart of management. Providing information demonstrates to the people in the organization that what they are doing is important enough for the organization to wish to monitor it. This will be especially significant for highly educated professionals such as conservators. Griffin (1987) identifies the organizational culture in museums as a 'professional bureaucracy'. Members of such organizations

are apt to feel a greater allegiance to their specialist profession than to the organization which employs them (Mintzberg, 1983, Ch. 10).

A wealth of information-based techniques has been developed in management studies and science which could be applied to the management of conservation. Management science encompasses work on mathematical and computerized aids to planning and decision-making generally, some of them used in operations research. Operations research is derived from the concepts embodied in engineering systems: a problem is identified, and a variety of mathematical modelling techniques is then employed to solve it. A variety of quantitative methods is potentially useful, for instance cost–benefit analysis, risk analysis and strategic planning. These methods are useful for solving problems if the situation is taken as given, but many public-sector organizational situations do not lend themselves to such a convergent approach, especially at a time of change, when current ways of doing things may need radical review. The solution to the problem may lie not in fixing the existing function, but in reviewing the earlier objective or taking an entirely different approach to achieving it. Non-quantitative analytical methods also exist, such as robustness and strategic choice analysis, and these are highly relevant and applicable to strategic planning and setting priorities.

Understanding the task

Before investigating how management information tools can be applied in a 'problem situation', techniques need to be employed to aid the full understanding of that situation. A museum may be funded publicly or privately; it may be a national museum, a local authority museum or a private museum, and have the appropriate constitution; it may have varied collections, or be extremely specialist. Yet all these institutions have basic functions in common, and they have to respond to not dissimilar pressures from their organizational environment.

One way to develop greater understanding and insight is to envisage the abstract systems which might be used to describe museums of whatever type. Systems thinking is a major analytical tool. Many writers demonstrate its pervasiveness in management research. One such approach, the soft systems analysis methodology, is a powerful method of enquiry into aspects of the world such as organizations. It has been selected as the principal analytical tool used in this book, since it is particularly designed for situations where 'the problem' is hard to define (Checkland, 1981).

The information requirements for museum preservation are quite complex, since collections serve several purposes and are subject to different, usually conflicting, priorities. Soft systems analysis is used to analyse the processes of collections preservation. The analysis primarily

focuses on information needs, but analysing the system also gives the opportunity to compare the actual organization of conservation/preservation with the system needs shown in the conceptual system, and thus to diagnose deficiencies.

Information in practice

Information for managing conservation is needed at all levels of conservation, ranging from individual people for managing their work to the senior management of the museum for setting long-term directions and strategies. Data are more easily obtained than ever before, due to the use of computers, but analysing the data so that they give useful information is as difficult as ever. Conservators are very good at collecting data – on conservation treatments, on the museum environment, on the condition of objects – but less inclined to analyse the data and to make use of the results. However, high-level analysis and presentation can have a dramatic impact on organizational thinking.

To determine what information we need to serve our aims, we have to determine what those aims really are. Writers on strategic planning (e.g. Bowman and Asch: 1987: 380) recognize that this will be particularly difficult for public sector organizations like museums, because these typically have multiple objectives, many of them measurable only qualitatively, not quantitatively. Also, the information must serve the people of the organization. Sir John Hunt, in *Managing people at work* (1979: 145–6), observes that quantitative approaches imply strong central control, and reflect the elitist Anglo-American view of managers not shared, he suggests, in other countries such as Germany or Japan. This view is expanded by Hampden-Turner and Trompenaars (1994), who show that there is a whole spectrum of views in different countries, east and west, of what management consists of and how it should be undertaken. Information, however, is useful not just to inform managers of what their subordinates are doing. Its real power is to inform people, at all levels of the organization, on the factors which determine whether objectives are being met and corporate values realized. If people are cut off from information on whether they are succeeding in their work they will be demotivated and uninvolved; conversely, timely feedback can have a powerful motivating effect.

Strategic directions need to be set before detailed plans can be developed. There are various useful approaches to strategic planning. Performance measurement as applied to museums is particularly discussed. This is in general terms the means of telling whether an organization is achieving its objectives: an essential component of management information systems. There is a strong case for developing

performance measures for conservation. If the collections of museums are fundamental to their operations, then a means must be found of assessing whether they are being preserved. And, as Griffin (1987) says, 'It is not enough simply to believe that there are benefits. One must display those benefits – using words and symbols which are at least familiar, if not appealing – to those who can be persuaded to pay for them.'

Peters, too, is convinced that public, timely measures have a valuable place in motivating people at work. He is convinced that the best strategy is that which insists on visible measures of what is going on in the trenches and on action there to achieve a high rate of improvement (Peters, 1987: 585). Such measures can be appropriate for many conservation functions, particularly on the broad preservation of the collections through providing proper storage and display conditions.

The new view of the role of museum collections which is developed through the soft systems analysis assists in understanding the objectives of and reasons for conservation. It can lead to a better understanding of the way in which the different components of the task – planning, environmental control, condition monitoring and conservation treatment – complement each other in a unified system. It is obvious that information for managing is essential. Finally, the use of information for managing conservation is reviewed and evaluated.

The case study

The affairs of the Historic City Museum are used to illustrate many of the examples in this book. The Historic City Museum is partly based on the Museum of London, but it is a composite of many other museums in the UK, in America and in Canada, and of others existing only in the imagination.

Historic City Museum is a large museum with a long and proud tradition, having been established in 1850 as an expression of civic pride in Historic City. It has two outposts, the Working City Project, in a former industrial area which is now being revived, and the Historic Art Gallery, which is run as a quasi-autonomous organizational unit in a separate building. An archaeology unit funded by developers and by English Heritage undertakes archaeological excavations in the city and its surrounding area.

The Conservation Department was created in 1960 by separating off some of the museum general technicians and giving them some extra training in, and special responsibility for, conservation. During the late 1980s it consolidated its professional presence in the museum, and changed from providing a reactive service to curators on request to taking an independent, proactive view of the preservation of the collections. This

was expressed through giving the conservation department viewpoint on museum matters generally whenever consultation was sought, compiling and presenting reports on topics such as the quality of storage and the condition of the collections, and putting forward programmes of work of its own.

The department now has an equal status with the curatorial and collections administration departments. It consists of about fifteen staff, some on the museum's permanent staff, some on fixed-term contracts funded by the excavation unit or through other specific short-term projects. The conservators are organized into four sections: archaeology conservation, applied arts conservation, paper conservation and textile conservation. By publishing research and development, attending and speaking at conferences and visiting other museums, its members have established its excellent international reputation for innovation both in the practice of conservation and in its management.

The museum has a busy programme of exhibitions, outreach projects, archaeological publications, loans and other interpretive activities. It has recently taken a policy decision to improve the care and management of its collections as well, so the climate for outgoing conservation activities is good. However, conservation still has to bid for resources against other museum activities.

In the case study, we shall see how the conservators in the Historic City Museum used some of the management and information tools which are discussed.

References

Audit Commission (1991). *The road to Wigan Pier?* Audit Commission Local Government Report 1991, no. 3. London: HMSO.

Bowman, C. and Asch, D. (1987). *Strategic management.* Basingstoke: Macmillan.

Checkland, P. (1981). *Systems thinking, systems practice.* Chichester: John Wiley.

Clutterbuck, D. and Crainer, S. (1990). *Makers of management.* Basingstoke: Macmillan.

Comptroller and Auditor General (1988). *Management of the collections of the English National Museums and Galleries.* National Audit Office Report. London: HMSO.

Griffin, D. J. G. (1987). Managing in the museum organization: I. Leadership and communication. *Int. J. of Museum Management and Curatorship,* 6, 387–98.

Hampden-Turner, C. and Trompenaars, F. (1994). *The seven cultures of capitalism.* London: Piatkus.

Hebditch, M. (1990). Why do we preserve objects? In *Managing conservation, conference preprints,* (S. Keene, ed.), London: UKIC.

Hunt, Sir John (1979). *Managing people at work.* London, Pan Books (paperback edition 1981).

MacDonald, G. F. and Alsford, S. (1991). The museum as information utility. *Museum Management and Curatorship*, **10**, 305–311.

Mintzberg, H. (1983). *Structure in fives*. New Jersey: Prentice Hall International.

Museums and Galleries Commission (1988). *Guidelines for a registration scheme for museums in the UK*. London: Museums and Galleries Commission.

Morgan, G. (1986). *Images of organization*. London: Sage Publications.

Paine, C., ed. (1992a). *Standards in the museum care of archaeological collections*. Standards in the museum care of collections, no. 1. London: Museums and Galleries Commission.

Paine, C., ed. (1992b). *Standards in the museum care of biological collections*. Standards in the museum care of collections, no. 2. London: Museums and Galleries Commission.

Paine, C., ed. (1993). *Standards in the museum care of geological collections*. Standards in the museum care of collections, no. 3. London: Museums and Galleries Commission.

Paine, C., ed. (1994). *Standards in the museum care of larger and working objects*. Standards in the museum care of collections, no. 4. London: Museums and Galleries Commission.

Peters, T. (1987). *Thriving on chaos*. New York: Harper Perennial.

2 Museums and collections

In this chapter the nature and roles of museums are discussed. What functions do they fulfil, and what are the important statistics relating to them: numbers, visitors and expenditure? The purposes of holding collections, and the roles played by different museum professionals, are reviewed. Finally, the nature of conservation in museums itself is explored.

Museums

Purposes of museums

The roles of art museums are reviewed by Weil in his compilation of essays, *Beauty and the beasts* (1983a: 32). They are for recreation; temples of contemplation; education; connoisseurship in the sense that they portray the highest standards; symbols of power; centres of scholarship; embodiments of bureaucracy, because of the need for continuity; agents of social change; representatives of the artists whose work is displayed; patrons; and caretakers of public patrimony. Not everyone admires these elevated roles. Hewison in his much-cited book *The heritage industry* (1987) claims that excessive public interest in the 'heritage' promotes conservative politics and national stagnation (p. 32), encourages 'a respect for privacy and private ownership, and a disinclination to question the privileges of class' (p. 66). According to Merriman, the hidden agenda of museums is to legitimize affluence by promoting an appropriate lifestyle: encouraging people to acquire 'cultural capital' (Merriman, 1991). Sir David Wilson, however, that strong defender of free museums when Director of the British Museum, claims public support for the British Museum from the diversity of its visitors: from London taxi-drivers through to Inuit hunters (Wilson, 1989: 9).

Merriman (1991: 18) takes issue with the pessimistic viewpoint of Hewison, and identifies a 'much more positive and potentially liberating role for museums and similar bodies'. He rejects the view that they represent a Marxist dominant ideology which defines and confines the

attitudes and social position of the mass of society, because, he says, the majority of their visitors are in fact from the dominant classes, not those who should potentially be dominated. Merriman calls for 'the exciting possibility that museums and other similar institutions promoting a non-commercial representation of the past based on the positive values of stewardship and scholarship, might have a vital role to play in providing materials for people to creatively construct the past.'

Publicly funded museums in the UK are under great pressure to increase the number of people who visit them, and they can only do this by attracting people other than the affluent middle-class families who are their main users at present. They are seeking to attract a wider spectrum of visitors by, in many cases, drastically changing the nature of what they offer. In the past, most museums exhibited showcases containing objects, or pictures hung on walls, supported by more or less graphic material to give the visitor a sense of context and involvement. Now, some of the most popular exhibitions (in the Natural History Museum and the Science Museum, for example) use interactive displays or elaborate 'experiences' (like the Jorvik Centre, the Tower Hill Pageant and others) to put across concepts and ideas, with far fewer objects on display. However, the most popular museums of all are the British Museum and the National Gallery – both relying on academic displays with a heavy emphasis on objects and relatively little interpretation, and both free to the public.

Numbers of museums

Rapid growth is a dominant characteristic of museums and their operations since the late nineteenth century, and particularly in the 1970s and 1980s. As surveys and reports have established (Prince and Higgins-McLoughlin, 1987), there are about 2000 museums in the UK. The growth in numbers has been phenomenal: in 1887 there were but 217, while in 1987 a new one was opening about every two weeks, with the total number almost double what it was in 1971. In the 1990s, some of these newly arrived museums are closing.

The size of collections

The growth in size of museum collections has paralleled their increased numbers. Sir David Wilson (1989: 25) points to collecting as one of the mainsprings of a museum: 'A museum which does not collect is a dead museum.' This statement is no doubt disputed by those in the many thriving non-collecting museums, such as the Wallace Collection, the Dulwich Picture Gallery, and many others. Even in the nineteenth century, one of the British Museum's famous

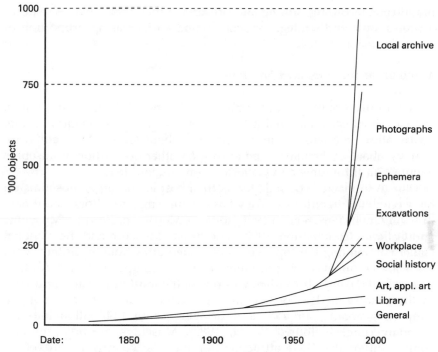

Fig. 2.1 *The growth of the collections of the Museum of London*

curators, Franks, enlarged the collections of the British and Medieval Antiquities Department from 154 feet of cases in 1851 to 2250 whole cases in 1896. Social history museums have increased their collections particularly rapidly, as *Collecting for the 21st century*, the survey of industrial and technological museums in Yorkshire and Humberside (Kenyon, 1992), shows. In the Science Museum, all the collections were housed on its main South Kensington site until the 1950s. Now, they are stored in four major sites, including two new museums. Many museum collections now are numerically enormous. The Museum of London holds about one million objects; the British Museum about six million.

Even quite modest local museums often have hundreds of thousands of individual objects, especially if they include paper-based collections such as photographs. About half the objects in the museums in the Yorkshire and Humberside survey are paper-based ones, and the same is certainly true of most local history museums (Kenyon, 1992). Simply providing storage for these large collections is a considerable function of museums. In 1992 the Museum of London occupied over 17 000 m² of collections storage space; the Science Museum over 25 000 m². Accounting for,

organizing, recording, storing and preserving these assemblages requires a professional and strategic approach, and an increasing proportion of museum finance.

Museum economics and finances

Expenditure on publicly funded museums in the UK is quite substantial: in total, about £406m annually. In 1991–92, central government funding, nearly all for the national museums, was about £259m; local authority funding about £128m; and expenditure on other non-national museums about £42m (Museums and Galleries Commission, 1992).

Though in macro-economic terms their cost is not large, museums do have economic significance. They have a great many visitors: about 57m in 1977; 72m in 1989; 80m in 1991 (sources: Merriman, 1991: 10; Museums and Galleries Commission, 1992). The British Museum and the National Gallery are among the top five most visited attractions in Britain, with 5.4m and 4.2m visits respectively in 1991 (Comptroller and Auditor General, 1994). In 1987 tourism was one of the most important industries in the country, and a considerable generator of income from abroad, supporting about 1.4m jobs and bringing about £14 billion into the economy (English Tourist Board, 1987). Museums are an important component of the UK's attraction for tourists. Nearly a third of all museum visits, and 44 per cent in London, were by overseas tourists (Myerscough, 1988).

What are collections for?

Despite all the pressures on museums to offer a kind of three-dimensional television experience to their visitors, their existence is still absolutely based on their collections. The possession of permanent collections is what distinguishes museums from primary schools, theme parks or car showrooms. The collections still form the basis for museum activities, however diverse. Preserving the collections is fundamental to all other museum activities (Weil, 1983a; Burrett, 1985).

But preservation is not the only basic museum function. The two major imperatives which are always cited in the statutes or other instruments establishing museums are on the one hand to preserve and care for collections; and on the other to display them and use them in other ways to entertain, educate and enlighten (International Council of Museums, 1990). Preservation and exhibition are conflicting objectives, since for most types of object it is almost impossible to establish optimum conditions for preservation during display or use. Every museum has to strike its own balance. The point at which this balance is struck will have

profound effects on the museum's preservation function. There is, too, a wide spectrum of types of museum, from art galleries where the aesthetic is all, to farm or industrial museums where the purpose is to preserve and demonstrate the function of the object as well as simply to use it as a passive source of information.

Paradigms for museums

The national museums in Britain offer, in a sense, paradigms which set the standards and limits of museumship. An important part of their role is to act as centres of excellence and sources of expert advice; to set an example to other, lesser museums. Three of the national museums strike one as being as different as they could possibly be. These are the Science Museum, the Natural History Museum and the National Gallery. Examining the roles and perceptions of the collections in these museums may shed light on some of the contradictions found in other less specialized museums.

The Science Museum is thought of as the example for museums of industry and machinery (e.g. Patrick Greene, 1990, *Museums in great cities*, internal Museum of London seminar), where public enlightenment through the active demonstration of how objects function is the paramount objective.

The National Gallery is the picture museum *par excellence*. Here, art and the aesthetic experience reign; the object must speak for itself (Wright, 1989) and it must be in such condition that nothing will interfere with the viewer's experience.

The Natural History Museum stands as an exemplar for museum collections of natural objects. Many of its displays use not objects but graphics, or three-dimensional constructions and interactive computer screens, along with other interactive devices, to put across concepts and ideas. In spite of this, it is a great research institution as well as a museum, with collections of objects numbering many millions, and its activities go far beyond and have a deeper significance than its public displays (Radford, 1990).

What are the differences that make these three institutions stand out from each other, and from the other national museums? One fundamental difference is the size of their collections. The Natural History Museum holds about 65 million objects, the Science Museum 250 000, and the National Gallery some 2 200. There is naturally an inverse ratio between the size of the collections and the proportion on display, with the National Gallery having all its pictures on display, the Science Museum about 10 per cent and the Natural History Museum less than 0.1 per cent of its objects in its public galleries. (Information: personal knowledge or the press offices of the museums.)

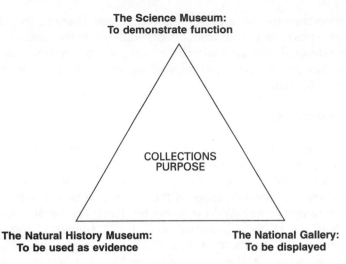

Fig. 2.2 *The purposes of museum collections*

Is it the nature of a collection that determines its use – do the museums have to be as they are, or could the National Gallery build a collection of a million or so paintings, and the Natural History Museum consign its insect and birds' egg collections to a few large skips? One could envisage a museum of natural history which held and exhibited only a few key objects; an art gallery, if it had access to enough money, could acquire and store an enormous archive of European painting, or set out to represent the history of society, technical advance and ideas which produced its works of art. The nature of (and cost of acquiring!) the collection obviously does have a great influence on the purpose of the museum, but the differences are not wholly dependent on the type of collection: they must arise from differences in the reasons for holding collections. The reasons for a museum holding collections will be derived of course from the museum's various fundamental purposes.

If the purposes for which these three museums hold collections are depicted as forming the coordinates of a triangle (Fig. 2.2), other museums can be placed within it (Fig. 2.3). For example, archaeological collections are like natural history collections and like archives of documents: the objects are being kept as a source of scientifically valid evidence about the past. In the early days of Rescue, the archaeological pressure group, the destruction of sites without excavation was often compared to tearing up historical manuscripts. Archaeological objects represent the last physical remnants of 'manuscripts' which have been destroyed through excavation. For natural history and archaeological objects alike, as for archives, their context is all important. Just as unbroken ownership must be demonstrable

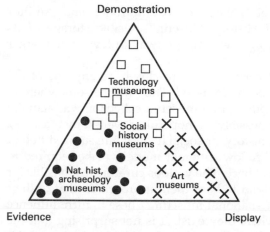

Fig. 2.3 *Types of museum vs. the purposes for which they hold collections*

for documents in an archive (British Standards Institution, 1989), so the connection of object and context must be unimpeachable if these collections are to constitute reliable evidence. If conservation treatment or other physical intervention has altered the nature of the object then its worth as evidence is severely diminished.

Similar to picture collections are other art collections: works of art on paper, and sculpture. They share with collections of furniture and other objects a prime purpose of display for appreciation.

Collections where demonstration is the objective include many of those in agricultural, industrial and transport museums. One might add to these, buildings themselves, since many historic buildings are used to demonstrate a past way of life and function. Particularly good examples are those at the Welsh National Folk Museum (St Fagans); and of course National Trust properties.

Implications for museum management

The divergent uses which museums make of their collections have far-reaching implications for the preservation of the collections and the nature of the conservation activities devoted to them. Although those who run museums are obviously aware of the differences between uses, there is little acknowledgement that the divergence is so fundamental. Discussions of 'what are museums for' tend to view museums as being of one general type (Hebditch, 1990; Weil, 1983a). Certainly the public is not aware of the differences in approach, and this was well demonstrated in the Auditor General's Report, which castigated museums for not showing

a greater proportion of their collections (Comptroller and Auditor General, 1988). The Natural History Museum's visible storage of its butterfly collections has long ago been swept away in favour of a larger shop.

Most museums do not, of course, conform closely to any one of the three paradigms which have been identified. They will be somewhere in the middle of the triangle. Nothing in a museum collection was actually designed to be there (except possibly by hopeful or well-known artists). Especially in the case of local history, or social history museums, different parts of their collections will follow different models, or be required to serve more than one purpose at once. The various curators responsible for the different collections will tend to base their approach on that of their role model, the corresponding national museum. These in turn influence specialist training courses, where they exist. It is not surprising that the individuals concerned, such as art and archaeology curators, often find it difficult to share a common approach within one institution: they are likely to disagree fundamentally on what a proper museum ought to be doing, and this disagreement will probably not be recognized as such.

Implications for preservation

The demonstration approach will have especially important consequences for the preservation of collections, if by 'collections' is meant assemblages of real, historic objects. This has been well explored by Peter Mann, using as his examples the treatment of historic cars (Mann, 1989). It might be questioned whether, if objects are likely to end up partly or even entirely as replicas, it would not be better to resolve the dilemma by building accurate replicas in the first place. There are other possible approaches to this. In the Welsh National Folk Museum, the approach is said to be to retain and not use the most perfect example of the object, and to designate other similar objects specifically for use.

The effects of the display approach can be just as destructive as demonstration. Objects can only be displayed if they are lit, and light falling on an object causes fading and other damage. Deterioration is not perceived to be happening, however. It happens slowly, and we can only retain imperfect memories of images and colours, and so we cannot compare the present state of a picture with what it was like in the past. Art curators and critics are notoriously unwilling to accept that pictures should be displayed at low or controlled light levels. To them, the question is beside the point, because as far as they are concerned the collections are not there to be preserved for nebulous future generations; they are there to be displayed and appreciated. But the image which is the point of the display and the source of the experience

is almost certain to be drastically altered if it is exposed to sufficient light energy. Can this be irrelevant, when museum collections are meant to be 'for ever'?

Preservation is more likely to rule the day when a collection is held as an archive. There are often millions of objects in collections like these – natural history specimens, paper or archaeology archives – and their immediate use is not obvious (why are we keeping all these bits of old pot?). They take much up-front investment to organize and inventory, and are expensive in storage materials, which must all be of archival quality. Once organized, however, they require little upkeep, and because the aim is to maintain them as unchanged evidence they need the minimum of remedial conservation treatment.

Museum users and their needs

So far only the attitudes of the holders of the collections, the museum professionals, have been discussed. But what about the users – the public? There is a surprising variety of them, from scholars to primary school children; from film producers to learned societies. Obviously, some users will want to benefit from the collections in one way, some another. Scholars will want to use the collections as evidence; film producers will be after objects for demonstration. The question is whether the short-term wishes of one particular set of users, or indeed museum professionals, should override the hypothetical needs of other future possible users. Does this matter? Museum people are fond of quoting Maynard Keynes, 'in the end we are all dead'; but the point about museums is that their collections are held 'in trust for the nation'; the needs of users a hundred years from now are meant to be borne in mind too.

The public is becoming both more and less sophisticated in its use of museums. On the one hand, the success of exhibitions such as Art in the making (National Gallery, series, 1989 and ongoing), or Fake! (British Museum, 1990) shows that substantial numbers of people want and enjoy an extremely detailed, accurate, academic and scientific treatment of objects (MacGregor, 1990). This can only be provided by preserving objects as evidence; in the case of Fake!, real fakes! On the other hand, the growth of simulated historical experience exhibits, science experiences such as Eureka! in Halifax and La Villette in Paris, and other 'demonstration' museums, indicates the reverse – that many people want history primarily as entertainment. Perhaps it is simply that more people are visiting museums more often, they want a wide range of education and entertainment, which is being provided by all these different museums, and above all they want something new.

Changing taste

Counterbalancing the pressure for the short-term exploitation of collections at the expense of their long-term preservation are pressures for accountability in museums, exerted by the National Audit Office (for national government), the Audit Commission (for local government), and the Museums and Galleries Commission (as a standard-setting and a grant-giving body). The collections are in the end a publicly owned resource. The standards which are being developed in connection with museum registration (e.g. Paine, 1994) will encourage a greater emphasis on the preservation and archive function of museums. Museums are also coming to terms with a plurality of views in their senior management, as on the one hand exhibitions and marketing specialists and on the other conservators and collections managers increasingly demand and find a voice in policy development.

There was a remarkably noisy public response to the strongly critical report by the Comptroller and Auditor General on the collections of the English national museums (1988), and the ensuing sitting of the Committee of Public Accounts. Most of the major newspapers ran stories (See Chapter 3, Management and Information). Perhaps the debate about the natural environment – at the core of which is the need to live within the limits of a fixed resource – strikes chords when the maintenance of museum collections is discussed. To the public, museums may be 'dingy places with different kinds of bits' (Trevelyan, 1991), but at least they are places where something is properly looked after, so in museums at least there should be no need to worry about using up a finite resource. Public visits to museum stores can unfortunately result in shattered illusions on this score, but good collections care can backfire too: the author has come across at least one visitor to well-stored collections who expressed surprise at how expensively they were being looked after. Museums are of course mostly no better at looking after their possessions than are private individuals; indeed, they are often far worse. Most museums could find examples of objects that were in excellent condition when first acquired, which have since suffered severe deterioration in overcrowded and unsuitable stores – ethnographic collections are especially vulnerable.

In the USA, as so often, there is more open and vigorous debate on the importance of caring for collections, and this has even occasionally been pursued in the courts. It is being demonstrated there that concepts such as 'due care', 'fiduciary responsibility', and 'standards in the industry' can be applied just as well to the responsibility of museums to preserve their collections as to the activities of many other institutions (Ulberg and Lind, 1989; Weil, 1983b).

Conservation and preservation, like museums themselves, are not universally seen as good things. Conservation is often perceived as being

puritanical and restrictive, insisting on preservation at the expense of natural enjoyment and use. For example, in a typical sideswipe at conservation attitudes, Hewison, referring to buildings and the built environment (1987: 98), complains that conservation creates a context and use of its own.

Conservation or restoration?

Alongside the debate on how museum collections should be used is that on the approach which should be adopted for their preservation and maintenance. At one pole are those who support the minimalist approach to conservation: do as little as possible; at the other, those who wish to restore the object to working order, looking more or less as new. In the first case only the work which is essential to the preservation of the object is undertaken, and additions are clearly distinguished from the original; in the second the object is made to look like and function as new. Although this debate is quite vigorous in museums, where privately funded museums, private collectors and private conservators and restorers are often identified as those in the 'restoration' camp, it does not often occur publicly. A rare example was a court case tried in 1989, when Edward Hubbard refused to honour a contract he had entered into to purchase a vintage Bentley because he considered the car to have been so heavily restored as no longer to be genuine. In fact, he lost the case, but only because he was held to have known about the car's state before he bought it.

When particular courses of action are debated for a particular object, the greatest number of options is left open if each party has the right of veto in favour of the option that least affects the original nature of the object. More thorough replacement, more extensive restoration can always be done later; but once original parts have been removed or altered then they can never be recovered. Objects which have been restored to a supposed earlier state, where someone has already decided what they looked like, will be no use in Merriman's vision in which people can draw on museum collections creatively to reconstruct the past (1991: 18). The minimalist approach to conservation, necessitated by the archive function of museums, is the one which leaves the widest range of options open for other and future 'uses' of the collections.

Conservation in museums

Defining conservation

Conservation is defined in the statutes and instruments of government of various organizations concerned with the heritage. It can be seen from the

various definitions that discussions of conservation in museums centre around two themes: firstly, the nature of the work carried out on objects: conservation versus restoration; and secondly, the role of the conservator or other agent carrying out that work.

The professional body for conservators, the United Kingdom Institute for Conservation, defines conservation as

> the means by which the true nature of an object is preserved. The true nature of an object includes evidence of its origins, its original construction, the materials of which it is composed and information as to the technology used in its manufacture. Subsequent modifications may be of such a significant nature that they should be preserved. (United Kingdom Institute for Conservation, 1981)

ICOM, the International Committee of Museums, defines the activity of conservation as technical examination, preservation and conservation/ restoration of cultural property (International Committee of Museums, 1985). ICOM gives further definitions:

> *Preservation* is action taken to retard or prevent deterioration of or damage to cultural properties by control of their environment and/ or treatment of their structure in order to maintain them as nearly as possible in an unchanging state.
> *Restoration* is action taken to make a deteriorated or damaged artefact understandable, with minimal sacrifice of aesthetic and historic integrity.

Professional roles

The relationship between curators and conservators is often a matter of power struggles over decisions concerning objects. What lies at the heart of this conflict, if such exists?

Basil Greenhill, as Director of the National Maritime Museum, in discussing museum management identifies three estates in museums: the curatorial one, concerned with the past and the present of the object; the conservation one, concerned with the present and the future of the object; and the management one, which has to coordinate and balance the functions of the other two estates. Each estate has its own functions but they overlap and interlock. However, it is management, he says, that must decide what happens and take responsibility for the whole (Greenhill, 1984).

Looked at dispassionately (and admittedly completely unrealistically), a museum simply employs people to carry out its functions. A museum

is defined in the ICOM statutes as an institution which 'acquires, conserves, researches, communicates and exhibits'. Thomson (1973) argues that, since deficiencies in all the functions except preservation are reversible, preservation of the collections is the museum administration's first duty. Indeed, statutes which establish museums in the UK typically begin by defining the function of the museum (in fact, the duty of the trustees or governors) as being 'to preserve and care for . . . the collections' (e.g. Museum of London Acts, 1985, 1986; National Heritage Act, 1983).

Curators, historically, have been in total charge of museums' collections, responsible for security, handling and organization, storage, display and conservation and restoration. But division of labour between individuals with differing expertise is one of the character-istics of organization in the twentieth century. In recent times, as museums have grown and their public has become more demanding, other disciplines have been employed to undertake some of the tasks formerly performed by curators: designers, educationalists, admin-istrators, conservators and, recently, registrars and collections man-agers. Curators have at the same time lost the automatic right to the top jobs in museums. The director of the National Gallery was before that an art historian and magazine editor; of the Natural History Museum, a university academic; of the Victoria and Albert Museum, its librarian.

Perhaps because they have previously had such an all-embracing function, curators seem not yet to have defined the core of their functions and responsibilities well enough to make it apparent what it is that is unique and exclusive to them. The Museums and Galleries Commission, in the Hale Report, Museum professional training and career structure (Museums and Galleries Commission, 1987) stated that it is 'curatorship for which training does not exist'. But this begs the question, training to do what? A decade later, this is still far from clear.

Turning to conservators, in museums they began very much as an extension to the curator, to undertake tasks perceived as low status, requiring craft skills or muscle. In 1936 the first training in conservation (at first for archaeologists) was set up, in the newly formed Institute of Archaeology of the University of London. In the 1950s this became the first training course for conservation as such. Since then, conservators have become highly educated, well trained, more professionally organized, and more confident (Corfield *et al*, 1989: 60; Museums and Galleries Commission, 1987). Their status is recognized as almost, though still not quite in some museums, equivalent to that of curators. Conservators now are expected to possess a blend of scientific knowledge, manual dexterity and craft skills that must be extremely rare in employment in the late twentieth century. Conservators have, until the arrival of collections managers, been the only group in museums other than curators which has

had objects at the centre of its work and training. It is not surprising that curators feel threatened when their power of decision is lessened, especially when their own role remains so ill defined. Why should museums continue to employ people known as curators when others do most of what curators used to do, and for lower pay?

The relationship of the professional to the object is another focus of conflict. There are countless examples of conservators past and undoubtedly present doing things to objects that have damaged them or altered them in undesirable ways. These are matched by curators insisting on exactly this sort of work being done, or on displaying objects in conditions in which damage is certain. The curator adopts a role of pseudo-ownership; the conservator that of carer, almost parent. Curators may justifiably be concerned that their proper concern and responsibilities for the object may be overlooked; and conservators that their careful and painstaking work will be wasted due to careless handling or inappropriate storage or display. A situation needing a rare degree of trust and communication from both sides, indeed!

When a conservator works on an object it is entirely within their power, intentionally or unintentionally, whatever the specification for the work may have been, to alter it in many drastic and fundamental ways. Cannon-Brooks proposed some years ago that the curator was responsible for *what* should be done, the conservator merely *how* (1976). But 'what' must depend on a diagnosis of what is the matter, and this diagnosis depends on the skill of the conservator. Curators may wish to control the what, but in the real world the only effective way to do this is through the wide promulgation of an agreed system of ethics. And practitioners too have a right to a say in what they do (Ashley Smith, 1982): they are entitled to set and maintain professional standards.

What should be the functions of the participants in this triangle? There are two separate bodies of knowledge and areas of responsibility, and they exist because museum objects exist in two metaphorical dimensions: the physical dimension and the intellectual or information dimension. If the object's existence in either dimension is damaged, then the other, sooner or later, will be affected also. Conservators should have expert knowledge of the physical existence of the object: diagnosis of ills and of the alternative treatments available; the effects a particular treatment will have, of its likely success, of the risks it carries; and of the ways in which it may affect the object's historic integrity and authenticity. They must communicate this knowledge. The curator must know what constitutes the intellectual dimension of the object: why it is in the collection; what is significant about it; why it is like it is. The curator can perhaps be seen as having intellectual ownership of the collections. Both these fields of expertise should be

brought to bear in deciding what should be done to the object; both participants have a duty to make sure that they acquire and maintain the necessary knowledge.

To a conservator, it is astonishing that as recently as 1988 it should have been reported as obvious that

> in general we [i.e. curators] do not really apply the concept of collections research which illuminates the objects and gives perspectives which on the one hand can guide us towards selectivity rather than random in-gathering, and on the other opens new paths of knowledge. (Fenton, 1988)

If curators are too distracted by power struggles to play their proper, expert part, then no wonder they feel threatened by those who do.

What do conservators do?

The conservator, then, is supposed to be expert in how to retard deterioration and remedy its effects. How is this done? The Museums Training Institute undertook a functional analysis of conservation and other museum work, in developing its scheme of national vocational qualifications (NVQs). It found the following areas relating to 'preserve and maintain items, collections and structures (conservation)' (Museums Training Institute, 1991, Sect. 2):

- Ensure optimum work area and supplies
- Assess items in context
- Identify and agree options for preservation
- Treat items
- Maintain item condition.

This dull little list completely fails to convey either the complexity or the substance of what conservators do.

The survey of conservators and facilities carried out by UKIC in 1987 established the amounts of time conservators spent on activities as set out in Table 2.1. The book published by the Getty Conservation Institute, *The nature of conservation: a race against time* (Ward, 1986; review by Gignac, 1988) discusses the crucial role that science plays in conservation; the rigorous training required; the nature of conservation services, and the role of the conservator and their colleagues. Gignac discovers 'the multiple aspects of conservation, a subtle and complex process, that can be as varied and brilliantly fascinating as there are past and present cultures on earth, and yet, simultaneously, as practical and straightforward as good housekeeping.'

Table 2.1 *Proportion of work time spent by conservators on different activities (from Corfield et al., 1987)*

	% of work time
Conservation treatment and documentation	55
Technical and scientific examination	13
Teaching	5
Display	5
Conservation research	5
Environmental control and monitoring	4
Photography	3
Enquiries from the public	3
Supervising volunteers	2
Casting, and other methods of reproducing objects	1
Curatorial activities	1

Indeed, it is the author's experience that the processes of conservation have so many facets that it is difficult to convey the full range of knowledge and skill that is included: from the diagnosing of chemical decay or hidden physical stress; the patient, painstaking removal of dirt, soil or corrosion to reveal the soul, though not often the exact original appearance, of the object; the surveying of whole collections to find out which of their members are the most vulnerable and the weakest; the monitoring of the environment and the understanding of the subtle influence of the results; and the constant communication, diplomatic negotiation and persuasion necessary in order to represent the object's best interests. It is this great variety of activities, skills and work that must be represented in the information needed to manage conservation.

References

Heritage Act, 1983. London: HMSO.
Museum of London Acts, 1985 and 1986. London: HMSO.
Ashley-Smith, J. (1982). The ethics of conservation. *The Conservator,* **6**, 1–5.
British Standards Institution (1989). *BS 5454: 1989. The storage and exhibition of archival documents.* Milton Keynes: BSI.
Burrett, G. (1985). After Raynor. In *The management of change in museums. Proceedings of a seminar held at the National Maritime Museum, Greenwich,* (Neil Cossons, ed.), London: National Maritime Museum, 27–9.
Cannon-Brookes, P. (1976). The art curator and the conservator. *Museums Journal,* **75**, 161–2.

Comptroller and Auditor General (1988). *Management of the collections of the English National Museums and Galleries.* National Audit Office Report. London: HMSO.

Comptroller and Auditor General (1994). *Department of National Heritage, National Museums, and Galleries: Quality of service to the public.* London: HMSO.

Corfield, M., Keene, S. *et al.,* eds. (1989). *The survey.* London: UKIC.

English Tourist Board (1987) *Annual Report.* London: English Tourist Board.

Fenton, S. (1988). Collections research: local, national and international perspectives. *ICOM UK Newsletter,* **28** (June).

Gignac, G. (1988). Book review: The nature of conservation. *J. of IIC Canadian Group,* **13**, 32–4.

Greenhill, B. (1984). Three problems of museum management. *Int. J. of Museum Management and Curatorship,* **3**, 67–70.

Hebditch, M. (1990). Why do we preserve objects? In *Managing conservation, conference preprints* (Suzanne Keene, ed.) London: UKIC.

Hewison, R. (1987). *The heritage industry.* London: Methuen.

International Council of Museums (1985). *The Conservator–Restorer: a definition of the profession.* ICOM News, 1985, 5–6.

International Council of Museums (1990). *Statutes.* Paris: ICOM.

Kenyon, J. (1992). *Collecting for the 21st century. A survey of industrial and social history collections in the museums of Yorkshire and Humberside.* Leeds: Yorkshire and Humberside Museums Service.

MacGregor, N. (1990). Museums for their own sake. *The Guardian,* 11 October, London.

Mann, P. (1989). Working exhibits and the destruction of evidence in the Science Museum. *J. of Museum Management and Curatorship,* **8**, 369–87.

Merriman, N. (1991). *Beyond the glass case.* Leicester: Leicester University Press.

Museums and Galleries Commission (1987). *Museum professional training and career structure.* London: HMSO.

Museums and Galleries Commission (1992). *Museums matter.* London: HMSO.

Museums Training Institute (1991). *Draft standards: conservation.* Bradford: Museums Training Institute.

Myerscough, J. (1988). *The economic importance of the arts in Britain.* London: Policy Studies Institute.

Paine, C., ed. (1994). *Standards in the museum care of larger and working objects.* Standards in the care of collections no. 4. London: Museums and Galleries Commission.

Prince, D. R. and Higgins-McLoughlin, B., eds (1987). *Museums UK.* London: Museums Association.

Radford, T. (1990). Cut down to skeleton staff. *The Guardian,* 16 May.

Thomson, G. (1973). Planning the conservation of our cultural heritage. *Museum,* **25**(1/2), 15–25.

Trevelyan, V., ed. (1991). *'Dingy places with different kinds of bits': An attitudes survey of London museums amongst non visitors.* London Museums Service for the London Museums Consultative Committee.

Ulberg, A. D. and Lind, R. C. Jr (1989). Consider the potential liability of failing to conserve collections. *Museum News* (January/February), 32–3.

United Kingdom Institute for Conservation (1981). *Guidance for conservation*

practice. London: UKIC.

Ward, P. (1986). *The nature of conservation: a race against time*. Marina del Rey, CA: Getty Conservation Institute.

Weil, S. E. (1983a). *Beauty and the beasts*. Washington DC: Smithsonian Institution Press.

Weil, S. E. (1983b). Breaches of trust: remedies and standards in the American private art museum. *Int. J. of Museum Management and Curatorship* **2**, 53–70.

Wilson, Sir David (1989). *The British Museum: purpose and politics*. London: British Museum Publications.

Wright, P. (1989). The quality of visitors' experiences in art museums. In *The new museology* (P. Vergo, ed.), London: Reaktion.

3 Management and information

In this chapter, the development of general management thinking and the place of information in it are reviewed. Current approaches are discussed. The climate for management in museums is described: as in other areas of the public services, it has seen rapid changes through the 1980s particularly. This has had deep and far-reaching effects on the ways in which museums manage their affairs and on how the different professionals involved perceive their roles.

Views from general management studies

Management theory

Many different theories have been developed to explain the complexity of organizations, and how people can best be managed to obtain the desired results. Machiavelli wrote on the management of states in the fifteenth century: he is still quoted today (Clutterbrook and Crainer, 1990, Ch. 1). Morgan (1986) has summarized various people's views of organizations, for example, as machines, as organisms, as brains, as cultures, as political systems, as instruments of domination. There have been a number of specific approaches to management during the nineteenth and twentieth centuries. Taylor, working in the early 1900s on 'scientific management', concentrated on the extremely precise specification of work as a number of separate tasks. His approach culminates in the production line, piece work, and a view of workers as mechanical parts of the production machine, in which physical work is separated from any mental interpretation. Henri Fayol originated the term 'bureaucracy'; he saw organizations in terms of line management, accountability and structures. In America, in the Second World War, operations research, also known as management science, developed in the Rand Corporation as a way of controlling highly complex defence development projects. In operations research, quantitative models are applied to solve organizational problems. Other views of management have been the human relations approach, the systems approach and the contingency / situational approach.

The popularity of different schools of thought, or variations on them, changes as the political climate swings from liberal and people focused to conservative and product and money focused. At present in the UK the prevalent climate is for the hard numbers- and objective-based app-roaches implied by targets, performance indicators, and Total Quality Management. These views of the world are termed 'hard' as opposed to 'soft' because they are based on the assumption that the world and the organizations we have established are ultimately rational and under-standable, and that if we can apply a sophisticated enough analysis we will be able to control them. There is a strong groundswell of other, 'soft' approaches, which reject this view and are based instead on the assumption that the world is too complex to be controlled or even predicted in any general sense: what is important are the perceptions, interactions and motivation of people, of values and of ongoing sustainable relationships.

Of today's most influential management writers, Peter Drucker, in some recent books, has begun to tackle the complexities of not-for-profit organizations (e.g. Drucker, 1990). Henry Mintzberg's book *Structure in fives* (1983) will help those interested in organizational structures to understand some of the reasons for the complexity of relationships in museums; Morgan explores some of the metaphors used to explain organizations such as the machine, the brain, the system, etc. (Morgan, 1986). Charles Handy, our own English management guru (*Understanding organizations*, 1981; *Understanding voluntary organizations*, 1988), provides a comprehensive look at organizations in general, and, recently, some crystal ball gazing into the future of work, which is not inapplicable to conservation employment (Handy, 1989). A recent movement is the quality approach, in which can be included Peters with books such as *In search of excellence* (1982); *Thriving on chaos* (1987). The roots of the quality approach lie in the work of W. E. Deming (Aguayo, 1990). Writers on systems include Stafford Beer, whose cybernetics theory of organizations is summarized in *Diagnosing the system of organizations* (1985). Peter Checkland's seminal books on soft systems including *Soft systems methodology in action* (Checkland and Scholes, 1990) have been extremely influential in promulgating a different view of organizations. Clutterbuck and Crainer review the most important management thinkers and writers in *Makers of management* (1990).

Differing perspectives on management

It is easy to assume that there is only one view of what sort of management brings success, and that people all have the same concerns – those of one's self, naturally. This is not so. Some people are motivated by the wish for interest and self-fulfilment in their job; others do the job

just to make a living, and place their main commitment outside work. Both may be valuable to the organization, but the adoption of crude measures such as performance-related pay assumes that everyone shares the second viewpoint.

In 1979, Sir John Hunt made some observations, which if expressed now would be both startling and unfashionable, about the differing style of male versus female managers (Hunt, 1979, Ch. 7). In 1979 it was male managers, he found, who had the greatest concern for people, while female managers were much more likely to be concerned with getting tasks done, and much less concerned with relationships and the social aspects of work. This was some time ago, when there were many fewer women in management, and when different social pressures may have prevailed.

The overwhelming tenor of what we come across in daily life, in newspapers, television and conversation is that tough management based on measurable objectives and short-term targets is what gets results. As Sir John Hunt also observed in 1979 (Hunt, 1979, Ch. 8), this viewpoint is far from universally held. In their book, *The seven cultures of capitalism*, Hampden-Turner and Trompenaars (1994) flesh out this viewpoint, and discuss the results of surveys into the attitudes of upper-middle managers in countries ranging from the USA, the UK, Germany, France and the far East (Singapore and Japan). Some examples of their results that may surprise are:

A company, besides making profit, has a goal of attaining the well-being of various stakeholders, such as employees, customers, etc.

or:

The only real goal of a company is making profit.

Agreement with the second statement ranged from 40 per cent in the USA, 33 per cent in the UK, 24 per cent in Germany, to 8 per cent in Japan.

A company is a group of people working together. The people have social relations with other people and with the organization. The functioning is dependent on these relations.

or:

A company is a system designed to perform functions and tasks in an efficient way. People are hired to fulfil these functions with the help of machines and other equipment. They are paid for the tasks they perform.

Agreement with the second statement ranged from 75 per cent in the USA, 55 per cent in the UK, 41 per cent in Germany, to 29 per cent in Japan.

> Would you prefer a job in which no one is singled out for personal honour, but in which everyone works together.

or:

> a job in which personal initiatives are encouraged and individual initiatives are achieved.

Range of preference for the second statement: 97 per cent in the USA, 90 per cent in the UK, 84 per cent in Germany, 39 per cent in Singapore.

> If an individual has worked well for an organization for many years, but their performance has recently fallen badly below standards, they should be dismissed.

Agree with statement: USA, 77 per cent; UK, 42 per cent; Germany, 31 per cent; Korea, 19 per cent.

There are very different opinions, too, on how a successful strategy can be arrived at. Mintzberg and Quinn (1993) richly illustrate this with a wide range of articles. The highly numbers-based, conscious strategy process might be expected to win every time, but Mintzberg's own research shows that managers in real life spend hardly any time in reflective, systematic planning (Mintzberg and Quinn, 1992: 21–31; Mintzberg, 1994). Some fabled examples of commercial success – for instance, the introduction of Honda motor cycles in the USA – were the result not of deliberate strategy but of Japanese business people going to the USA themselves to set up their marketing operation and noting and responding to what happened there (Hampden-Turner and Trompenaars,1994).

Excellence and quality

During the 1980s, in America particularly, there was a growing awareness that management by systems and numbers, as overwhelmingly taught in the business schools, can create problems of its own. This was fuelled by the publication of *In search of excellence* (Peters and Waterman, 1982, especially Ch. 2). Peters, in his sequel *Thriving on chaos* (1987), reaffirms his view that excellence lies in a focus on people: on the customers, and on the workers in the organization. These general approaches are categorized by Bowman and Asch (1987) as 'best practice'. In the 1990s, many of the firms selected by Peters and Waterman as paradigms of success are experiencing

problems to the point of going under (for example, IBM) but there is now such a bandwagon of courses, books, etc. hitched to the 'excellence' approach that it will be some time before it goes out of fashion. The basic philosophy of quality management has a great deal to recommend it, but its facile derivatives such as the Citizens' Charter, because they simply address outcomes and not causes, are more likely to evoke cynicism.

Studies of how organizations operate in the successful Japanese economy have reinforced awareness that information alone is not sufficient. For example, Ohmae (1982: 3) contrasts the then prevalent management approach in the USA, strongly business school and numbers based, with that in Japan. But at the same time (pp. 12, 24–34) he emphasizes that 'No proper business strategy can be built on fragmentary knowledge or analysis ... analytical method and mental elasticity ... are complementary.' Imai (1986) expounds the concepts of 'KAIZEN', an all-embracing value system devoted to total quality. Analytical information is vital, but only as a tool in its application. Perhaps ironically, it is an American, W.E. Deming, who is credited with laying the foundations of the quality approach (Clutterbuck and Crainer, 1990: 202–6; Imai, 1986, App. F Aguayo, 1990); he was brought to Japan in the early 1960s at a time when Japanese technology had lost its reputation for high quality and innovative engineering, and Japanese goods were synonymous with cheap and nasty. Building on these Japanese studies, and on Deming's own work, a current management movement is towards quality. Deming's approach is closely allied to KAIZEN, described by Imai (1986), and is now being imported back from the East to the West as 'Total Quality Management', or TQM. A British Standard (BS 5750: British Standards Institution, 1991) now exists to encourage this (Munro-Faure and Munro-Faure, 1992).

In Total Quality Management, every operation in an organization is analysed. For each, details of where work input comes from and what is required (i.e. the suppliers to the operation), and where work output goes to and what is required (i.e. where are its customers, and what do they need) are recorded. Improvements are effected until each piece of work needs to be done only once, and reaches its customer, whether internal or external, perfectly correct and on time. Adopting Total Quality Management can be expensive; it requires the commitment of the entire organization from top to bottom. Its adherents claim impressive success; its detractors, expensive bureaucracy.

Not-for-profit organizations

Museums are not businesses, and like much of the public sector, their 'products' are hard to measure quantitatively. Although much general management theory and writing is just as applicable to what is generically known as the 'not-for-profit' sector as to private firms, it is

businesses which are offered overwhelmingly the most advice and exhortation. However, not-for-profit organizations have been receiving more attention recently, as governments round the world begin to apply what they see as the forces for efficiency that exist in profit-making firms to the users of public funding. Unfortunately, many of the nostrums now being compulsorily fed to public service organizations have been abandoned as useless years previously by businesses. An example is performance related pay.

Drucker has legitimized the management existence of not-for-profits first in the Harvard Business Review (Drucker, 1989), and subsequently in his book, *Managing the non-profit organization* (1990). Handy, *Understanding voluntary organizations* (1988) and Bowman and Asch (1987) in their invaluable review, *Strategic management*, address the problems of strategic management and decision making in these organizations. Difficulties derive from the structure of the organizations, the workers in them (often professionals with greater allegiance to their profession than to their employers), their often complex and conflicting objectives, and the difficulty of objectively assessing performance. Although the UK government has not ignored the 'excellence' approach (Wright, 1991, Ch. 16), it, among others, is firmly of the view that quantitative measures are a valuable tool and, through Citizens' Charters, is requiring them to be produced in many public sectors operations, including museums.

Interestingly, much of the government's quantitative approach would be inimical to W.E. Deming (quoted in Munro-Faure and Munro-Faure, 1992: 292). He identified five 'Deadly Diseases' in Western management style:

1 A lack of constancy of purpose
2 Emphasis on short-term goals (especially profits)
3 Evaluation of performance, merit rating or annual review
4 Mobility of management
5 Management only by the use of visible figures with no consideration for unknown figures.

Information in management

In the literature on general management, it is only comparatively recently that information in organizations has been accorded specific discussion and advice in its own right. For example, Drucker's classic work, *The practice of management*, written in 1954, acknowledges the crucial role of information (e.g. Drucker, 1954, Chs 8 and 9), but only implicitly. By 1976 Handy, in his comprehensive review, *Understanding organizations*, has a whole chapter 'On the systems of organizations', and a section specifi-

cally on information systems. His book *Understanding voluntary organizations*, one of the few works to specifically address management in the non-commercial sector, written in 1988, in general summarizes his earlier book, but devotes a much larger proportion of it to information.

In the recent past, information for management has been identified as a specific need more in America than in Europe and the UK (Hunt, 1979: 145–6). This is probably because of the larger numbers of business schools there and the earlier and more widespread use of computers. In the UK, at least in publicly funded institutions, it was not until the 1980s and 1990s that the political climate and the wider introduction of computers brought about a rapid increase in the perceived importance of information to management. The emphasis is on the measurement of performance by using quantitative measures, and on accountability for the use of public money in this economically large sector, for instance the health and education services and, with less publicity, museums. Many businesses and public sector organizations also have internal operations research or management consultancy units, where the quantitative methods of operations research are applied to problems such as hospital waiting lists.

The systems approach is important to the development of management information. Systems analysis is widely assumed to apply only to computer systems. On the contrary, the systems approach is a whole intellectual view of the world, developed as an acknowledgement that scientific reductionism, in which the whole is understood by studying its parts, was not adequate for the understanding of complex biological and organizational problems.

In systems studies at present there is a significant dichotomy between so-called 'hard' and 'soft' methodologies. 'Hard' methods include operations research, and are thought to be most usefully applied to problems where the desired outcome can be confidently specified, and which can easily be defined in pseudo-engineering terms. Solutions can often be expressed quantitatively. 'Soft' techniques have been developed in the recognition that organizational, social and political problems are embedded in 'human activity systems'. These are some of the most complex types of system around, because people's behaviour can never be exactly predicted or controlled.

Missions and objectives

If management-by-numbers is not the recipe for success, should the numbers be discarded? Views are often expressed that numbers, and information, are useful, if they are used in the service of what could be called 'management by corporate values', as instanced by the adoption of Mission Statements, or Statements of Purpose, by many organizations.

Klemm *et al* (1991) demonstrate their remarkably rapid spread. The communication of and focus on the overarching objectives of organizations is identified by many writers as the single most important factor for success, and work on management information, especially at a strategic level, is increasingly directed towards serving this (e.g. Rockart, 1979; Lucey, 1987: 1). Peters and Waterman (1982: 279) note the overriding necessity to 'Figure out your value system. Decide what your company stands for.' A value system is not, of course, the same as a set of objectives.

Performance can only be measured if objectives have been set. But Checkland (1981: 261–2) cites Vickers' view of the barrenness and artificiality of rational objectives as a model of the real-life social interaction that constitutes management:

> In the cabinet, in board rooms, in Trade Union branch meetings, on committees, and in our everyday life … the bulk of our activity is concerned with establishing and modifying relationships through time, rather than seeking an endless series of 'goals', each of which disappears on attainment.

Performance measurement

The use of performance indicators is one of the most controversial topics around in public sector management today. Despite the problems inherent in objectives and management-by-numbers, government interest in the measurement of museum performance is a reflection of current intense concern with the measurement and assessment of performance in public service functions generally. This is most apparent in the Citizen's Charter initiative.

Performance indicators are dealt with by most writers on strategic management as a means of monitoring whether plans are being achieved. They may be envisaged as a component in a control loop (Lucey, 1987, Ch. 13). One of Peters' top 'prescriptions' (1987: 583 ff) is 'Measure what's important'. Interestingly, 'what's important' is by no means necessarily financial. Handy (1988: 127) says that organizations should have a vision, a set of specific tasks, and a set of measures which will indicate what success means in each task.

However, the hazards of an approach based on measuring performance are also evident. Handy (1988: 129) cited 'the hospital that decided that patient turn-round time was the criterion of success for each ward, only to find that wards became reluctant to admit long-stay patients no matter how ill they were.'

In 1991, the Government set an objective of reducing waiting time for patients on lists for operations to two years. The exact effect cited by

Handy was the almost immediate result (press reports in November–December 1991, e.g. Hencke, 1991).

There is no doubt that it is difficult to find the right measures of performance for public service functions. Bowman and Asch (1987: 382–3) only discuss performance measures in the context of the conflicting objectives and other awkward characteristics of this kind of organization. Where outputs, 'effectiveness', are not directly measurable then attention turns either to the measurement and control of inputs, 'efficiency', or to 'proxy measures' – some aspect of the task that can be measured. Handy observes, however, that 'the hard overrides the soft. Numbers matter.... They had better therefore be the right numbers.' Allden and Ellis (1991a) suggest that 'a bias towards financial and numeric measures should not be encouraged in the MIS [management information system], which should be capable of communicating both numbers and text. ... provide comparative or superlative gauges ... "the best display of clay pipes in the country".' In the author's experience, producing information that is truly relevant is just as elusive (and as expensive) as when Drucker wrote optimistically that 'Within a few years our knowledge of what to measure and our ability to do so should ... be greatly increased.' (Drucker, 1954: 65). But perhaps finding the relevant measures is really no more difficult than it is for any organization to truly find the answer to Peters' Prescription S1: 'Measure what's important' (1987: 583).

The management of museums

The operating climate

Most sizable museums are in the public sector (Prince and Higgins-McLoughlin, 1987, Fig. 6.2). They are subject to the same increasing pressures for efficiency as is the rest of that sector, through the engineering of 'market', or at least business-derived, forces. Museums in the private sector are much more directly exposed to financial pressures arising from the changing economic climate, but this is not to say that public sector museums are protected. Loss of local authority revenue due to revenue capping and local government reorganization has already resulted in severe cuts and the closure of some museums. However excellent their management, a benign economic climate is necessary for the survival of privately and publicly funded museums alike. Efficient management will not protect museums from closure when local councils have to make choices between funding them or statutory duties such as education; nor from staff cuts due to falling sponsorship revenue.

A review of the management context in which museums have been operating through the 1980s is given in Allden and Ellis (1990a). Raynor Scrutinies of the Victoria and Albert and the Science Museum in 1981–2, primarily concerned with reducing waste in public expenditure, were followed by the 'Financial Management Initiative' in the mid-1980s. Important features of the Financial Management Initiative are delegated financial control, and the development of output indicators and performance measures. The introduction of Corporate Plans for museums, the recent investigations and reports by the Audit Commission (1991) and the Comptroller and Auditor General (1988), and the Office of Arts and Libraries' Performance Indicators initiative (Office of Arts and Libraries, 1991; Museums Association, 1994) are recent developments of the Financial Management Initiative. The widespread application of compulsory competitive tendering in local government is now being followed by its adoption in the central government civil service.

The national museums

The national museums are worth particular examination, because they are in many ways subject to the most direct pressure to conform to government policies. Because they are relatively well protected financially, they have the resources to implement these policies in their management and organization. In 1983 and 1986 the legal status of some of them was altered in various Acts of Parliament (e.g. the Heritage Act, 1983; the Museum of London Act, 1986), most of them being hived off from the Civil Service and becoming instead trustee museums governed through Boards of Trustees, as the British Museum has always been. Pressure on accountability has been exercised by the Civil Service mechanisms generally, by the Office of Arts and Libraries (now subsumed into the Department of National Heritage), which is taking a more directive stance than did the Office of Arts and Libraries in the past, and by Parliament itself through the National Audit Office and the Public Accounts Committee.

In 1982, the Raynor Scrutiny of the Victoria and Albert and Science Museums was carried out, directed by Gordon Burrett (discussed by him in Burrett, 1985). These operations were designed to subject the Civil Service to an outside view under the banner of Lord Raynor, from what was seen as almost the national flagship company, Marks & Spencer. For the first time, the effect on museum operations of the traditional role of the curator, the Keeper-as-King (or as Burrett puts it, Keeper Baron), the surrogate owner of his or her collections, was examined by the organizations' political masters or mistresses. The effects of some of the major changes of the early 1980s are reviewed in Cossons (1985).

From the late 1980s, the national museums were required by the Office of Arts and Libraries to submit annual corporate plans for the following five years. This discipline has forced them to be much more explicit about plans for all activities, including collections care and preservation. These corporate plans are hybrid bid and planning documents, since they include bids for funding, such as schemes for expansion, etc., as well as strategic plans based on the grant-in-aid the museums can actually count on.

Current issues in museum management

Griffin (1987, 1988, 1991) illuminates many of the major management issues in museums by reference to general management literature. In his view (1987), museums are not very successful as institutions; they conform to Mintzberg's model of the professional bureaucracy, in which specialists work independently of each other and seek to control administrative processes which touch them. Staff are most concerned with the product, not the market. Museums appear to be at risk of being overwhelmed by the search for money and related activities; few are clear about what their business is. To remedy these ills, communication is essential. His second paper deals with conflict, choice theory and decision making, cultural revolution, staff issues and corporate planning; his 1991 article considers the role of museum governing bodies.

Accountability

Accountability for the operations of museums which are publicly funded is monitored by the Comptroller and Auditor General (who as head of the National Audit Office scrutinizes central government affairs), the Audit Commission (for local government) and the Public Accounts Committee of the House of Commons. A series of reports on various national museums and their activities has been produced since 1980/81. If anything, this interest is increasing, with relevant reports in 1989, 1991 and 1992. This is giving these watchdog bodies considerable influence on how museums set their priorities and allocate resources.

1988 brought a particularly relevant report by the Auditor General on the care and management of the collections of the national museums (Comptroller and Auditor General, 1988). In fact, the prime importance of collections preservation had been flagged a number of years previously, for instance Thomson (1973) and Greenhill (1984). The matter had also drawn comment from Burrett (1985: 7):

What museum manager or Trustee would dare to dissent publicly from the view that museums should not acquire or keep objects which cannot be conserved to an acceptable standard ... But this principle is not in fact reflected even imperfectly in the actual policies of many, if any, museums.

The House of Commons Committee of Public Accounts took further evidence on this report from the directors of the Victoria and Albert and British Museums in 1989 (Committee of Public Accounts, 1989). Both report and hearing were widely reported in the press: e.g. A case of arts for oblivion (*The Times*, 1 April 1988); MPs warn of 'breakdown' in museums (*The Guardian*, 15 December 1988).

Standards and the management of collections and preservation

For museums in England, these areas are mainly in the domain of the Museums and Galleries Commission. As well as operating its Museums Registration Scheme, this body is vigorously developing standards for museums, presently for the curation of particular collections and for the museum environment. In America, the Association of American Museums and the National Institute for Conservation have been active in developing the Museum Assessment Program (MAP). Rather than assessing museums against fixed standards, these questionnaires give consultants a validated structure within which to frame their advice to museums. MAP I is on general museum management; MAP II, collections management (Association of American Museums, 1985); and the Conservation Assessment, drawn up jointly by the National Institute for Conservation and Getty Conservation Institute in 1991, deals more specifically with conservation and preservation. Collections care in America has received statutory or semi-statutory attention, being the subject of a Department of the Interior Special Directive (US Department of the Interior, 1986). The more litigious climate in the USA has also touched collections care and preservation, as in the cases cited by Weil (1983), and noted by Ulberg and Lind (1989). References for standards literature are given in Chapter 8, Conditions for preservation, below.

In general, then, the literature on the management of collections care and preservation shows the increasing introduction and raising of standards in both America and the UK, a consequence of museums being held more accountable for the proper discharge of this function. The introduction of collections management as a specific function in museums, with designated posts, is accelerating this process.

Raising the profile for preservation

From as far back as 1974 the UK Institute for Conservation has been publishing concern about the state of museum collections (United Kingdom Institute for Conservation, 1974), with an update in 1989 (Corfield *et al.*, 1989). 1989 also brought specialist surveys of collections in Scotland (Ramer, 1989) and industrial collections (Storer, 1989), telling the same story of neglect of public assets. Recently, the Museum Council for Yorkshire and Humberside has once again identified major deficiencies in the management of collecting and collections care, in a report on industrial and social history collections in the region (Kenyon, 1992).

It is interesting to contrast the 1971 report, *The preservation of technological material*, by the Standing Commission on Museums and Galleries (as the MGC then was) with the Storer Report (1989) and the others cited above. The 1971 report is exclusively on the need to take such material into public ownership, with no mention of funding its physical maintenance. A fund (the PRISM fund) was in fact set up to aid the process of acquisition. By the early 1990s the emphasis is all on how the physical conservation and housing of this material can be afforded, and in fact conservation is expected 'to absorb an increasing percentage of the Fund's resources, as museums assume a more rigorous attitude towards collecting.' (Price and Robinson, 1991). The Yorkshire and Humberside report shows just how necessary this is.

Conservation management

The production and publication of the two surveys on the state of conservation in museums, *Conservation in museums and galleries* and *The survey* (United Kingdom Institute for Conservation, 1974; Corfield *et al.*, 1989) have done much to raise awareness of the management issues surrounding conservation in museums. Despite this, the conservation literature has practically nothing specifically on management, or even on using the large amounts of data collected, beyond analysis for environmental control. Even the obvious use of conservation treatment records for assessing the success of treatments is not exploited. The preprints of a conference, *Managing conservation* (Keene, 1990) draw together some people's work. However, there is a considerable body of work on data collection and use, particularly on environmental monitoring and latterly on collections condition, discussed below in Chapters 8, Conditions for preservation, and 9, Collections condition.

Why are conservators apparently little interested in the management of their work? Many of the posts are relatively junior, and hence they have little influence in their organizations. Many of them entered the profession because they enjoyed the actual practical treatment of objects;

they much prefer this to tackling the wider, less practical, and often less immediate issues of collections preservation. It will probably always be the exception to find equal aptitude for these very different tasks in the same person. Conservation training courses do not on the whole include management elements, beyond environmental monitoring and perhaps condition surveying. Conservators do identify questions of management perception, organizational priority, and preventive conservation as having the greatest influence on the preservation of collections (Corfield *et al.*, 1989). The rise of collections management as a museum functional area in its own right has only just begun to be recognized; conservators have not yet had to come to terms with this new organizational approach.

Conclusions

There are few museums in which the whole of the collections is already well looked after. Where this is the case, their upkeep will continue to consume a substantial proportion of museum resources and this will need to be properly managed and controlled. In many, perhaps the majority, the tasks of improving the condition and preservation of collections which have been accumulated reactively, with little consideration of the practicalities of properly managing them, are often enormous (Kenyon, 1992). If they are to be accomplished, then information on the size and nature of what is required must be assembled, options for dealing with them weighed up, choices made and decisions implemented and monitored. For all these purposes accurate, timely and relevant information is essential.

Formal management processes in museums are increasingly being adopted, largely because of government pressures for accountability, in this country and abroad, especially in the USA, through the Museums Assessments Program (MAP: Association of American Museums, 1985), and in Australia (see below, Chapter 10, Directions and strategies). Consequently, museum managers and directors are beginning to draw on the considerable body of work that exists on general management and management information. Management information is mainly quantitative information, but it is clear that the use of this information in not-for-profit organizations, of which museums are one type, presents particular problems which must be addressed. Despite this, public sector museums are increasingly required to use quantitative measures of performance; indeed, these are inevitably of central concern. The implications, for good or ill, of the provision and use of information on the motivation of staff are a further important dimension that must be taken fully into account.

References

Aguayo, R. (1990). *Dr Deming: the man who taught the Japanese about quality.* London: Mercury Books.

Allden, A. and Ellis, A. (1990a). Management: the flavour of the month. *Museum Development* (November), 35–9.

Allden, A. and Ellis, A. (1990b). Management – naming the parts. *Museum Development* (December), 11–13.

Allden, A. and Ellis, A. (1991a). Back to the future. *Museum Development* (January), 39–40.

Allden, A. and Ellis, A. (1991b). Management – the problems of implementation. *Museum Development* (February), 11–13.

Association of American Museums (1985). *Museum Assessment Program: MAP I and MAP II questionnaires.* Washington DC: AAM.

Audit Commission (1991). *The road to Wigan Pier?* Audit Commission Local Government Report 1991, no. 3. London: HMSO.

Beer, S. (1985). *Diagnosing the system for organizations.* Chichester: John Wiley.

Bowman, C. and Asch, D. (1987). *Strategic management.* Basingstoke: Macmillan.

British Standards Institution (1991). *BS 5750: 1991. Quality systems.* Milton Keynes: BSI.

Burrett, G. (1985). After Raynor. In *The management of change in museums. Proceedings of a seminar held at the National Maritime Museum, Greenwich,* (N. Cossons, ed.), 27–9. London: National Maritime Museum.

Checkland, P. (1981). *Systems thinking, systems practice.* Chichester: John Wiley.

Checkland, P. and Scholes, J. (1990). *Soft systems methodology in action.* Chichester: John Wiley.

Clutterbuck, D. and Crainer, S. (1990). *Makers of management.* Basingstoke: Macmillan.

Committee of Public Accounts, 1989. Management of the collection of the English national museums and galleries. First report House of Commons: Session 1988–89. London: HMSO.

Comptroller and Auditor General (1988). *Management of the collections of the English national museums and galleries.* National Audit Office Report. London: HMSO.

Corfield, M., Keene, S., *et al.,* eds (1980). *The survey.* London: UKIC.

Cossons, N., ed. (1985). *The management of change in museums. Proceedings of a seminar held at the National Maritime Museum, Greenwich.* London: National Maritime Museum.

Drucker, P. F. (1954). *The practice of management.* New York: Harper & Row (paperback edition, 1986).

Drucker, P. F. (1989). What business can learn from non-profits. *Harvard Business Review,* July–August, 88–93.

Drucker, P. F. (1990). *Managing the non-profit organization.* Oxford: Butterworth-Heinemann.

Greenhill, B. (1984). Three problems of museum management. *Int. J. of Museum Management and Curatorship,* 3, 67–70.

Griffin, D. J. G. (1987). Managing in the museum organization: I. Leadership and communication. *Int. J. of Museum Management and Curatorship,* 6, 387–98.

Griffin, D. J. G. (1988). Managing in the museum organization: II. Conflict, tasks, responsibilities. *Int. J. of Museum Management and Curatorship*, **7**, 11–23.

Griffin, D. J. G. (1991). Museums – governance, management and government. *Int. J. of Museum Management and Curatorship*, **10**, 293–304.

Hampden-Turner, C. and Trompenaars, F. (1994). *The seven cultures of capitalism*. London: Piatkus.

Handy, C. (1981). *Understanding organizations*. Harmondsworth: Penguin Books.

Handy, C. (1988). *Understanding voluntary organizations*. Harmondsworth: Penguin Books.

Handy, C. (1989). *The age of unreason*. London: Business Books Ltd.

Henke, D. (1991). MPs berate health chiefs over queues. London: *The Guardian*, 12 December.

Heritage Act, 1983. London: HMSO.

Hunt, Sir John (1979). *Managing people at work*. London: Pan Books (paperback edition 1981).

Imai, M. (1986). *KAIZEN: the key to Japan's competitive success*. New York: Random House.

Keene, S., ed. (1990). *Managing conservation: conference preprints*. London: UKIC.

Kenyon, J. (1992). *Collecting for the 21st century. A survey of industrial and social history collections in the museums of Yorkshire and Humberside*. Leeds: Yorkshire and Humberside Museums Service.

Klemm, M., Sanderson, S., *et al.* (1991). Mission statements: selling corporate values to employees. *Long Range Planning*, **24**(3), 73–8.

Lucey, T. (1987). *Management information systems*. Eastleigh: DP Publications (paperback edition).

Mintzberg, H. (1983). *Structure in fives*. New Jersey: Prentice Hall International.

Mintzberg, H. (1994). *The rise and fall of strategic planning*. London: Prentice Hall.

Mintzberg, H and Quinn, J. B. (1992). *The strategy process*. London: Prentice Hall.

Morgan, G. (1986). *Images of organization*. London: Sage Publications.

Munro-Faure, L. and Munro-Faure, M. (1992). *Implementing Total Quality Management*. London: Financial Times/Pitman Publishing.

Museum of London Acts, 1965 and 1986. London: HMSO.

Museums Association (Public Affairs Committee) and University of Leeds (School of Business and Economic Studies) (1994). *The use and value of performance indicators in the UK museums sector*. London: Museums Association.

Museums and Galleries Commission (1988). *Guidelines for a registration scheme for museums in the UK*. London: Museums and Galleries Commission.

Office of Arts and Libraries (1991). *Report on the development of performance indicators for the national museums and galleries*. London: Office of Arts and Libraries.

Ohmae, K. (1982). *The mind of the strategist*. Harmondsworth: Penguin Books.

Peters, T. J. and Waterman, R. H. Jr. (1982). *In search of excellence*. London: Harper and Row.

Peters, T. (1987). *Thriving on chaos*. New York: Harper Perennial.

Price, R. and Robinson, J. (1991). CICF and PRISM: two steps towards conservation. *1991 Science Museum Review*. London: Science Museum.

Prince, D. R. and Higgins-McLoughlin, B., eds (1987). *Museums UK*. London:

Museums Association.

Ramer, B. (1989). *A conservation survey of museum collections in Scotland*. Edinburgh: Scottish Museums Council.

Rockart, J. F. (1979). Chief executives define their own information needs. *Harvard Business Review*, **57** (2 (March/April)).

Standing Commission on Museums and Galleries (1971). *The preservation of technological material. Report and recommendations*. London: HMSO.

Storer, J. D. (1989). *The conservation of industrial collections*. London: Conservation Unit of the Museums and Galleries Commission/The Science Museum.

Thomson, G. (1973). Planning the conservation of our cultural heritage. *Museum*, **25**(1/2), 15–25.

Ulberg, A. D. and Lind, R. C. Jr (1989). Consider the potential liability of failing to conserve collections. *Museum News* (January/February), 32–3.

United Kingdom Institute for Conservation (1974). *Conservation in museums and galleries*. London: UKIC.

US Department of the Interior (1986). *Special Directive 80–1*. Washington DC: United States Department of the Interior.

Weil, S. E. (1983). Breaches of trust: remedies and standards in the American private art museum. *Int. J. of Museum Management and Curatorship*, **2**, 53–70.

Wright, P. (1991). *A journey through ruins*. London: Radius.

4 Management tools: quantitative planning

This chapter explores the range of techniques that has been developed to assess options and take decisions. There is a large area of management studies, known as operations research or management science, that is concerned with how quantitative methods and formulae can be applied to everyday problems and decisions. Many of the applications are not relevant to conservation, but some, such as cost–benefit analysis, some medical assessment techniques, and numerical methods of options appraisal could be helpful. A few methods have been selected as being applicable to conservation, and not so technically complex as to be confusing rather than helpful. This chapter and Chapter 5 are complementary; this chapter focuses on quantitative and detailed techniques, while Chapter 5 covers non-numerical methods of analysis and strategy development.

Management science

The decision areas

Quantitative and analytical analysis is applicable to any area of conservation where work or objects can be quantified, where alternative costs can be expressed, where areas can be measured, or where storage equipment or materials can be costed. These quantitative methods are particularly useful in making bids for resources or funding. Although it is often objected, with much validity, that collections preservation depends on quality rather than quantity, in practice it can be very enlightening to do some scientific measuring in order to form or confirm one's own opinion.

Much depends on the nature of the objects and on the problem. For example, an extremely important and valuable object which required conservation would probably receive it even at the expense of hundreds of others which needed mounting or other first aid. Flood-damaged

objects would be top priority for treatment, because they will be highly unstable and liable to further deterioration unless worked on. There are many cases where a decision is not so clear cut, for example, between different methods of achieving environmental control (mechanical air handling vs 'passive' control methods such as silica gel) or in assessing the effectiveness of alternative treatments.

General methods: operational research and management science

Operations research is defined by the operational research society as:

> the application of the methods of science to complex problems arising in the direction and management of large systems of men, machines, materials and money ... the distinctive approach is to develop a scientific model of the system ... with which to predict and compare the outcomes of alternative decisions.

Operations research, then, consists of developing or applying logical and mathematical models to assist in the solution of problems. Solutions are such that they can be applied to other similar problems of the same generic sort. For example, there are well-developed operational research approaches to transportation problems, the analysis of demand, inventory control, project management, queuing theory, decision analysis. Cost–benefit analysis can be included in operational research, as can investment appraisal as developed by the Treasury (see below). There is much literature on operational research and management science. Two useful reviews of the basics are those of Rivett and Ackoff (1963) and Littlechild and Shutler (1991). Wyatt (1989) gives a very accessible review of some other numerical techniques that can be used in planning, among them multivariate analysis, inferential statistics, goal hierarchies and goal planning (including multi-objective, multi-criteria techniques); optimization, forecasting, and numerous others. The Treasury has developed an investment appraisal technique which is used to support bids for substantial capital expenditure by the national museums.

Recently, operational research practitioners are becoming very interested in 'soft operational research' – methods similar to soft systems analysis. The basis for soft operational research seems to be an acceptance that defining the problem can be as important as finding a route to a solution; that the actors in the problem need to be involved in finding and implementing its solution; that in real life many (though not all) problems are too complex to be solved by a single pass of a quantitative method, and are more likely to require an iterative approach.

Critical views are to be found in Jackson and Keys (1987). Keys describes how the view of operational research has changed over the years since its

first development in the Second World War, to one where, as 'the number of well-defined but unsolved problems declined' general limitations are recognized in its applicability to new problems, especially social ones. Friend and Jessop have emphasized the many uncertainties in complex public sector organizations such as local government. Keys concludes that management science remains an extremely useful tool, as long as its limitations are recognized: the presence of multiple views when defining the problem; the difficulties posed because many problems exist within highly complex systems; and the conservatism of the operational research/management science approach, which assumes that the world is stable and highly predictable, with the people in it acting according to well-defined roles: the set of social, economic and political relationships of which operational research is a part.

There are some extremely well-known examples of the failure of classical operational research, such as the the Roskill Commission report on the site of London's third airport, which never commanded political or public support, the accident at the Three Mile Island nuclear power station, and the collapse of the Alexander Keilland oil rig (Bignell and Fortune, 1989). To these failures could be added those of the hard systems approach to designing computerized information systems, such as 'Taurus', the London stock exchange system, work on which was publicly and embarrassingly abandoned.

The shortcomings of operational research derive from three aspects of it:

1 It is an application of scientific method, and as such is highly reductionist, in that it selects a well-defined part of a situation to study and strictly controls the variables being examined.
2 Quantitative values often have to be assigned to variables which are essentially qualitative and based on people's perceptions.
3 It relies on the premise that problems recur and that generalized algorithms can be developed and applied to them.

Application of management science to conservation

In the conservation literature, there are few attempts to apply quantitative scientific management methods. As in environmental and health-care decision making, there is the central problem of how to quantify the benefits of better preserved objects and the costs of deteriorated ones. Terry and Chandra Reedy, in the Getty Institute publication, *Statistical analysis in art conservation research*, review the use of statistics and suggest some approaches, mainly to assessing treatments and analytical results. But we can go wider than this.

'Probability of conservation' and 'valuation of the cultural heritage'

Benarie, editor of the *European Cultural Heritage Newsletter*, occasionally explores these areas (Benarie, 1987, 1989). Benarie has discussed the 'probability of conservation of cultural heritage', applying the principles of risk management from industrial engineering. Failure mode and effect analysis consists of: identification of the system components; definition of the 'failure modes', i.e. the way(s) in which the part could break; modelling the behaviour of the system, often by a so-called event tree. Failure mode probabilities can be computed from the event tree. Benarie constructs an event tree from the factors leading to the preservation of an object:

- *Factors at its origin*: its value at the time it was made; its bulk; the durability of its substance.
- *Owner or collector*: the richer and more powerful, the more likely the object's survival.
- *Liability to looting, pilferage or destruction*: intrinsic value; controversiality; geopolitical factors.
- *Fluctuations in taste.*
- *Time.*

These are exogenous factors, outside the control of any institution, we are not likely to be able to affect any of them. Substitute factors intrinsic to the object and events which can affect it and these techniques could be useful, perhaps for applying to the factors affecting the condition of objects.

In Benarie's second article, he reflects on the valuation of the cultural heritage (Benarie, 1989). The value of an article follows 'a catenary curve, as in a freely hanging rope' (Fig. 4.1). When new, the value of an object is high. As it gradually goes out of fashion and suffers damage, its value falls. In course of time, it becomes rare and acquires scarcity value, and so its monetary value rises again, Benarie suggests, to something near its original value. Benarie proposes formulae for calculating the amount of damage suffered, the expected half-life for an object and for a population of such objects, and the rise in price as a class of object becomes scarce. This could be a way of calculating the benefits of conservation and preservation, and so assigning quantitative values.

Benarie's curves reflect monetary value, and there will be many different curves according to taste in the commercial world of owners and dealers. Changing taste, reflected in a varying purpose or 'mission', will also affect the perceived value of an object to a museum, perhaps to the point at which it is disposed of and becomes vulnerable to external factors. The real 'value' of an object to a museum is derived from its

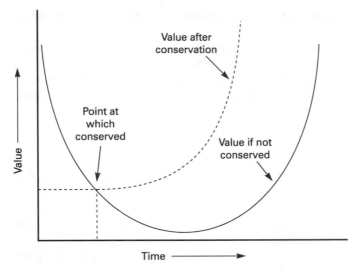

Fig. 4.1 *Changes in the value of an object over time and conjectural effect of conservation: a catenary curve*

intrinsic historic relevance to the collections, but monetary value can never be ignored.

This concept could assist in quantifying the benefits of preservation actions. Preventive action will as always be even more effective than remedy in preserving value. If the object is prevented from suffering as much damage as might be expected, then it might be expected that the bottom of the value curve may be truncated, and the eventual value of an object both rare and well preserved will be the greater. However, antique dealers clearly find radical restoration to be effective in raising the value of an historic object.

Cost–benefit, or cost-effectiveness, analysis

Books reviewing the main principles of cost–benefit analysis are easily found, such as that by Walshe and Daffern (1990). Simple approaches, cost-effectiveness analysis and pay-back period, are probably most relevant for conservation. In the more sophisticated forms of cost-benefit analysis, numerical measures are assigned to complex social and environmental benefits and disbenefits. One critic of cost–benefit analysis said of the report on the siting of London's third airport 'it is not so much that the experts prove or disprove something, but that ... they can make any proposition, no matter how simple, impenetrably complex and incomprehensible.' The technique of options appraisal, which national museums are required to apply to certain buildings

investment decisions, is an example of cost–benefit analysis where weightings are used.

In assigning quantitative measures to what are in fact matters of opinion there is of course a considerable temptation to weight the qualitative measures towards a desired outcome. Goal hierarchies and paired comparisons are described below; if wished, they can be used to obtain a genuine consensus view of the weights to be assigned to benefits. As in the health service, another difficult area, it is difficult to place values on the improved 'health' and longer 'life' of an object. On the other hand, Land (1976: 290) points out that more straightforward approaches can also distort, by ignoring many benefits that do not carry direct costs or savings.

The most straightforward application of cost–benefit analysis, although all too infrequently adopted in museum applications, is that exemplified by Ayres *et al.* (1989) in their analysis of the energy requirements of narrow vs. wide parameters for temperature and relative humidity, in different climatic zones. It was not in their remit to cost alternatives to air handling plant, such as energy-conserving and climatically stable building designs, for instance using the principles of thermal mass (Jones, 1991), and it would be extremely interesting to see cost-benefit analysis extended to this type of comparison.

Staniforth (1990) has made the only attempt so far to compare the estimated costs of remedial conservation treatment with those of installing environmental control equipment. She uses as examples for her model typical (albeit approximate) costs incurred in National Trust houses. Modifying a heating system, using light control measures and purchasing monitoring equipment would cost in the region of £50 000. Staniforth 'guesstimates' that even these simple control measures can double the time between conservation treatments, from 50 to 100 years. Remedial conservation costs for a typical National Trust house could fall from £10 000 to £5000, and so the environmental control measures could pay for themselves in ten years. Because the National Trust uses mainly private conservators, treatment costs are more apparent than for many museums, where conservators also carry out preventive conservation. Added to this would be the benefits of the greater monetary value of the better preserved objects, as well as the difficult-to-quantify benefits of their greater 'historic integrity'.

Opportunity cost

This is the cost of not doing whatever was precluded by the chosen action. For example, £10 000 might have been spent on purchasing an item for the collection rather than on fixing the roof of the store. The consequence of this might be a flood in the store, the cost of which could

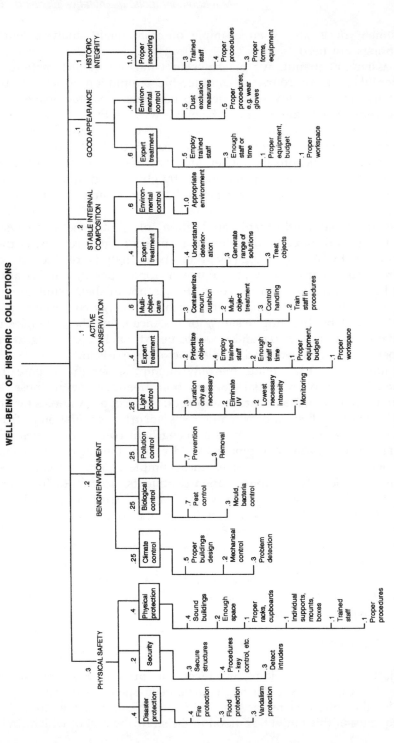

Fig. 4.2 *A possible goal hierarchy for the concept 'well-being of historic collections'*

be ascertained. The concept of 'opportunity cost' is particularly useful if applied to people time. There is a finite number of work hours: shall we spend them in writing grant applications, on carrying out urgent conservation treatment, or on replacing acid mounts for 100 objects?

Goal hierarchies

There are a number of variants on numerical methods applied to planning. It is a weakness that some of them employ extremely complex statistical formulae, and only an expert statistician could evaluate the results with any confidence. A relatively straightforward method is the concept of goal hierarchies (explained in Wyatt, 1989: 67–78). This technique focuses on the essentials of unclear situations: the connections between concepts, rather than the concepts themselves, which can be too debatable or vague.

An example of one possible goal hierarchy for the summary concept 'well-being of historic collections' is set out in Fig. 4.2. There is no single, or correct hierarchy: this version has been produced in order to assess the technique. Drawing up a goal hierarchy is not difficult. It can usefully be applied by a group working together, in which case it will develop understanding of the choices available and a consensus on desirable actions.

A general goal is first agreed. The next step is to identify what would be needed in order to achieve it, then the second-level factors, and so on. Only four levels are shown in the example (Fig. 4.2), but one can sub-divide further, as in Fig. 4.3. By the time one gets to the bottom level, the elements of a practical plan are appearing. However, throughout the hierarchy it is desirable to use goals that are as abstract as possible, since this facilitates

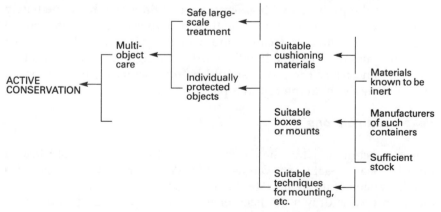

Fig. 4.3 *Further levels in a fragment of the goal hierarchy*

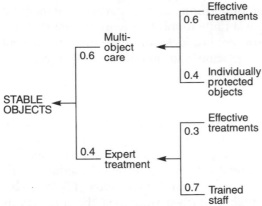

Fig. 4.4 *Fragment of a weighted goal hierarchy. The weightings for the sub-goals of each goal must add up to 1*

lateral thinking. The example in Fig. 4.3 descends to practicalities too near the top, but it shows the sort of thing that is intended.

Although a goal hierarchy can facilitate the development of a plan, it is still no help in prioritizing what should be done. To assist with this, the relative importance of each goal at each level can be denoted by a weighting figure (Wyatt: 1989: 74–78). The weightings for the sub-goals of each goal must add up to 1. Figure 4.2 shows the weights assigned in the trial exercise; Fig. 4.4 shows a fragment of a weighted hierarchy.

The total contribution of each sub-goal to the central goal can be calculated. For example, the overall weighting of 'Individually protected objects' is $0.4 \times 0.6 = 0.24$. The overall weighting of 'Effective treatments' is $(0.6 \times 0.6 = 0.36)$ plus $(0.3 \times 0.4 = 0.12) = 0.48$. It occurs twice, and so its weighting is the sum of both occurrences.

Some of the problems with assigning weightings will be immediately apparent to any conservator reading this. No two people will agree on the weightings of different factors, and weightings may well differ for different types of collection. It will be better if weightings are the result of a group consensus. The group should be representative, not composed only of those with an interest in a particular outcome.

Paired comparisons

This is a technique which has been developed to a highly sophisticated form by Saaty (Saaty and Vargas, 1991). Wyatt gives an example of a simple version of it (Wyatt, 1989: 82–6). A list of elements contributing to the main goal is drawn up. Each element is given a 'Dominance score' against each other element, on a ten-point scale.

Table 4.1 *Paired comparisons for factors leading to 'well-being of historic collections'*

Key: Dominance scoring:

9 = overwhelmingly dominates 4 = weakly dominated
8 = greatly dominates 3 = clearly dominated
7 = substantially dominates 2 = substantially dominated
6 = clearly dominates 1 = greatly dominated
5 = weakly dominates 0 = overwhelmingly dominated

	Physical safety	Environment	Cons. treatment	Stable chem.	Appearance	Historic integrity	Σ	Importance weighting
Physical safety	–	7	7	6	8	6	34	0.27
Environment	2	–	5	3	1	4	15	0.12
Cons. treatment	2	3	–	3	8	5	21	0.16
Stable chemistry	4	5	6	–	8	6	29	0.23
Appearance	8	2	2	1	–	3	16	0.13
Historic integrity	2	5	3	2	1	–	13	0.10
							$\Sigma\Sigma = 128$	

Σ denotes 'sum'; $\Sigma\Sigma$ is therefore the sum of the sums. The Importance Weighting is calculated as $\Sigma/\Sigma\Sigma$: it thus represents the contribution of each factor to 'well-being' as a whole.

Applying this to conservation factors as in Table 4.1 is an interesting exercise. It seems easier to be objective in this method than in weighting a hierarchy of objectives, at least the first time the exercise is carried out. For example, most would probably agree that *Appearance* was greatly dominated by *Environment* as a contributing factor to the 'well-being of historic collections'; and that sheer *Physical safety* substantially dominated both *Conservation* and *Environment*. The overall results in this case, the *Importance weighting*, show that in the author's opinion physical safety and the stable chemistry of the object are much the most important factors. Summing is only one calculation that can be used, and Saaty and Vargas (1991) give more sophisticated methods.

Quantifying collections preservation

The costs of environmental control will never be nil, since it implies the modification of the ambient humidity, temperature, and air quality. The more the environment has to be modified, the greater the costs are likely to be, both of initial investment and of running costs. In exhibitions, the costs may include less than ideal conditions in which to view the object. To provide proper information for decisions, we need a way to directly relate environmental conditions to the deterioration of objects.

Environment and deterioration: cause and effect

Although there is overwhelming international emphasis on the importance of creating a suitable environment for the preservation of objects, little attention has been paid to quantifying the actual effects of climatic conditions on the deterioration of different materials. Michalski (1990) claims that the existence of standards stifles debate on and research into these fundamental matters: for instance, does the law of diminishing returns operate, and at what point? What are the benefits of *nearly* or *more or less* or *usually* attaining standards, which may be far, far less expensive than attaining them completely for 100 per cent of the time? The quantified basis for this new perspective is published in his 1993 paper.

Measuring environmental 'threat'

Some studies which quantify the relationship of adverse environmental factors and damage to objects are listed in Table 4.2. Early work was largely on the effects of light, e.g. Harrison (1953); Stromberg (1950). Both calculated the relationship between strength loss of materials and exposure to light (lux-hours and wavelength).

Table 4.2 *Published work including empirical measurement or modelling of the effects of environmental factors on objects*

Object type or material	Environmental factor	Reference
Textile fibres	Light	Stromberg, 1950
Paper	Light	Harrison, 1953
Natural dyes	Light	Cox and Crews, 1988
Japanese colourants	Pollutants (ozone)	Whitmore and Cass, 1988
Artists' colourants	Pollutants (nitrogen dioxide)	Whitmore and Cass, 1989
High volumes of wood or other organic material (e.g. libraries or furniture stores)	Relative humidity	Padfield and Jensen, 1990
Paintings on canvas	Temperature + relative humidity	Mecklenberg and Tumosa, 1991a,b
Archaeological iron	Relative humidity: desiccated storage	Keene, 1994
Easel paintings and social history objects	Temperature + relative humidity	Michalski, 1993

The actual, as distinct from predicted, effects on objects of different values of relative humidity and particularly temperature have received little attention until recently. However, in the Conservation Analytical Laboratory of the Smithsonian Institution a materials testing programme has been under way in recent years to develop a database of the mechanical properties of artists' materials such as paint, canvas and grounds (Mecklenburg and Tumosa, 1991b). Some of the results will be applicable to other types of object made of comparable materials. Mechanical properties include strength, stiffness or flexibility, and elastic or plastic properties: i.e. the nature of the material's response to forces. The combination of its physical and mechanical properties will condition the material's response to changes in environmental factors such as temperature and relative humidity, and to physical forces such as those involved in transporting or moving an object. Response will vary from the delamination of layered structures, such as painted surfaces; cracking; distortion; and many other effects which are the familiar signs of deterioration.

Except by Padfield and Jensen (1990), who have modelled the actual changes undergone by the surface of wood during variations in humidity, these research results have not yet been brought together with the costs of environmental control to make a quantified assessment of the benefits to be gained from different options. Benefits will be specific to each type of material or object: for example, Mecklenberg's work is on paintings on canvas: and the results can be extended to many types of social history object with paint films on flexible supports, but they will not apply to objects mainly of metal. Much work is now being directed to this new perspective.

Measuring 'losses': the deterioration of objects

The collections condition audit methodology described in Chapter 9, below, Collections condition, Defining the data, describes some terms for accurately and consistently describing condition.

In a way, we need a concept like that being developed for cost-benefit analysis in health care: 'quality-adjusted life years', or QUALYs, though this concept too is plagued with shortcomings (Walshe and Daffern, 1990). QUALYs are an attempt to quantify the quality of life as well as how long a person lives. For example, for someone with severe rheumatoid arthritis each year lived might only be worth 0.25 of a QUALY. Standard QUALYs for different medical conditions have been developed by interviewing numbers of people. By using them, the benefits of an operation or course of treatment can be assessed against its calculated costs (McGuire *et al.*, 1988). Objects do have an explicitly acknowledged value, cultural or monetary. This may have a greater bearing on whether they are treated or not than will the outcome of the treatment. For example, famous works of art damaged in attacks will always be treated, even if they have to be heavily restored, though this might well result in a low QUALY score. Interestingly, the present public may well be satisfied, but one can envisage future publics recognizing the low QUALY rating of an object and rejecting it. QUALYs for objects would obviously relate to historic integrity, although physical integrity may be a part of this.

A further difficulty in measuring treatment success for objects is that, unlike people, we cannot say when an object is 'dead' (unless we specifically define 'death': Keene, 1994), so the simple and conclusive measure of life expectancy is denied us.

Quantification: do we need it?

In the absence of the rigorous assessment of different options, theoretical studies, undertaken using samples of new materials rather than the

much more complex chemical and physical systems that real, aged objects represent, are translated straight into practice, and become 'received wisdom'. For example, as part of Turgoose's work on the chemical processes causing partly mineralized iron objects to deteriorate afresh, he pointed out that relative humidities lower than 18 per cent would prevent the most deliquescent of the minerals normally involved, iron hydroxide, from deliquescing (Turgoose, 1982). A standard was therefore set that archaeological iron be stored at 15 per cent relative humidity or lower. It is now the general practice in many countries to store this material in sealable boxes with desiccated silica gel. In 1991, however, a simple statistical technique used to evaluate the benefits of medical treatment, survival probability (Mould, 1981), was employed to construct life tables for large samples of excavated iron objects. The life tables enabled the comparison of the actual state of preservation of iron objects stored at ambient, fluctuating humidity with that of those stored in desiccated conditions (20 per cent or less relative humidity, using the best practicable technology): no difference could be found in the preservation of the two groups (Keene, 1994). Contrary to prevailing professional belief, observations of that sample of objects led to the conclusion that it had been far more effective to treat them than to store them in desiccated conditions. These results certainly point up the need for assessment before new treatment techniques are widely adopted as effective.

Conclusions

Cost–benefit, or cost-effectiveness, analysis is at present hampered by the lack of data on the direct relationship of the environment to deterioration. Risk analysis, goal hierarchies and paired comparisons help in identifying what is desirable, and thus in setting priorities. These are all numerically based techniques which can potentially assign numerical values to different choices. Since the initial numerical data can only be assigned subjectively, such values will always be of doubtful use. However, they were found to be an aid to analytical thinking. For example, it is quite interesting to note that where conservation treatment has been ranked against preventive measures (goal hierarchies, Figs 4.2–4.4; paired comparisons, Table 4.1; robustness analysis, Chapter 5, Case Study, and Fig. 5.4, Table 5.3) it rates more importance and a higher priority than is presently fashionable to assign to it.

This chapter has reviewed numerically based approaches available to aid planning; the next one discusses some alternative analytical techniques not based on numbers.

References

Ayres, J. M., Druzik, J. *et al.* (1989). Energy conservation and climate control in museums. *Int. J. of Museum Management and Curatorship*, **8**, 299–312.

Benarie, M. (1987). Probability of conservation of cultural heritage. *European Cultural Heritage Newsletter on Research*, **1**(4), 9–13.

Benarie, M. (1989). Valuation of cultural heritage. *European Cultural Heritage Newsletter on Research*, **3**(4), 7–9.

Bignell, V. and Fortune, J. (1989). *Understanding systems failures.* Manchester: Manchester University Press in association with the Open University Press.

Cox Crews, P. (1988). A comparison of clear versus yellow ultraviolet filters in reducing fading of selected dyes. *Studies in Conservation*, **33**, 87–93.

Harrison, L. S. (1953). *Report on the deteriorating effects of modern light sources.* New York: The Metropolitan Museum of Art.

Jackson, M. C. and Keys, P. eds (1987). *New directions in management science.* Vermont: Gower.

Jones, D. R. (1991). A stable future for Suffolk's archives. In *Storage, Conference preprints, Restoration '91 RAI Conference*, London: UKIC.

Keene, S. (1994). Real-time survival rates for treatments of archaeological iron. In *Ancient and historic metals, conference proceedings 1991*. Marina del Rey, CA: Getty Conservation Institute.

Land, F. F. (1976). Evaluation of systems goals in determining a design strategy for a computer based information system. *The Computer Journal*, **19**(4), 290–4.

Littlechild, S. C. and Schutler, M. F., eds (1991). *Operations research in management.* Hemel Hempstead: Prentice Hall.

McGuire *et al* (1988). *The economics of health care.* London: Routlege.

Mecklenberg, M. F. and Tumosa, C. S. (1991a). An introduction into the mechanical behaviour of paintings under rapid loading conditions. In *Art in transit, conference proceedings, London.* Washington: National Gallery of Art.

Mecklenberg, M. F., and Tumosa, C. S. (1991b). Mechanical behaviour of paintings subjected to changes in temperature and relative humidity. In *Art in transit, preprints of a conference, London.* Washington: National Gallery of Art.

Michalski, S. (1990). Towards specific lighting guidelines. In *ICOM Committee for Conservation, 9th Triennial Meeting, Dresden, Preprints.* Marina del Rey, CA: ICOM/Getty Conservation Institute.

Michalski, S. (1993). Relative humidity: a discussion of correct/incorrect values. In *ICOM Committee for Conservation, 10th Triennial Meeting, Washington, DC, Preprints.* Marina del Rey, CA: ICOM/Getty Conservation Institute.

Mould, R. F. (1981). *Introductory medical statistics.* London: Pitman Medical.

Padfield, T. and Jensen, P. (1990). Low energy control in museum stores. In *ICOM Committee for Conservation, 9th Triennial Meeting, Dresden, Preprints.* Marina del Rey, CA: ICOM/Getty Conservation Institute.

Reedy, T. J. and Reedy, C. (1988). *Statistical analysis in art conservation research.* Marina del Rey, CA: Getty Conservation Institute.

Rivett, P. and Ackoff, R. L. (1963). *A manager's guide to operational research.* London: Wiley.

Saaty, T. L. and Vargas, L. G. (1991). *Prediction, projection and forecasting.* Boston: Kluwer Academic Publishers.

Staniforth, S. (1990). Benefits versus costs in environmental control. In *Managing conservation, Conference preprints*, London: UKIC.

Stromberg, E. (1950). Dyes and light. *ICOM News* 3(3).

Turgoose, S. (1982). Post-excavation changes in iron antiquities. *Studies in Conservation*, **27**, 97–101.

Walshe, G. and Daffern, P. (1990). *Managing cost-benefit analysis*. Basingstoke: Macmillan.

Whitmore, P. and Cass, G. (1988). The ozone fading of traditional Japanese colorants. *Studies in Conservation*, **33**, 29–40.

Whitmore, P. and Cass, G. (1989). The fading of artists' colorants by exposure to atmospheric nitrogen dioxide. *Studies in Conservation*, **34**, 85–97.

Wyatt, R. (1989). *Intelligent planning*. London: Unwin Hyman.

5 Management tools: options and priorities

The classic dilemma in conservation is whether to put resources of time and money into remedial conservation treatment, or into improving conditions for preservation. How do we prioritize and choose between the actions we could take? Is creating the right climatic environment more important for the survival of the collections than their physical safety? When funds are limited, should they be spent on conservation treatment, or on remounting objects for storage? Should the bid for stores improvements be for an existing building upgrade, or a new build project? These are some of the conflicting priorities that conservators and museum managers have to choose between almost every week.

While Chapter 4 described some of the numerical, quantitative methods than can help in decision making, there are non-numerical methods which can be even more useful. More general approaches to strategic planning are explored in Chapter 10, Directions and strategies.

Risk analysis

The principles of risk analysis and management are summarized by Crockford (1986). Many texts on risk management focus on financial risk, for example in insurance or in currency dealing, but Crockford discusses the general principles of reducing risk itself as well as the financial consequences of it. This is an area which is highly applicable to conservation. In order to control and reduce the risk to resources, we must understand the types of risk and the relationship between their severity and their natural frequency; systematically identify the sources of risk and measure them; take decisions on how to handle risk; develop systems of loss control; and finally plan how to recover from large-scale loss should it occur.

The components of risks to collections

Risk is seen as being made up of four components:

- *Threats*, the forces which could cause loss;
- *Resources*, what is at risk (in our case, historic objects and collections);
- *Modifying factors*, which reduce the probability or the severity of the consequences of risk;
- *The consequences if the threat materializes*: the effect of the loss on the operations of the organization.

Michalski (1990) has also worked on this area, in order to develop a general understanding of the risk to collections, and to communicate this clearly to professionals such as facilities managers and fire officers. He sets out the causes of deterioration internal to the institution (the threats) and categorizes the range of conservation responses (the modifying factors) using the principles of fire prevention theory. Threats he identifies as: physical forces, criminals, fire, water, pests, contaminants, radiation (light), incorrect temperature, incorrect relative humidity. These can be condensed into:

- *Physical forces*,
- Threats from *people*,
- Threats from an *inappropriate environment*,
- Threats from *disaster*.

Michalski analyses conservation responses in detail as a series of stages, again as in fire prevention and control, *prevent, detect, contain, control, recover*.

Risk: severity and frequency

There is a relationship between the severity of risk and the likelihood that loss will occur (Fig. 5.1). This analysis has obvious application to the deterioration of objects or collections (Table 5.1). A disaster such as a major fire will be catastrophic, rare, and difficult to predict, while each occurrence of damage due to a poor environment will be almost undetectable, but frequent and highly predictable. Yet a probability can be calculated even for rare, catastrophic loss. For example, there have been three disastrous fires in historic properties in the UK in recent years: Uppark, Hampton Court and Windsor Castle, as well as Norwich Local History Library and Archive. The probability that another will occur in a particular year and house, while small, is finite and could be calculated.

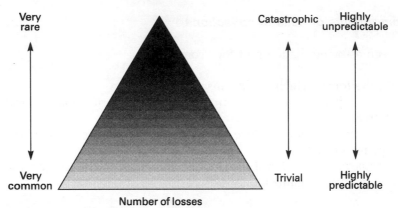

Fig. 5.1 *The relationship between risk and frequency, severity and predictability*

It can be reduced by such measures as heat and smoke detectors, frequent patrols, and strict control over the use of hot working methods and smoking by contractors, etc.

Loss control

Loss control is already familiar in museums as preventive conservation: the holistic analysis and prevention of causes of deterioration of collections and objects, from environmental control to disaster recovery planning.

In conservation we seem, although not perfect, to be somewhat ahead of our commercial counterparts, since Crockford (1986, Ch. 10) laments the compartmentalization of loss control into rigid specialisms: security, health and safety, data protection, etc. We can, however, accept the message that where the control of loss to the collections is concerned storage and conservation, and indeed security, are points on a continuum, not separate functions. Table 5.1 shows a generalized analysis of some

Table 5.1 *Some threats to collections analysed by frequency, severity and predictability*

Threat	Frequency	Severity	Predictability
Unsuitable environment	Very high	Very low	Very high
Rough handling	High	Low	Good over one year
Water services leak	Low	Medium	Good over ten years
Major disaster (other than above!)	Very low	High	Minimal

familiar threats to collections. However, in statistical analysis of complex problems such as those posed by collections, the average can often be less important than the distribution and the outliers – the extreme cases. In this example, some types of object will be very much more vulnerable to some threats than to others (e.g. an unsuitable environment could be catastrophic for unstable glass) so such a table could be compiled for each specific collection, and perhaps for each different store. The table should really be multi-dimensional. The shapes of the distribution curves for each column would differ according to the type of collection, and could be an aid to strategic planning.

The consequences of loss

When the consequences of loss are mainly financial, a business is likely itself to cover the small, predictable losses that present no threat to stability, but to insure against unpredictable but catastrophic loss: 'i.e. transfer the risk to another organization (the insurance company) in exchange for a small, certain loss (the premium) (Crockford, Ch. 8). It might be thought that in the case of museum collections the risk (of serious loss of a collection or a valuable object) is not primarily financial, and hence that it cannot be passed on except by transferring the ownership of the resource. However, local authorities do treat the risk as financial, although it is in the nature of museum collections that they are largely irreplaceable. National museums do not insure their collections: instead, government indemnifies them against loss, although in practice they would not receive compensation for the loss of collections objects. In either case, the institutions must take steps to reduce the risk. The costs and benefits of various actions are not easily calculated. The calculation of loss as it applies to collections and objects is further discussed below; the effect of the loss on the institution's operation could also usefully be considered. Apart from the effect on its ability to achieve its central purpose through exhibitions and through having collections available for research, it needs to bear in mind the possible damage to its reputation, and consequent effects on funding, either from a disaster that could have been avoided or through the discovery that collections have deteriorated through neglect.

Decisions on risk

When the nature of the risk to collections is better understood, priority for actions and funding will need to be allocated to risks which combine severity and probability. This may well involve tightening up procedures rather than making costly investments. For example, contractors working on site always bring about a sharp increase in risk (for example, the

Uppark fire was a consequence of contractors hot-working lead on the roof). Floods have been caused by roof drainage being blocked by contractors' lunchtime sandwich wrappers. The Windsor Castle fire arose because of the incorrect installation of a light fitting. Damage to objects from handling can almost always be reduced through designing effective procedures and training staff to follow them.

When it comes to choosing between disaster control measures (fire detection and control; intruder alarms) and environmental improvements, a judgement will have to be made on which threat should be addressed first. However, it is likely that the institution will eventually have to take most of the measures it identifies, and that prioritization will be mainly a matter of spreading the expense over time. Really serious risks arising from environmental conditions are likely to arise from structural defects in the building, and will probably require radical solutions, such as moving to a completely different storage building. Simply identifying risks and the costs of preventing them, and placing them in ordered lists, is likely to be a powerful aid to decision making.

Many or even most threats to collections can be reduced by good management: planning to avoid them at the design and briefing stage, which will minimize costs (Table 5.2). It may, for example, be more effective to divide stores into smaller fireproof enclosures, which will contain the threat of fire, rather than to install expensive sprinklers, which themselves constitute a risk should they discharge by mistake. Services should never be designed to run through stores. Stores should not be situated below the water table, or near a source of flooding. Exhibitions can be designed to minimize the threats to objects.

Table 5.2 *Threats to collections and costs of prevention*

Threat	Frequency	Severity	Predictability	Cost of prevention
Environmental	Very high	Very low	Very high	Low if better controls/ equipment needed; High if building unsuitable
Theft, vandals	Medium	Medium	Reasonable	Normally low
Handling	High	Low	Reasonable	Nil – procedures only
Services leak	Low	Medium	Reasonable	Low at design stage Very high later
Disaster	Very low	High	Minimal	Can be high Normally lower at design stage

Strategy development

There are almost as many different approaches to strategy development as there are writers on the subject. Bowman and Asch, in their extremely useful and comprehensive book, review the whole spectrum (1987, especially Ch. 14 and Table 14.2). They distinguish eight main views, placed on a scale from 'deliberate' at one end (analytical, objectives consciously set) to 'emergent' (incremental, not analytically worked out) at the other. There is, they say, no one 'correct' method of strategic planning, although they incline to the more incremental processes. What sort of method is right in a particular situation will depend on the culture and other characteristics of the organization on the one hand, and the context and pressures in the outside world on the other. Mintzberg and Quinn (1992) have assembled a variety of articles and readings which give the whole spectrum of views on strategic planning. Rosenhead (1989) describes six techniques that fall into the category of soft operational research, including soft systems methodology (described in the following two chapters, 6 and 7), strategic choice, and robustness analysis.

'Deliberate' strategies

Much work has been done on strategy for commercial companies. Michael Porter is an often-quoted writer. Several of his articles are included in Mintzberg and Quinn (1993), and his approach is summarized by Bowman (1990). Ohmae (1982) writes for an American audience but drawing on the Japanese experience. He advocates first, identifying key factors for success; then the [customer's] objective functions – what is conceptually required from the product or process. Other writers describe the benefits of avoiding dwelling on the present situation – what is wrong – and starting instead with what *should* be. There is the notion of a 'strategic staircase', the steps of which consist of capabilities which must be acquired and strategies which must be developed in order to attain the mission (see Fig. 10.2).

'Ladders of choice'

The concept of a 'ladder of choice' has been developed by Farbey, Land and Targett (1993). The ladder leads from what the institution must do because of commercial or other pressure, to the highest rungs which potentially bring the greatest benefits but also the greatest risk of failure. Their model has been developed in the context of strategy for information technology development, but it has general applications. On the lower rungs of the ladder the institution has little choice. These are things it must do because its competitors provide a similar service or product, and

thus are expected by customers. On the higher rungs the activities are optional, and while the benefits may be much greater, because the organization will be offering something distinctively different, so are the risks, because the development may turn out to be inappropriate. For museums, the lowest rungs for collections care will be to account for their collections and to keep them secure. In real life, their physical preservation is a rung higher. It may be that the highest rungs introduce public involvement in the collections care process. An example is to be found in the plans of the National Museums and Galleries on Merseyside, which is constructing top-flight collections care facilities with substantial elements of public access to the conservation process the risk lies in the ongoing income generation required. The 'ladder of choice' concept can be used in evaluating success as well as in developing strategies.

Deliberate approaches are also known as the 'moonshot' type (Rosenhead, 1989: 196). The problem with them is that by the time you reach the top stair the world may have changed around you, and your proud achievement may no longer be very relevant. Rosenhead argues that the likelihood is that a planned strategy for an organization will not confer competitive advantage, because it will be similar to those of other similar organizations. Despite the benefits of an analytical, planned, approach, there is the the risk that flexibility and creativity will be stifled.

'Emergent' approaches

There has been a lot of research into the success and evaluation of strategic planning by those working on the use of information technology. On the whole, emergent strategies – where plans develop incrementally as a series of small-scale steps – appear to have the most successful outcome. Earl, investigating strategies for information technology in five well-known companies, found that highly emergent, unplanned developments, arising directly from operational needs, were the most likely to be implemented and used (Earl, 1990, 1992). Mintzberg (1994) writes on 'The rise and fall of strategic planning'. There is however the risk with emergent strategies that the organization takes only a short-term view. In the author's experience, too *dirigiste* an approach can be experienced as directionless drift. Some 'soft' analytical approaches aim to combine the best of both perspectives, and a few of them are summarized below.

Strategic choice analysis

This approach is described by Friend (1989), who has worked particularly with local government planning. It combines techniques from operational

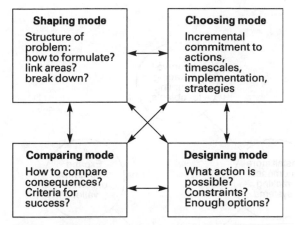

Fig. 5.2 *Working modes in strategic choice analysis. Planners can move between modes at random*

research with concepts developed in the Tavistock Institute of Human Relations. Friend distinguishes three categories of uncertainty in selecting from different alternative actions:

- uncertainty from the *working environment;*
- uncertainty about *values;*
- uncertainty about *related decision fields;*

and four modes in which people work when planning strategy:

- *shaping*
- *choosing*
- *designing*
- *comparing.*

Friend describes several techniques for use in each mode. Figure 5.2 illustrates the working modes and how the planner moves between them when developing a strategy. Figure 5.3 illustrates the application of one of the techniques, the analysis of decision areas and links between them, in 'shaping mode'. The scene as a whole is not very complex. In fact, all the decision areas are linked, but by the constraint of the availability of finance; most of these actions are likely to have to be taken eventually, and the main decision is about priorities rather than alternatives. This cursory investigation suggests that this methodology is more applicable to strategic planning for the wider system, the museum itself, where a greater variety of strategic directions offer themselves, than to the conservation sub-system. This brief description is far from doing justice

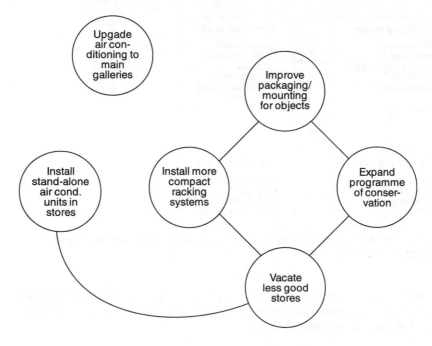

Fig. 5.3 *Strategic choice analysis: the analysis of decision areas and links between them, in 'shaping mode'*

to the strategic choice approach, which clearly does offer many useful tools (for instance, analysis of comparative advantage, the setting out of feasible decision schemes).

Robustness analysis

Robustness analysis is 'a format for exploring aspects of planning problems under uncertainty, not a method for finding an answer' (Rosenhead, 1989: 215). It is applicable to situations of uncertainty, which include the operational climate in many museums today. Robustness analysis is predicated on the recognition that it is impossible for anyone to know what the future will be like; that any strategy based on a future extrapolated from the present is likely to rapidly become irrelevant; but that it is possible to imagine a range of futures, and develop plans to take account of this. There are two important keys to uncertainty planning: first, that the existence of multiple possible futures is acknowledged; and second, that decisions (the commitment of resources to an action) are distinguished from plans, 'foreshadowing of sets of decisions'. Plans can be altered losing nothing but time; however, it may be objected that

nothing is gained from this, either, and credibility and commitment may be lost.

The whole methodology is quite complex (Rosenhead, 1989: 213, Fig. 12), but the concept of robustness analysis which lies at its heart is relatively simple. A plan contains a number of stages at which decisions on different courses of action must be taken. The alternative courses of action lead to different outcomes. The desirability of each outcome will depend on which of the possible multiple futures comes to pass. Decisions, outcomes and futures can be set out diagrammatically, as in Fig. 5.4.

This technique clearly needs a good deal of practice before its full potential is realized. Rosenhead points out, however, that it can be simplified as much as is desirable for a particular situation as long as its key features are retained. Its striking advantage is that it is directed to clarifying the key question, 'but what should we do now?', and explores actual consequences, when most of the other techniques that have been investigated only help to understand the desirability of different actions.

Case study: robustness analysis

The Historic City Museum was faced with a dilemma. The council's Leisure Services Committee had made it very clear that it expected the city's heritage to be better looked after. If the stores continued to look like junk yards heads would roll. But despite this commitment from councillors, it was not possible to commit funding for more than a year ahead. By that time, it was feared, local government funding might be reduced, and the museum might be much more reliant on income from visitors. How could the museum use the short-term funding to bring about improvements to collections care that would be useful in either future?

The museum set up a Care of Collections Working Party to help decide on priorities. They first defined the imagined futures as:

1 That most of its funding will continue to come from the council, which will therefore insist on accountability for both collections preservation and access to the collections, through the Audit Commission and the Museums and Galleries Commission Standards.
2 That local government funding, and therefore pressures for account-ability, will sharply diminish. Pressures to attract more visitors will increase, and access to stored collections can assist this.

In both these futures, the most desirable outcome is one in which collections are well cared for and also stored in ways that can be made accessible to the public.

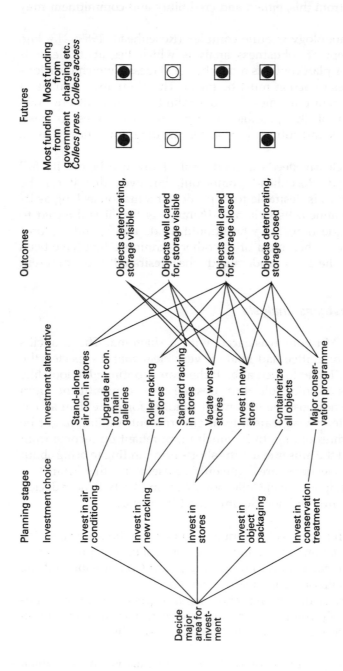

Fig. 5.4 *Robustness analysis: decisions, outcomes and futures applied to the Historic City Museum's investment decision*

Table 5.3 *Robustness analysis: preferred and unpreferred options left open by alternative decisions on investment in collections preservation*

Investment choice	Options left open			
	D	A	U	
Air conditioning	2	1	1	Key
Racking	2	1	5	D: desirable
Stores	2*	0	3	A: acceptable
Packaging	0	1	3	U: undesirable
Conservation	2	1	1	

*Outcome accessible by two routes.

The decision to be taken was on what major area of collections improvement to invest in. This is recorded on the left hand side of the analysis diagram (Fig. 5.4). The choice of investments forms the next column. The central column shows one or two alternatives for each investment choice, linked by lines. Finally, there are four possible outcomes, combinations of preserved/deteriorating objects and closed/ visible storage. A line indicates where an investment alternative can be linked to an outcome.

A simple value (desirable, acceptable, undesirable) is ascribed to each outcome under each future. Finally, the outcome values to which the lines from each of the investment choices lead are counted up (Table 5.3).

The diagrams and processes looked fearsomely complex, but the working party found that if they worked carefully through the process it was quite clear. They could have used more levels of decision and more futures had they wished to do so.

The working party scrutinized their results (Table 5.3). Since desirable outcomes were of most concern (rather than the avoidance of undesirable ones) then no one decision had a clear advantage, but investment in packaging (protection and support for individual objects) alone would not contribute significantly to any desirable outcome. It was assumed that packaging will prevent objects being seen, and thus rule out visible storage (this need not necessarily be the case). A decision to invest in racking would open no more desirable outcomes than other options, but carried a much higher risk of undesirable outcomes (inaccessible storage), because of the need to decide between normal and roller racking. Roller racking would make the collections easy to retrieve, and maximize cost-effectiveness in the use of storage space, but it would preclude any practical form of direct access to the stored collections.

The two decisions (conservation and air conditioning) that kept open the most desirable outcomes, and minimized the risk of undesirable ones, both implied investment in the preservation of the collections themselves rather than the means of displaying or storing them. This conclusion seemed obvious as soon as the working party uttered it, but it certainly had not been at the start of the exercise.

The museum applied the analysis in a simplified manner, but the results prompted some extremely interesting observations. Insight can be gained in this way by imposing simplicity. Analysis may prompt investigation of other choices. One needs to be imaginative, and to be ready to completely change the frame of reference for decisions. When the Historic City Museum conservators went on to develop a strategic plan (Chapter 10), they realized that choices should not be between major avenues of investment, but between different stores as candidates for a coordinated package of store-by-store improvements.

Conclusions

In this and the previous chapter, several different logical and numeric aids to decision making and planning have been investigated. Each of them has uses in managing the conservation of museum collections. All of them assist in clarifying the nature of the decisions to be taken. The methods will also assist individual and organizational learning if staff are widely involved, especially if the planning processes is iterative, with evaluation and review at regular intervals. Although institutions may subscribe to the idea of corporate learning, it can be hard for them to find the time and circumstances that are conducive to this. Ways of assisting this include setting aside specific time for looking ahead, including the familiar management awaydays for planning, a planning day, or a special staff seminar.

Finally, the importance of applying cost–benefit and opportunity cost principles to planning itself should be borne in mind. The costs of indecision are well known: planning blight can severely affect morale and land the institution in a slough of inertia. Elaborate assessment processes can themselves be very expensive in time and effort: what is not being done because of this?

References

Bowman, C. (1990). *The essence of strategic management*. Hemel Hempstead: Prentice Hall International

Bowman, C. and Asch, D. (1987). *Strategic management*. Basingstoke: Macmillan.

Crockford, N. (1986). *An introduction to risk management.* Cambridge: Woodhead-Faulkner.

Earl, M. (1990). Approaches to strategic information systems planning: experience in twenty-one United Kingdom companies. In *Proceedings of the International Conference on Information Systems, Copenhagen.* Baltimore: ACM.

Earl, M. (1992). Putting IT in its place: a polemic for the nineties. *J. of Information Technology,* 7, 100–8.

Farbey, B., Land, F. *et al.* (1993). *How to assess your IT investment.* Oxford: Butterworth-Heinemann.

Friend, J. (1989). The strategic choice approach. In *Rational analysis for a problematic world* (J. Rosenhead, ed.), Chichester: Wiley, Ch. 6.

Michalski, S. (1990). An overall framework for preventive conservation and remedial conservation. In *ICOM Committee for Conservation, 9th Triennial Meeting, Dresden, Preprints.* Marina del Rey, CA: ICOM/Getty Conservation Institute.

Mintzberg, H. (1994). *The rise and fall of strategic planning.* London: Prentice Hall.

Mintzberg, H. and Quinn, J. B. (1992). *The strategy process.* London: Prentice-Hall.

Ohmae, K. (1982). *The mind of the strategist.* Harmondsworth: Penguin Books.

Rosenhead, J. (1989). Robustness analysis: keeping your options open. In *Rational analysis for a problematic world* (J. Rosenhead, ed.), Chichester: Wiley, 193–2

6 A systems view

Museums, like other organizations during the 1980s and 1990s, have felt a blast of change in the roles that they are expected to play, and in what is expected of the people working in them. Another factor is the enormous increase in recent years in the size of the collections. Organizational arrangements that were adequate to manage collections where individual curators could hold in their own heads the identity, significance and whereabouts of most, if not all, the objects in their collections are not at all appropriate to circumstances where collections commonly number hundreds of thousands of objects. As has been shown above, the growth in collections has mostly taken place only from the 1960s.

The combination of perceptions still based on the past with continuing rapid change makes it difficult to see clearly how collections preservation should best be managed. In order to understand properly the nature of the new tasks we need to step back from the situation in which we are immersed, to understand what preservation really entails, and then seek the necessary information. A powerful and illuminating method of enquiry has been developed during the last twenty years, used in management studies and consultancy. Rooted in systems studies, it is known as the Soft Systems Methodology.

The systems approach

Development of systems theory

The development of systems theory has been important in studies of organizations and the development of approaches to management information. A variety of papers on some of the many applications of systems work is given in the compilation of papers by the Open Systems Group (1972). Systems theory arose between 1940 and 1950, as biologists in particular began to recognize the limitations of scientific method. Checkland has set out a detailed review of the development of systems theory and its application in his book, *Systems thinking, systems practice* (1981), summarized below.

Scientific method is very powerful; it has gained almost complete supremacy as a way of understanding the world. It has profoundly shaped our world and indeed our whole outlook on it. Yet scientific method is a highly reductionist view of the world. It is founded on the premise developed first by Descartes in the eighteenth century: that we can understand the whole by studying each part in turn. Scientific experimental method is a very precise way of developing and testing hypotheses. The results are expressed in such a form that the tests can be repeated and either confirmed or refuted by others, especially since the results are usually numerically expressed.

However, scientific method has serious limitations, identified by Aristotle, as in 'the whole is more than the sum of its parts'. There are many examples of unforeseen consequences completely swamping the benefits of applying scientific knowledge: for example, economic modelling; the use of DDT; drug side effects such as thalidomide. As the reductionist approach becomes ever more powerful, its failures to take account of the world as a whole system become catastrophically more apparent. Especially when living organisms or organizations are concerned, it is not possible to understand the working of the whole by studying it as a series of discrete parts. If the world is imagined as a hierarchy of complexity, with inanimate components at one end through living organisms to societies or ecologies at the other, then scientific method becomes the less powerful the more complex is the area of interest.

The systems approach has two main roots. One is in the study of biological systems, where von Bertalanffy, who was a biologist, developed ideas about systems, and presented a 'general system theory'. He envisaged that there would arise a high-level meta-theory of systems, which could be mathematically expressed. Bertalanffy was the person who first developed the concepts of 'open' and 'closed' systems. 'Closed' systems are essentially mechanical: they cannot adjust themselves to take account of external changes. 'Open' systems are purposeful and adjust themselves so as to continue operating in a changing environment: examples are biological, ecological and organization systems.

A second major root for systems thinking lies in work on communication and control systems. Here, Norbert Wiener developed the theory of cybernetics: a conceptual framework for machines 'on which all individual machines may be ordered, related and understood'. The Rand Corporation's work in this area during the second world war is often seen as the foundation for operations research and management science.

Systems thinking now has a wide variety of applications, including engineering, manufacturing, sociology, geography and planning, politics, and of course information and information technology.

Operations research, systems and soft systems

Although systems approaches have an overarching unifying theme, within them there is a significant dichotomy between so-called 'hard' and 'soft' methodologies. 'Hard' methods, such as the quantitative and logically based techniques described above, assume that the world is of its nature systemic, that we can discern these systems or install new ones, and if we are clever enough fix them so that they work properly. The soft viewpoint is that the world is not of its nature systemic: the system in the soft systems methodology lies in applying a systemic analysis to the real-world 'mess' (to use Russell Ackoff's term), in the hope that improved understanding will help us to bring about improvements.

Hard systems approaches include mainstream operations research and cybernetics, expounded chiefly at present by Stafford Beer (for example, Beer, 1985). Beer's work gained such credence that he was summoned by Presidente Salvador Allende to apply his concepts to the running of a whole country – Chile. The well-known structured information systems analysis methods such as SSADM (structured systems analysis and design method) are hard approaches. Soft approaches include the strategic choice techniques described above in Chapter 5, and would include prototyping, evolutionary development and socio-technical approaches in information systems design, described in Chapter 12.

The soft systems methodology

The soft systems methodology is as important for its general spirit of enquiry through the involvement of the actors in the situation as it is for the analytical tools it offers. It has been developed by Peter Checkland in the specific context of academic research into organizations, applied to and informed by management consultancy (Checkland and Scholes, 1990). It is being adopted by increasing numbers of management academics and management science practitioners. The particular strength of soft systems methodology lies in its encouragement of an open mind and a highly imaginative approach to the nature of problem and solution alike, and in the tools it provides for facilitating structured discussion by the actors in the situation themselves. The stated objective of the method is to bring about 'real, desirable change'. A successful outcome would usually aim to include changes in the perception of those within or in charge of 'the situation'. The soft systems techniques are also finding increasing application in the early stages in developing information systems.

In essence, the method consists of developing understanding of the real world situation-of-interest, and then imagining one or more abstract systems which would be relevant to it. The insights gained like this are

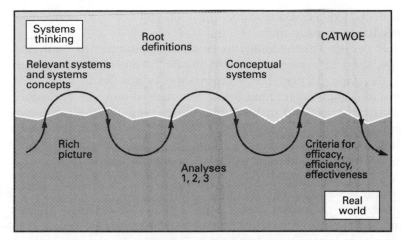

Fig. 6.1 *The soft methodology: the user moves between the abstract system and the real world, constantly comparing the two*

then applied, by contrasting the real world with the abstract situation. This brings about further insights during structured discussion of what would constitute 'real, desirable change'. Figures 6.1 and 6.2 depict the method diagrammatically. In this chapter and the following one, the soft systems methodology will be employed to enable us to understand what

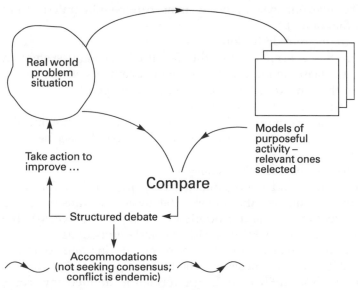

Fig. 6.2 *Diagram of the soft methodology*

the tasks of collections preservation consist of, and hence what information is needed to manage them.

The soft systems methodology consists of a number of analytical techniques, used in sequence but also iterated – repeated – as understanding develops. At first it was interpreted as a series of prescribed stages, but it has now been found that it can be used much more flexibly. The analyst can select and make public those components which seem most applicable rather than following a sequence. Its essence still lies in contrasting the real world with an imaginary system or systems which would be relevant to it. The soft systems toolkit consists of:

● Real world understanding: the rich picture
 The analyst or the actors depict the world by means of a graphic summary of it. This encourages an overview approach.
● Real world understanding: Analyses 1, 2, 3
 The rich picture is supplemented by analyses of the nature of the problem (Analysis 1), of the cultural situation (Analysis 2), and of the distribution of power (Analysis 3). Each analysis is a series of precisely targeted analytical questions; undertaking these analyses can be most enlightening for the participants. For examples of Analyses 1, 2 and 3 see Chapter 7, Exhibit A.
● Systems concepts: relevant systems
 From these analyses, and in particular from the rich picture, or from an equivalent discussion, a number of strictly abstract concepts can be developed which would be relevant to the situation which is of interest. The relevant system or systems can be illustrated using conceptual diagram(s).
● Systems concepts: root definition
 Drawing on the concepts from the favoured relevant system, a complete yet concise definition of how the relevant system would be embodied in the context of the real world is developed.
● Systems concepts: the conceptual system
 The root definition is employed to construct a diagram showing the processes implied by the root definition and the dependencies between these processes.
● Systems concepts: the CATWOE check
 The root definition and conceptual systems are checked for these elements: the customers, the actors, the system's transform, the *Weltanschauung* (implicit and underlying view of the world), the owners, and the environment in which the system operates.
● Systems concepts or real world: criteria for monitoring and control
 The EFFICACY (how to measure whether the perceived system is working properly), EFFICIENCY (performance divided by cost), EFFECTIVENESS (would the overall objective be better met by doing

something altogether different?). These criteria can be established either for the conceptual system or for a real-world prescription.

- Systems concepts contrasted with real world
The conceptual system or systems are then compared and contrasted with the real world, and this assists the actors to determine real, desirable improvements.

This process sounds dauntingly complex. In real life application, the analyst does not necessarily plod through this process in strict serial order. Some aspects of the methodology may be found more helpful than others, in which case the analyst would concentrate on them. The analyst may not admit to be using this method at all: they may just pose a series of questions for discussion. The importance of the method lies primarily in the structured discussion it engenders, which it is hoped gives rise to new perspectives on the situation of interest.

A soft systems look at museums

The problem situation unstructured

The unstructured situation has been portrayed above, in Chapter 2, Museums and collections, and Chapter 3, Management and information.

The problem situation expressed: the rich picture

A diagram called a rich picture (Fig. 6.3) is used to express the main features of the problem situation more vividly than pages of text, especially the issues at stake. The first stage towards examining the role of conservation must be to examine the museum system which is relevant to these processes, and so conservation is depicted in the context of museums in general.

The relevant elements of the rich picture are:

The processes:	in the museum: management, conservation, curation, exhibition.
The collections:	consisting of objects, stored and exhibited.
The people:	managers, curators, conservators, designers, and very importantly, the public.
Inputs and outputs:	within the system: collections not preserved become collections preserved.
Outside pressures:	the National Audit Office, the government, other local or national government influences.

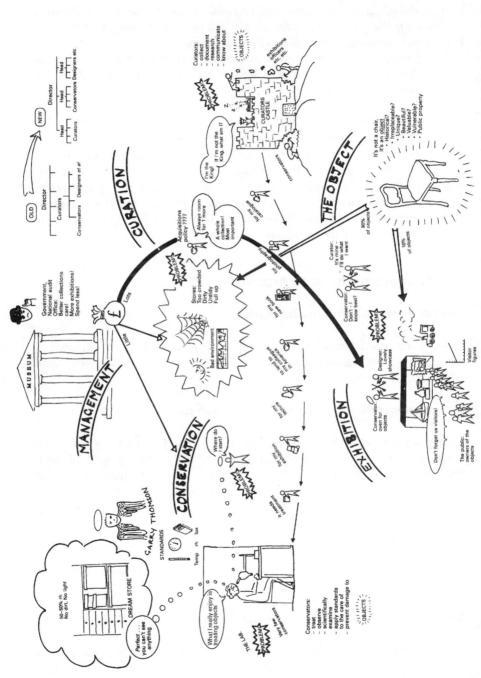

Fig. 6.3 A soft systems rich picture of conservation in museums. The focus is on issues, rather than tasks or processes

Many issues: among them: that curators feel threatened by the rise of other museum professionals (Anderson, 1985; Cossons, 1990); that many conservators prefer to spend time actively treating objects rather than preventing damage; that there are many reasons why a particular object may be a candidate for conservation at any one time; conflicts of priority; difficulty deciding where to start in conserving objects; pressure for accountability from outside bodies.

A decision has to be taken on whether the analysis is to focus on issues, structures or tasks. Since this analysis is directed towards understanding a generalized museum system and its information needs, it is most useful to examine tasks. Focusing on tasks, or functions, also makes it easier for an analyst who is herself part of one of these systems to distance herself from issues, such as the conflict over the collections and objects between one group, the conservators, who see themselves as 'carers', and another, stronger and more numerous group, the curators, who see themselves as 'owners'. This is an element of the rich picture which is very apparent to the actors within these real-world systems (see Analyses 1, 2 and 3 in Chapter 7, Exhibit A). It is symptomatic of the dual objectives of the system (see below, Relevant systems).

The rich picture does not depict structures or tasks at all clearly, although it does show conservation work taking place. In the light of ongoing change in the roles and management of museums there is still unclarity about responsibilities and roles, with consequent conflict. The task in the soft analysis was to inspect the situation as it existed in the real world and to propose an abstract system of tasks and functions that would more effectively reflect the purpose of museums.

Relevant systems

The museum system that we need to imagine is one relevant to the conservation and preservation of its collections. The various definitions of museums which exist (e.g. ICOM, 1990, Statutes, Article 2) have been helpful in compiling the rich picture, but they are not descriptions of systems. More than one relevant system needs to be developed, to aid freedom of thinking. From the rich picture, a variety of relevant systems for museums suggests itself:

A system to

- focus on the tasks of preserving the collection rather than on inter-professional rivalry

- provide management information on the preservation of the collections
- minimize the number of objects that needs to be treated (because they are all in good condition)
- set and apply standards for the care and maintenance of objects
- maintain original objects in good condition for exhibition or other 'use'.

What lies at the heart of the activities and purposes of museums? Perhaps this is best approached by considering other types of organization first. What about a factory making shoes, or any other commodity for sale? A record office? Commercial exhibitions? Figure 6.4 shows diagrammatically some systems with their inputs and outputs. A production system takes raw materials, turns them into something else, and passes them out of the system. A records office takes something which constitutes original evidence, organizes and maintains it, and makes it available to the public

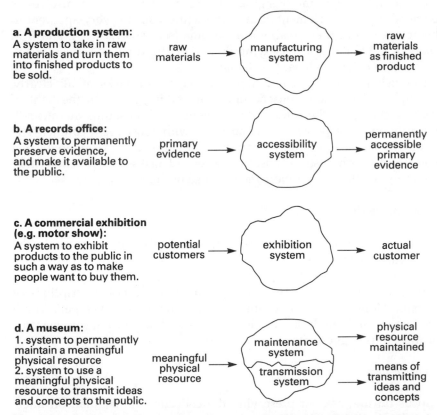

a. A production system:
A system to take in raw materials and turn them into finished products to be sold.

raw materials → manufacturing system → raw materials as finished product

b. A records office:
A system to permanently preserve evidence, and make it available to the public.

primary evidence → accessibility system → permanently accessible primary evidence

c. A commercial exhibition (e.g. motor show):
A system to exhibit products to the public in such a way as to make people want to buy them.

potential customers → exhibition system → actual customer

d. A museum:
1. system to permanently maintain a meaningful physical resource
2. system to use a meaningful physical resource to transmit ideas and concepts to the public.

meaningful physical resource → maintenance system → physical resource maintained

transmission system → means of transmitting ideas and concepts

Fig. 6.4 *Concepts for relevant systems for different organizations compared*

in a form as nearly unchanged as possible; i.e. as primary evidence. In a commercial exhibition the fate of the products is irrelevant (except for their cash value): the system is to transform possible customers into eager customers.

What is the least that a museum can do and yet be a museum? Preservation and display of collections are the dual concepts at the heart of museums. Would display alone suffice? An organization such as the Sainsbury Centre that is simply a venue for a changing series of displays would not qualify, although it might be known as 'a gallery'. Does preservation alone make a museum? The British Rail Pensions Fund held a collection but it in no way constituted a museum. To be a museum, an organization has to hold a collection in some ongoing way and also provide access to it even if only privately. It is not necessary to acquire new objects, and indeed many 'closed' collections exist, such as the Wallace Collection and the Dulwich Picture Gallery. As well as the quality of permanence, there is also the implication that a collection consists of objects which are meaningful and capable of being ordered in some way. Together these imply that the objects are in some way unique and therefore irreplaceable. There are overtones that meaning that is in some way inherent in the objects is made explicit by virtue of their being members of a museum collection, as museum objects.

But this study is concerned with publicly funded museums. The relevant system which seems to best represent this situation of interest is:

A system to permanently maintain an irreplaceable and meaningful physical resource and to use it to transmit ideas and concepts to the public.

In this system, one input is being used in two separate systems transformations, as in Fig. 6.4d. This combines the two essential features of museums, expressed in all definitions and in most implements of governance: to maintain collections and also to exhibit them and use them in other ways to transmit ideas, etc. Collections have two conceptual dimensions: the intellectual, comprising their information content and significance, and their physical presence. Since they are of real objects, each unique because of its historical context or associations, collections can be seen as 'an irreplaceable resource'. The term 'resource' implies something being used up. Nothing can prevent objects gradually deteriorating, and displaying them generally accelerates this; therefore, this term seems appropriate. Exhibitions, lectures, educational activities, actors in galleries, and all the other public service activities of museums today are essentially different ways of transmitting ideas and concepts to the public.

The actual relevant system, then, is a dual one, with both the processes that go on inside the system in Fig. 6.3d: that is 'maintenance' and also 'transmission', which take the same 'meaningful objects' as their input, and output from them both 'preserved objects' and also objects of which the meaning is explicit.

Alternative museum systems

The museum relevant system depicted here might be called the classical system. But in Chapter 2, What are collections for?, it was shown that there is a variety of uses for museum collections: display, demonstration and evidence. Do these various uses imply different relevant systems?

In another relevant system (Fig. 6.5b), objects themselves are an essential input, because the operation of the system, if no restrictions are placed on it, entails the alteration of the objects by replacing parts, repainting, etc. This might eventually be to such an extent that they are no longer the same as they originally were. In this case, it might be said that the physical dimension of the object is out of step with its intellectual or informational dimension. It is supposed to be a genuine historical object, but in fact it is no longer so.

If Fig. 6.5 a and b are, respectively, the 'classical' museum system and one where collections are used for demonstration, is a third type of system required where the primary purpose is display? The prime example of this is a picture collection. In systems terms, display can be seen as a form of demonstration, or the 'use' of objects. Just as running an historic engine or maintaining an historic house will lead to original parts

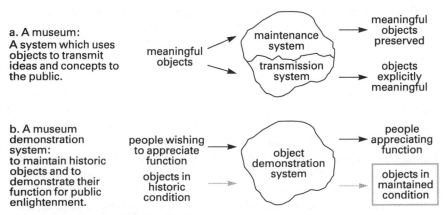

Fig. 6.5 *Relevant systems for a generalized museum, and one having 'demonstration' of objects as its primary purpose*

wearing out and either continuing to exist in a changed form, or being replaced or modified, exposing a picture to light energy in display will result in changes to colour, texture, and physical and mechanical properties. The system in Fig. 6.5b appears to be generally relevant to collections for demonstration and display. Dual objectives still seem necessary, but instead of a permanent resource, historic objects are being maintained for demonstration.

Is there a sense in which the two different relevant systems, 6.5a and 6.5b, can be expressed as one? In both cases, historic objects are both an input and an output. If they are in a museum, then objects will deteriorate, whether from display, demonstration, or natural processes, and need to be maintained. Perhaps there is a compromise system in which historic objects are maintained as nearly as possible in their original form.

Sticking to the simple relevant system, the concept for a system that will do this is illustrated in Fig. 6.6.

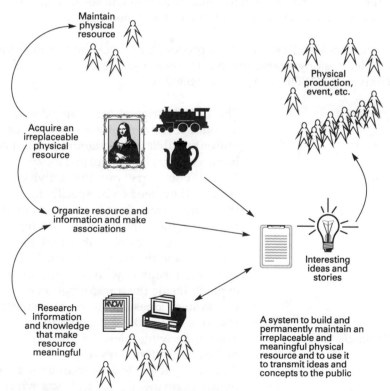

Fig. 6.6 *The broad concept for a museum system*

Root definitions

The relevant system that has been adopted for the purpose of this discussion is:

> A system to build and permanently maintain an irreplaceable and meaningful physical resource and to use it to transmit ideas and concepts to the public.

The next stages in the analysis are to develop the abstract concept embodied in the relevant system, and use it as the basis for a root definition. A root definition describes the features of the real world situation in some detail in the light of the relevant system.

A first attempt at a root definition for a museum might be:

> *Root definition of a museum, Version 1*:
> A system which uses public money to acquire and maintain an irreplaceable and meaningful physical resource and maintain it for the future, and to use and reuse it to transmit ideas, concepts and insights about culture or history to the general public.

Part of Checkland's soft analysis process is to check the root definition for completeness by examining the following elements, designated by the acronym CATWOE (Naughton, 1983: 37):

Customers:	The beneficiaries of the system, in this case, the public. The complication arises because the museum public is the ongoing public; people a hundred years hence, not just today.
Actors:	Those who carry out the activities in the system: they need to be specified.
Transformation:	What the system does to its inputs in order to transform them into outputs. The input to the system is the irreplaceable and meaningful resource, and the output, both its maintenance and the resource with the meaning made explicit. Inside the transformation is whatever the system does in order to maintain the resource and make it meaningful.
Weltanschauung:	The underlying view of the world which makes the system relevant. In this case, this is that the public desires museums as places which permanently hold objects which for a variety of reasons are irreplaceable.

Owners:	Those who have sufficient power over the system to cause it to cease to exist. This is implicit in 'public money' – whoever provides the resources can also withhold them.
Environmental constraints:	What constraints does the system take as given? That the organization is permanent, that objects, as a resource, are essentially non-renewable, that they must be preserved for the future.

The CATWOE process is used not so much to check that all elements are included as to be a tool for thinking about the relevance and completeness of the root definition. Working through it resulted in fairly fundamental adjustments to the root definition; in particular, 'actors' were inserted, and a variety of means of 'transmission' were specified.

> *Root definition for a museum, Version 2*:
> An organization which receives public funding to permanently preserve objects which are irreplaceable and meaningful because of their historic or social significance or aesthetic qualities, in which trained people are employed to build and maintain collections in order to use them to transmit ideas and concepts to the public through display, publishing, lecturing or other means of communication.

Of particular importance is the *Weltanschauung* – the 'world view'. Its significance is underlined by the discussion above of alternative relevant systems. The world view from the demonstration museum is said to be that although objects are irreplaceable it is not important to preserve them permanently. They are to be used to help people experience the past. The world view from the 'classical' museum system is that the collections are to be permanently preserved in some sort of 'original' state. It is obvious that the world view has profound implications for the conservation system, and that differences may account for many of the issues and conflicts identified in the rich picture.

A first version of the root definition was developed in 1988. By 1991 pressures on public organizations to contract out work to the private sector had greatly increased. The root definition was revised to embody the principle that, while it is necessary for trained people to undertake the work, it is not essential to employ them:

> *Root definition of a museum, 'final' version*:
> An organization which receives public funding to permanently preserve objects which are irreplaceable and meaningful because of

their historic or social significance, or aesthetic qualities, in which trained people build and maintain collections in order to use them to transmit ideas and concepts to the public through display, publishing, lecturing or other means of communication.

A conceptual model

A conceptual model shows the activities which would be the logical consequences of picking the chosen relevant system. It is essential to maintain an abstract view, in order eventually to gain a sharp contrast with the real-life system shown in the rich picture. To ensure that the view of the real world maintains its abstraction, we need to draw both on the relevant system and its concept, and on the root definition. What would it be essential to do in order for the relevant system to operate? The relevant system includes two different basic, but interlocking, processes, one concerned with the physical, irreplaceable resource, and the other

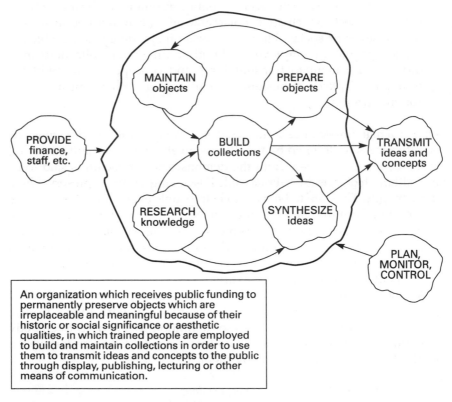

An organization which receives public funding to permanently preserve objects which are irreplaceable and meaningful because of their historic or social significance or aesthetic qualities, in which trained people are employed to build and maintain collections in order to use them to transmit ideas and concepts to the public through display, publishing, lecturing or other means of communication.

Fig. 6.7 *Conceptual model for a museum system. Arrows indicate logical dependencies*

with its meaning: the knowledge and information connected with it. Figure 6.7 is a more formal systems view of the processes which seem to be implied in the root definition.

Since the collections are of original objects, and they are permanent (the resource is non-renewable), it is clearly essential to physically MAINTAIN them. Collections need to be BUILT, in which we can include adding to them, organizing the objects, recording and maintaining associations between objects and information (their meaning), and if necessary refining the collections by means of disposal. If ideas and information are to be transmitted, then obviously there must also be a means to build knowledge: i.e. RESEARCH. The resource and the knowledge of it must be combined in SYNTHESIZING ideas for transmission. The objects will need to be PREPARED both to ensure that their appearance does not distract from the concepts they are meant to 'transmit' (a missing leg does call into question the meaning of a chair) and to guard against damage, but without compromising their originality, since they will in due course be reused to transmit other, different ideas. Since a system must operate in a purposeful way, there must also be the means to PLAN, MONITOR AND CONTROL all these activities.

For the purposes of this study, providing resources such as staff and finance, and producing the means of transmission of ideas, concepts and information to the public are held to be outside the boundaries of the relevant system. They are obviously critically important to the operation of an organization, but they need not be understood in detail here as part of the relevant system itself.

Were we undertaking a full analysis for a museum, the processes inherent in each of these frontline activities would need to be developed and detailed in accordance with the root definition. But the museum analysis is here only the preliminary to analysing the preservation sub-system concerned with preservation.

Real world and system contrast

The comparison stage is the means to the end of the soft analysis process: the identification of 'meaningful, desirable change', carried out jointly with the parties within and in control of the situation. The 'success' of the methodology depends on those involved responding in a rational way to the enlightenment brought by a new view of life. In this, soft analysis is no different from other reviews undertaken by management consultants, except that soft analysis, in common with other socio-technical methods, can explicitly engage the actors themselves in the analysis of their situation.

The process of comparison can be more or less structured, according to the preference of the analyst. It is not proposed to go deeply into the comparison stage. The aim of this study is to uncover what information is needed within the system, not to make it function better; its primary concern is information for the conservation of the collections. We need to focus down on this.

It is likely that the root definition would be broadly acceptable to museum 'actors'. It is not far removed from most definitions of museums. Thus, if the root definition has been reflected accurately in the conceptual system, the conceptual system processes will be a fair basis for contrast with the real world. An examination of each of the processes in the conceptual system is shown in Table 6.1.

A major contrast between the rich picture and the conceptual system is the lack of processes in the former. The conceptual model focuses sharply (as was the intention) on the processes needed in order for the system to operate. The impression that is gained from the rich picture is that the system's purpose is to give meaningful roles to different professionals, who put much energy into defending their positions, power and roles. The processes themselves are hardly visible. Another feature is the conflict of priorities. Discussions of museum organizations by Burrett (1985), Griffin (1988), etc. indicate that this view is not inaccurate. It might be concluded that the main item on an Agenda for Action could usefully

Table 6.1 *Comparison of the real museum world with the processes of the conceptual system*

Process	Exists in real world?
Build collections	Much more emphasis on acquisition than on making collections and information into an integrated working resource
Research knowledge	Some art historical research, but little in museum collection terms
Maintain objects	The physical state of many museum collections shows that this has had a low priority in planning and finance
Prepare objects	This is the top priority for conservation where provision for this exists
Synthesize ideas	This activity has high priority in museums that have any sort of exhibition programme
Plan, monitor, control	In the national museums this is assuming a higher priority – but corporate plans can be window dressing, with little relation to actual plans

be to focus on processes – on what needs to happen – rather than on who does what, and controls whom.

Recent developments

It is crude to categorize all museums like this. In a way, the rich picture shows worst practice. These days, more individual museums have some of these desirable processes in place than was the case then. Few have all of them. The accuracy of the analysis is confirmed yet again in 1992, in the survey of industrial and social history collections in Yorkshire and Humberside (Kenyon, 1992, iv): 'Has the stampede to interpret the past been at the expense of neglecting the collections held for the future ... Does it matter?'. The report goes on to supply an amply fleshed out 'yes'.

In the UK, the large national museums have led the movement of reform (if it can be called that), especially the National Maritime, the Victoria and Albert, and the Science Museums. They are being followed by museums countrywide. This change is due to pressures from government, as the major source of funds, for measurable results, for greater accountability, and also for organizational adaptation to meet new requirements (Burrett, 1985). The new structures that are emerging fit the system depicted in the conceptual model much more closely than did the previous common arrangement, where the organizations and the collections were divided into fiefdoms ruled by 'Keeper Barons'. A common feature is that collections management (which may subsume conservation) is established as a function in its own right. The British Museum, however, is so far maintaining the traditional structure of curatorial departments each headed by a senior keeper, and must be judged successful by any publicly accessible measures of performance (visitor figures, new galleries and exhibitions). Less publicly accessible is its performance in preserving the collections.

It seems, therefore, that the situation shown in the rich picture has become unsustainable in many museums due to changing circumstances in the real world. The new organization arrangements conform much more nearly to the processes shown in the conceptual model.

References

Anderson, R. (1985). The museum curator as an endangered species. In *The management of change in museums. Proceedings of a seminar held at the National Maritime Museum, Greenwich* (N. Cossons, ed.), London: National Maritime Museum.

Beer, S. (1985). *Diagnosing the system for organizations*. Chichester: John Wiley.

Burrett, G. (1985). After Raynor. In *The management of change in museums. Proceedings of a seminar held at the National Maritime Museum, Greenwich* (N. Cossons, ed.), London: National Maritime Museum. 27–9.

Checkland, P. (1981). *Systems thinking, systems practice*. Chichester: John Wiley.

Checkland, P. and Scholes, J. (1990). *Soft systems methodology in action*. Chichester: John Wiley.

Cossons, N., ed. (1985). *The management of change in museums. Proceedings of a seminar held at the National Maritime Museum, Greenwich*. London: National Maritime Museum.

Griffin, D. J. G. (1988). Managing in the museum organization: II. Conflict, tasks, responsibilities. *Int. J. of Museum Management and Curatorship*, 7, 11–23.

International Council of Museums (1990). *Statutes*. Paris: ICOM.

Kenyon, J. (1992). *Collecting for the 21st century. A survey of industrial and social history collections in the museums of Yorkshire and Humberside*. Leeds: Yorkshire and Humberside Museums Service.

Naughton, J. (1983). Soft systems analysis: an introductory guide. In *Course T301, Block 4. Complexity, management and change: applying a systems approach*. Milton Keynes: Open University Press.

Open Systems Group (1972). *Systems behaviour*. London: Paul Chapman in association with the Open University.

7 The preservation system

Analysing the operations of museums generally in systems terms has provided a context for the analysis of conservation itself. Maintenance and preservation lie at the heart of the museum system, and this task is wider than the treatment of objects alone.

As an aid to maintaining an abstract view of a system in which one is oneself an actor, it is helpful to consider other different or comparable systems. Preserving museum collections is close to the concept of terotechnology (Checkland, 1981: 202–6). Terotechnology is defined as:

> a combination of management financial, engineering and other practices applied to physical assets in pursuit of economic life-cycle costs. Its practice is concerned with the specification and design for reliability and maintainability of plant, machinery, equipment, buildings and structures, with their installation, commissioning, maintenance, modification and replacement, and with the feedback of information on design, performance and costs.

Although there are similarities, there are also important differences. Terotechnology is primarily concerned with minimizing the financial costs of not caring properly for assets, whereas in museums it is the preservation *per se* of physical assets, not the control of the costs of maintenance, that is the purpose of the system. Therefore, in museums there is less emphasis on acquiring, and replacement is not, in the pure system, possible, since the particular state of wear and historical associations of the original could never be reproduced. The uniqueness of a museum object derives from its association with information (indeed, its embodiment as information); this is not necessary in terotechnology.

Checkland offers a conceptual model for terotechnology, redrawn in Fig. 7.1.

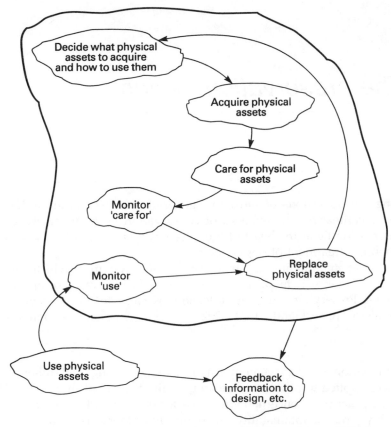

Fig. 7.1 *The conceptual system for terotechnology. Arrows indicate dependencies*

The real world: the rich picture and Analyses 1, 2 and 3

The museum rich picture (Fig. 6.2) depicts the real-world conservation situation, and observations made above in Chapter 6, The problem situation expressed: the rich picture, apply to it. Issues especially relevant to conservation are that the preferred activity of many conservators is actively treating objects, that there is difficulty in deciding priorities between the maintenance of collections and treatment, and between one treatment task and another. The general impression is that conservation is seen as a service to other more important activities, rather than as the central preservation function of museums. There is no logic or control over the flow of work.

The rich picture has been supplemented by undertaking Analyses 1, 2, and 3. These consist of a series of very carefully designed questions.

Debating the answers to these can be as enlightening and interesting as any stage in the soft methodology. The results of the analyses are shown in Exhibit 7A.

Relevant systems

A relevant system for conservation could be directly derived from the conceptual model for a museum. However, a number of relevant systems for conservation can be imagined from the rich picture, and it is preferable not to converge too rapidly on one solution. Issue-based systems would be those to:

- increase awareness among curators (as people holding power within the system) of the requirements for preservation
- make the museum's operations more purposeful
- prioritize conservation activities
- focus on the tasks of preserving the collections rather than on inter-professional issues
- make sure that the care of objects gets enough resources.

It has been decided to focus on task-based systems for the present study. These could be to:

- treat and restore objects
- minimize the number of objects that need to be treated
- set and apply scientific standards for the care of objects
- maintain a non-renewable resource.

From the museum model itself, the relevant system that arises is:

Relevant system 1
A sub-system to permanently maintain an irreplaceable and meaningful physical resource ...

The essence of this system, the transformation, can be expressed in even more abstract terms, shown diagrammatically in Fig. 7.2:

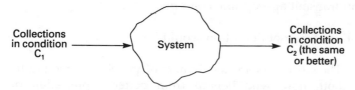

Fig. 7.2 *The central concept or 'transform' in the conservation relevant system*

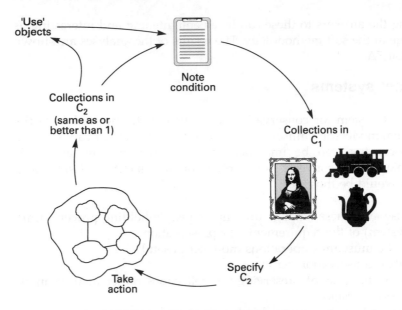

Fig. 7.3 *A concept for a relevant preservation system*

Relevant system 2
To maintain collections or objects so that the resulting condition, C_2, is the same or better than their past condition, C_1.

The essence of these relevant systems can be combined, and this is shown in the concept illustrated in Fig. 7.3.

Root definitions

A first root definition for conservation could be:

A sub-system of a museum in which trained people work to preserve objects which have been collected, remedying damage and removing causes of future deterioration so that the objects when displayed can transmit appropriate concepts.

The CATWOE for this root definition would be:

Customers: The customers are the owners of the objects, the public both now, who benefit from better appreciation of displays, and in the indefinite future.

Actors:	Trained people.
Transform:	Collections (or objects) in one condition, C_1, transformed into collections (or objects) in the same or better condition, C_2 (see Fig. 7.2).
Weltanschauung:	(world view) The same as for museums, i.e. that the public wants museums to permanently maintain collections of real, original objects, and to provide ideas, etc. for their entertainment and education.
Owners:	The museum system itself can cause any preservation sub-system to cease to exist.
Environment:	The collections are preserved in order to serve the purpose of museums, i.e. to transmit ideas, etc. Preservation is not in museums an end in itself, since an institution which merely stores collections is not a museum, although it could certainly employ a conservation department or service. Therefore, it must be clear that the conservation sub-system is part of a wider system.

The museum root definition and the comparison of the conceptual system with the real world (Chapter 6, Real world and system contrast) can be revisited here. The systems of real-world museums do embody the duality of the abstract conceptual system. How can we express the need to preserve the object in its original form while accepting that time and maintenance will alter it? The concept of 'historic integrity' is suggested, because it implies not that an object will undergo no change – this is impossible – but that changes, whether intentional or unintentional, will be accurately recorded and the effects on the object will not be concealed. It also implies the crucial association of object and information.

Root definition for conservation: 'final' version
A sub-system of a museum in which trained people preserve the historical and physical integrity of museum collections for the present and future public, by maintaining objects, preventing deterioration, controlling use, and raising awareness of requirements for preservation. They thus contribute effectively to museum objectives.

The conceptual model

The conceptual model for the system that would carry out the processes implied by the root definition is shown in Fig. 7.4. Figure 7.5 shows the

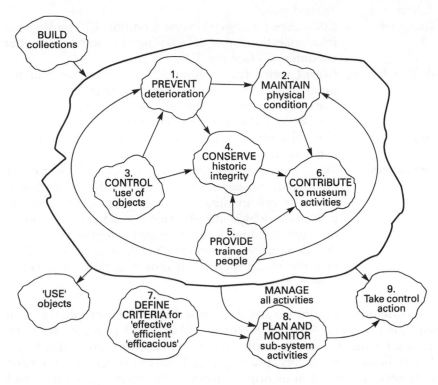

Fig. 7.4 *Conceptual model for the preservation sub-system. Arrows indicate dependencies*

details of the processes. The conceptual model needs to be checked for its viability as a system. This is done against the criteria below.

Systems check:

Sub-systems?	Yes
Connectivity?	Yes – both between sub-systems and with the wider system
Environment?	The wider museum system
System boundary?	These processes form a distinct and related group
Resources?	It is understood that finance and people are available through the wider system
Continuity?	By virtue of the wider system itself

The only source for the processes shown in the conceptual model must be the root definition. Outside the preservation system are processes from

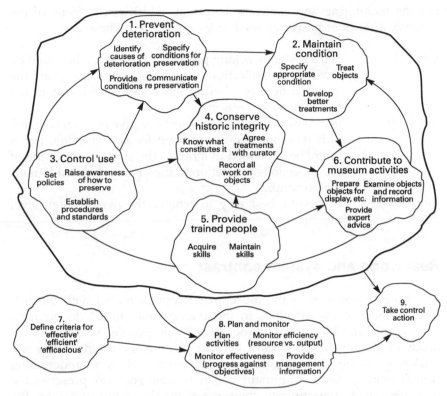

Fig. 7.5 *Detailed conceptual model for preservation*

the main system: the building of the collections and the use of objects. The processes in the conceptual model for preservation are:

PREVENT deterioration by providing suitable conditions, procedures, etc.

MAINTAIN physical condition of collections, by rectifying deterioration and removing its causes

CONSERVE historic integrity of collections, i.e. the object-as-evidence

CONTROL use: set policies for use, demonstration, display, etc. and raise awareness of what contributes to preservation

CONTRIBUTE to museum activities such as exhibition, publication, information, etc.

PROVIDE trained people – by hiring qualified people, and by maintaining their skills and knowledge

MANAGE all activities: define criteria for effective operation, plan and monitor, take control action.

For the monitoring and control sub-system, which is the focus of the exercise, a series of measures need to be established. These are:

Efficacy: Is the system working properly? This would be tested by monitoring collections condition over time, as the question here is whether the system can maintain the condition of collections.

Efficiency: Is the system making the most effective use of resources? This measure is quite difficult for conservation, but it might be expressed in terms of the size and condition of the collections in relation to the money devoted to their maintenance.

Efficaciousness: Is this the best way to achieve the overall, high level objective?

Real world and system contrast

As in the comparison of the museum conceptual model with the rich picture, most of the activities in the preservation model do occur in the rich picture, but not as a coordinated, purposeful system. Again, much of the mismatch occurs because the actors in the scene are unclear as to their role. Rather than seeing themselves as undertaking complementary tasks in pursuit of an overall goal (to preserve the collections and communicate their meaning) the actors focus on the internal politics of who has the first call on resources, and who has the power to set priorities and decide what happens to objects. Rather than a preservation operation or task, there is a conservator with a procession of people bringing work. The accuracy of the rich picture was discussed above, in Chapter 6, Conclusions.

The purpose of this analysis is to arrive at information needs. But the opportunity can also be taken to analyse the organizational system itself, at this general level. In Table 7.1 the detailed conceptual model, Fig. 7.5, is compared with the real world.

From analysis into information

Soft systems conceptual models can be used in different ways to define information systems. They can be the basis for a data flow diagram, an information systems analysis tool (Avison and Wood-Harper, 1990). Data flow diagrams describe diagrammatically the origination, flow, use and storage of data. Avison and Wood-Harper discuss the use of soft systems analysis in this way in some detail. Another way of using a conceptual

Table 7.1 *Comparison of preservation in the real museum world with the processes of the conceptual preservation system (see Fig. 7.5)*

Process	Exists in real world?
1. Prevent deterioration	This includes pest control, display design, appropriate storage conditions. Seldom thoroughly done, due to lack of awareness as identified above
2. Maintain physical condition of objects	Usually top of the list of preservation processes, this is well established in most museums, either as an in-house activity or by contracts with private conservators or other organizations. 'Maintenance' includes removing causes of deterioration such as acidity in paper, rectifying damage, and monitoring condition. Surveying collections condition has been considered important for some time. General method developed as part of this research (see Chapter 5)
3. Control 'use'	Best developed in the form of conditions for loans. Includes proper procedures for handling, transport, etc. 'Awareness of conservation needs by curators . . .' was third priority for conservators in 1987 Survey (Corfield *et al.*, 1989). Still hard for preservation to be taken seriously in many museums
4. Conserve historic integrity of objects	Trained conservators are mostly very aware of the need to avoid making an object 'like new', and to record what is done to it. Where the ethic is to demonstrate objects' function this may not be considered so important
5. Provide trained people	As examples of a craftsmanship approach to object maintenance show, specialist training is necessary if the causes of deterioration are to be understood and eliminated, rather than the object simply being restored to 'a supposed earlier state'
6. Contribute to other museum activities	Much of the work conservation is undertaken specifically for other museum activities, particularly exhibition. Also, observations during conservation or through examination contribute to the information about objects
7, 8, 9. Manage sub-system activities	The tendency is towards planning preservation of collections as a continuum from storage through to remedial conservation: cf. increasing numbers of 'collections management' posts

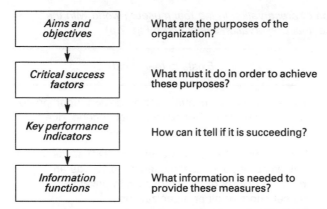

Aims and objectives	What are the purposes of the organization?
↓	
Critical success factors	What must it do in order to achieve these purposes?
↓	
Key performance indicators	How can it tell if it is succeeding?
↓	
Information functions	What information is needed to provide these measures?

Fig. 7.6 *The 'business analysis' process described by Rockart*

model is as the basis for the series of questions set out in Fig. 7.6. The concepts of objective setting, critical success factors and performance indicators are all widely used in management today. This analytical technique is essentially that described by Rockart (1979: 84) as the 'total study process' (first developed, he says, by IBM as its Business Systems Planning methodology) with his 'critical success factor' method added to it. Rockart's article is widely referenced, and the success factor concept has been developed by, for example, Ohmae (1982, Ch. 3), a well-known writer on management matters as seen from the Japanese perspective. This series of analytical steps is used by the large software systems company Oracle, who call it a 'business analysis'.

The essential processes of the conceptual system can naturally be expressed as objectives. These are discussed below.

1 *To prevent deterioration, by ensuring that the environmental, physical and other conditions in which objects and collections are kept are appropriate to their preservation*
Preventing deterioration is much more efficient and effective than rectifying the consequent damage.

2 *To maintain and improve the physical condition of the collections so that standards set by the museum for their condition are met*
It may not be an effective use of resources to maintain every item in the collections in top exhibitable condition; sometimes untreated objects may constitute a better source of evidence than treated ones. It will usually be better to set a basic standard for condition below which no object should fall.

3 *To control use: handling, exposure to light, demonstration, etc.*
Museum objects are there to be used in display, etc., but this nearly

always accelerates the processes of deterioration. Policies need to be set on procedures for and the extent of use. Policies will only be effective, however, if people subscribe to the need for them, so raising awareness is integral to controlling use.

4 *To conserve the historical integrity of objects in the collections*
Unless the objects are the 'real thing' they are not properly meaningful; they cannot play their proper part in transmitting ideas, etc. An objective needs to be set to specify the kind and degree of restoration, for example, separately from maintaining physical condition.

5 *To provide trained people*
All these activities require knowledge to graduate level or better, and some of them require high manual skills as well. Knowledge and skills need to be constantly updated.

6 *To contribute effectively to museum activities*
As well as the major museum objective, to preserve collections, the preservation sub-system can contribute to: preparing objects for display, etc., recording and passing on observations about technique, composition, etc., and providing expert advice on policies, authenticity, and the use of objects.

7, 8, 9 *To manage all activities effectively and efficiently, and to make sure that they are the most efficacious way to attain objectives*
Managing these activities implies developing a strategic view, planning activities, monitoring them, and taking control action where necessary. This needs to be applied to each of the objectives.

The results of using the preservation conceptual model (see Fig. 7.5) as the basis for understanding information requirements are shown in Tables 7.2 and 7.3. In the soft analysis, we already considered what processes would be essential to the operation of the conceptual system as implied by the root definition. Table 7.3 summarizes the full analytical process from objective to success factor to performance indicator to information function. Objectives have been derived from the main processes of the conceptual system: clearly, the detailed processes are what must be done to meet them. From these can be derived the measures, the key performance indicators in business analysis terms, which will show whether or not the organization is succeeding in meeting its objectives.

Since this book is concerned with information for managing, only the information functions mostly concerned with this need be considered in depth. These are:

F1 Set standards for and monitor the condition of objects and collections: discussed in Chapter 9, Collections condition.

Table 7.2 *The processes and sub-processes in the conceptual model for preservation (see Fig. 7.5)*

Main process	Sub-processes
1. Prevent deterioration	Identify causes of deterioration Specify conditions for preservation Provide preservation conditions
2. Maintain physical condition	Specify appropriate condition for objects and collections Monitor condition Treat objects to remove causes of or rectify deterioration Develop improved treatments
3. Control 'use'	Set policies Establish procedures and adopt standards Know requirements for preservation Communicate requirements
4. Conserve historic integrity	Know what constitutes historic integrity for object Agree treatments with curators Record all work on objects
5. Provide trained people	Acquire skills through hiring policy, courses, etc. Maintain skills through reading, refresher courses, conferences
6. Contribute to museum activities	Prepare objects to 'transmit ideas and concepts' Examine objects and record observations Provide expert advice
7, 8, 9 Manage sub-system activities	Define criteria for 'efficient', 'effective', 'efficacious' Plan activities Monitor efficiency (resources vs. output) Monitor effectiveness (progress against objectives) Provide management information Take control action Review 'efficaciousness': is this the best way to meet the overall objective?

F2 Set standards for, monitor and record the storage and display environment: discussed in Chapter 8, Standards and prevention.

F5 Plan, schedule, monitor work: discussed in Chapter 11, Planning and monitoring work.

F6 Manage resources: time, money, space: discussed in Chapters 10, Directions and strategies; 11, Planning and monitoring work; and 13, Future, present, past.

Table 7.3 *Management preservation for information*

Objective	Critical success factor: What must we do?	Performance indicators: Measurement of success	First level information functions
Maintain physical condition	Specify appropriate condition Monitor condition Treat objects needing it Develop improved treatments	Specifications recorded Current vs. past condition Priority objects treated Treatments developed ~	F1 Set standard for and monitor the condition of objects and collections
Preserve historic integrity	Know what constitutes historic integrity for object Agree treatments with curators Record all work on objects Monitor presentation of historic integrity	– Agreed treatments recorded Record for every treatment Curatorial and colleagues views ~	F2 Set standards for, monitor and record the storage and display environment
Ensure preservation conditions	Identify causes of deterioration Specify requirements Provide preservation conditions Monitor preservation measures	– Specifications for all spaces containing objects Conditions: rh, etc. meet standards Deterioration of objects	F3 Examine objects, record and communicate results
Control 'use'	Set policies Establish procedures and standards Raise awareness Monitor compliance	Policies adhered to Procedures and standards adhered to	F4 Record diagnoses and agreement on treatment: record treatment
Contribute to museum activities	Prepare objects Record observations Provide expert advice	All objects to be used prepared? Every observation recorded Advice timely, accurate ~	F5 Plan, schedule, monitor work
Manage sub-system activities	Set criteria for 'efficient' Monitor input and output Review, take control action Define objectives (effectiveness) Plan tasks, monitor progress Review, take control action	Criteria defined Plan exists – Use of time Use of budget All indicators –	F6 Manage resources: time, money [space] F7 Acquire and use expertise
Ensure 'trained people'	Acquire skills Maintain skills Monitor skills	All people qualified Articles read, training attended Published articles, lectures	F8 Provide management information on whether objectives are being met

F8 Provide management information on whether objectives are being met: discussed in Chapters 10, Directions and strategies; 11, Planning and monitoring work; and 13, Future, present, past.

Information functions 3 and 4 are to do with adding to the richness of information about objects; function 7 concerns acquiring and using expertise. These information functions will be discussed in Chapter 11, in the context of designing a computerized information system.

Conclusions

Over the last five years or so the perspective on conservation in museums has changed. From being thought of as work done in laboratories by conservators to a series of individual objects, there is now a clear perception that preserving collections is an holistic activity which must be

the concern of everyone in museums. Looking at the information needed to manage this function from its previous narrow definition would not have got us very far. Checkland and Holwell (1993) have reviewed the use of the soft systems enquiry process in developing information strategy. They see it as contributing to the conceptualization not just of the information an organization requires, but to 'coherent thinking about purposes, organization and information support'. This conceptualization is 'crucial if a satisfactory combination of organizational purposes, activity, structure and information support is to be achieved ... it is the domain which is usually missing from the [information systems] strategy literature.' Indeed so!

References

Avison, D. E. and Wood-Harper, A. T. (1990). *Multiview.* Oxford: Blackwell.

Checkland, P. (1981). *Systems thinking, systems practice.* Chichester: John Wiley.

Corfield, M., Keene, S. *et al.*, eds (1989). *The survey.* London: UKIC.

Checkland, P. and Holwell, S. (1993). Information management and organisational processes: an approach through soft systems methodology. *Journal of Information Systems*, (3), 1–15.

Ohmae, K. (1982). *The mind of the strategist.* Harmondsworth: Penguin Books.

Rockart, J. F. (1979). Chief executives define their own information needs. *Harvard Business Review*, **57**(2 March/April), 81–93

Exhibit 7A: Soft systems analyses 1, 2, and 3

ANALYSIS 1: The intervention

Problem situation	To understand the organizational nature of the preservation of museum collections, in order to understand what information is needed to manage them
Clients	The readers of this book
Clients' aspirations	To obtain a better mental model of preservation in museums so as to understand what information we need to manage it
Problem solvers	The author (readers can also try the method!)
Resources available	Own understanding and experience; feedback from seminars, etc.
Constraints	Cannot involve the clients in the analysis
Problem owners: who feels we should address this?	Conservation managers; museum managers
Implications of selected problem owner	Conservators concerned mainly with practical treatment may not find the analysis very relevant
Reason for regarding the problem as a problem	Professional relationships tend to cloud issues; holistic view of 'preservation' is very recent development
Value to the problem owner	Will enable more proactive approach to work; will enable greater influence over priorities, etc.
Problem context: how will we know when the problem is solved?	When conservation and museum managers feel confident that they have a full and accurate picture of the preservation of their collections, and of plans for maintaining and improving this.

ANALYSIS 2: The social context

Roles, norms, values in the context of the problem situation

Roles: what roles are played by those concerned with preserving collections?	Curators: 'curator-as-king', but evolving into 'responsible for the intellectual aspect of collections' Conservators: 'technicians who maintain or restore the collections', but evolving into 'responsible for the maintenance of the physical aspect of the collections' Museum directors, managers: 'super-curator', but evolving into 'responsible for each of the several different objectives of the museum'
Norms: what does the organization expect?	'Get on with the job and don't think too much' but evolving into 'meet targets for all objectives and prove this; provide value for money'
Values	'Guardian of historical memory banks', but evolving into 'encourage access to and use of historical memory banks'.

ANALYSIS 3: Power

In relation to the problem situation:

Disposition of power concerning the collections	Historically with curator as surrogate owner, but moving towards those who act as collections managers
Nature of power concerning the collections	Staff and finance for doing work on them (which determines whether work is on exhibitions + interpretation or on preservation); Control over the size of the collection and hence the size of the preservation task Control over what conservation treatment is used; Physical access to places where objects are kept

Processes by which power over the collections is:

Obtained	Through control over line management structure and distribution of resources
Exercised	Through procedures for dealing with collections and line management control
Preserved	By defining intellectual work as superior to technical and physical work
Passed on	By appointments to museum director and other senior posts.

8 Information for preservation

To establish the conditions for preservation is one of the nine basic processes of the preservation system (see Fig. 7.5). Preservation – preventive conservation – is not easy. Like rigorous total quality management, preservation will affect procedures and work practice in practically every museum operation. It includes raising awareness of what can be done to avoid damage to objects. Many necessary measures are negative ones – 'thou shalt not' – and attempting to implement them unfortunately gives conservators a reputation for being negative spoil-sports.

Conservators are often urged to compromise. This notion could do with some examination. Compromise in these terms can be taken to mean giving permission for objects to be displayed or housed in conditions that are less than optimal. This is not the conservator's role. The conservator's role is to be a source of expert knowledge of the effects on objects of various physical and climatic factors, and of how these factors can be modified, and to give their opinion and advice accordingly. This advice may be taken or not taken; but the conservator cannot say that in their opinion a watercolour will not fade if displayed at 2000 lux if it is their opinion that it will fade. As a designer once remarked to me, dealing with conservation requirements is no better and no worse than dealing with building or fire regulations. They exist for the wider benefit and have to be worked with, if the organization so decides.

Where the notion of compromise enters is in accepting that the risk from imperfect conditions over a finite period may be minimal. Risks from environmental factors may in fact be less serious than we previously thought. Innovative ways are being found to address requirements. The watercolour could be exhibited at 2000 lux for ten days and still be within Thomson's standards if it was stored for the rest of the year. In fact, the conservator cannot say that the watercolour will not fade if it is displayed at 50 lux, the accepted limit for sensitive material. 50 lux was chosen as the light limit for sensitive materials not because it does no damage, but because that is the lowest light level at which people can effectively perceive colour. Recent studies have indicated that people aged over fifty need higher light levels, and so the standard should be adjusted to take

account of that. Conservators' efforts might be better spent ensuring that security lighting was minimal out of visiting hours – something that nobody could disagree with.

If they are to be expert advisers, then there is a strong obligation on conservators to be genuinely expert. One of the first duties of the preservation conservator is to keep up with the latest thinking on the effects of climatic factors. These are likely to become less significant, not more, as real life effects are assessed. Recent work by Michalski and by Mecklenberg is establishing this new view (Michalski, 1990; Mecklenberg and Tumosa, 1991a,b; Michalski, 1993). As Christoffersen (1993) observes, there is now 'no overwhelming evidence that a perfectly steady climate is necessary for the stability of ... objects'.

Conservators are highly knowledgeable and intelligent, and they come from a wide variety of technical backgrounds. Because the profession is not very large, they are also very good at networking on an international scale, and do not suffer from information overload to the degree that is experienced elsewhere. This means that in conservation there really is a great deal of real understanding of the effects of environmental factors on objects, of how these factors can be controlled, and of highly innovative ways in which this can be done; more than is found in most heating and ventilating engineering companies. The trouble is that conservators lack credibility with these other professionals, because they do not hold their recognized qualifications, and because contractors can be sued (though in my experience this is rare) if what they install fails to provide the specified conditions. An excellent example of this situation, and of what can be achieved by applying understanding and imagination, is set out by Cassar and Clarke in their work on environmental control for the Courtauld Gallery in Somerset House (Cassar and Clarke, 1993).

Standards and policies

Standards for the museum environment should, ideally, express the results of expert work and knowledge in a form that can be easily communicated and the application of which can be monitored. Outside standards for museum operations can be used as a valuable counterweight to the drive for accountability based on finance and public activities alone. Conservators should seize on standards; they are an official validation of professional knowledge and opinion. The relevance of standards to museums generally is discussed by Caton (1991), and specifically to conservation by Cassar and Keene (1990). Fortunately, there are many recognized standards and guidelines for the conservation of collections. Standards may exist, however, but the organization needs

to express its organizational will to apply them by specifically adopting as policy those it considers most relevant.

Standards and specifications for the environment for collections are thoroughly dealt with by Thomson (1986), and in the extensive literature (see Section B1 in the Art and Archaeology Technical Abstracts). These now include the curatorial standards and museums registration schemes being developed by the Museums and Galleries Commission (1988; Paine, 1992a,b, 1993, 1994) for different types of collection. They are discussed in Cassar and Keene (1990).

Standards do have to be used with circumspection. While many authors advocate the use of fixed standards, another view, put forward by Michalski (1990), is that standards are too rigid and encourage institutions to disregard the undeniable fact that some objects will deteriorate even though standards are adhered to. For example, he says, in the case of maximum light (lux) limits, standards for maximum exposure may be too high for some objects, and needlessly low for others. Michalski is extending his critical appraisal of standards into those for relative humidity and temperature.

The concepts embodied in these approaches differ more than do their use in the management of deterioration. In both, it will be necessary for the institution to set *policies* for the environment for its *objects*, and apply these to the *spaces* in which they are kept by means of *specifications*. If standards are to be used, then the particular ones to be adhered to will need to be stated: for instance, BS 5454 for paper and archive collections; Thomson (1986: 33) Class I for sensitive objects. If standards are not to be used, then the policy must specify the procedure for setting parameters for the storage or display environment for each class of object or individual object. But either way, parameters still have to be set, and a formal record of them maintained.

While standards are commonly set for temperature, humidity and light, parameters for gaseous and particulate pollution are less often specified, because they are much more difficult to measure and expensive to control. While Thomson does give parameters for these factors, they are not included in, for example, BS 5454: 1989 (British Standards Institution 1989), the British Standard specification for library buildings, other than for mechanical air handling; or in the Museums and Galleries Commission *Standards in the museum care of ... collections* (Paine, 1992a,b, 1993, 1994) other than for particulates such as dirt and dust.

Special reports

From time to time, it will be useful to take an overview of preservation in the museum. This will entail special investigations, to draw together the

results of ongoing monitoring, and to assess factors such as storage quality that it is not useful to monitor continuously. Investigations like this will form the basis for strategies for preservation. Examples are assessments of the standard of stores, and audits of collections condition. Information for conservation strategies and planning will need to be collected to answer the questions:

- What is the size of the tasks we will be addressing?
- What are we aiming to achieve?
- What do we need to do to achieve it?
- How should we plan to do it?

Judgements and assessments of quality

To a conservator, environmental monitoring usually means logging temperature, humidity and light; but many of the most drastic effects on the well-being of objects are brought about by aspects of the environment that can only be assessed by making a visual judgement. Examples are the adequacy of space in stores, whether buildings are sound or have leaks, whether conditions are clean or filthy dirty, whether objects are adequately enclosed or supported, and whether organizational procedures are satisfactory, such as those for putting objects away after use. The Museums and Galleries Commission's *Standards in the care of ... collections* (for instance, Paine, 1994) set out desirable standards for these aspects. They are further discussed below, under Stores assessments.

Like numerical information, this more qualitative information should be collected at regular intervals. In order to set targets for improvement, and measure progress, these non-numerical assessments need to be categorized in some way.

Stores assessments

Appropriate storage is the foundation for effectively preserving collections. There are several models for stores assessments. In the USA, the Department of the Interior is responsible for archaeological collections and archives held by the National Parks Service. *Special Directive 80–1*, issued in 1986, requires any National Parks site having collections to assess the standard of storage annually, to declare what improvements are necessary, and to report action since the report the previous year. Also in the USA, the Getty Conservation Institute (GCI) and National Institute for Conservation (NIC) have jointly developed a procedure and published guidelines for 'conservation assessment' (Getty Conservation Institute and National Institute for the Conservation of

Cultural Property, 1991). This is an explanatory checklist, which takes a holistic view of the care of collections. It is meant to be used by independent consultants, from another institution or working privately, who are commissioned by a museum to visit it and report on the care of its collections. The report then forms the basis for action and for seeking grants.

Other more general views of the care and management of collections, again in the USA, are gained through the Museum Assessment Program (MAP). This is run by the Association of American Museums (Association of American Museums, 1985), and encourages assessment and improvement among museums in a similar way to that described for the Conservation Assessments. In the UK, we have the *Standards in the museum care of . . . collections* which are being issued by the Museums and Galleries Commission (e.g. Paine, 1994). These standards do not include assessment checklists, but they do provide detailed guidelines on how collections should be cared for.

Case study: stores assessments

The Conservation Department in the Historic City Museum was becoming much more outgoing, and as they all made more visits to the stores, the conservators became very aware of what a tiny proportion of objects in the collection they were able to treat. Each conservator was familiar with some stores, those that housed their particular type of collection, but few of them had even visited all of the stores. They knew that, as in many museums, while storage for some collections was exemplary, storage for others verged on disastrous.

Storage improvements were in the air, because the museum was in the early stages of specifying a large new off-site store, which would take the contents of many of the existing stores. The Conservation Department had been encouraged by the senior management team to develop a strategy for collections preservation (see Chapters 9 and 10). They decided that as part of this strategy development all the museum's stores should be surveyed, necessary actions identified, and the results summarized and included in the strategy as recommendations to the museum's senior management.

The conservators debated how to collect and analyse the information. The museum had many different stores – altogether about thirty separate spaces. From attending conferences and visiting museums abroad, the conservators were familiar with developments in America, in particular, the Conservation Assessment and Museum Assessment Program, and the National Parks Service Special Directive (Getty Conservation Institute and National Institute for the Conservation of Cultural Property, 1991; US Department of the Interior, 1986). They

STORES ASSESSMENT FORM

Museum: Store name/i.d.:

Floor area, m²: Location: Collections type/names:

Usable volume, m³: Fullness (%): 0 25 50 75 85 95 100 Over 100%

Most urgent action?:

Building type Overall rating for collec. type:	Good	Adeq	Poor	Unac.
Purpose store				
"Office" type				
Light industrial building				
Open air				
Airtightness				
Thermal mass or insulation				
Action needed?:				

Maintenance Overall rating for collec. type:	Good	Adeq	Poor	Unac.
Structural condition				
- walls, plaster, etc				
- roof				
- drains, gutters				
Decoration				
Preventive maintenance schedule				
Services				
Energy efficiency				
Action needed?:				

Action summary:

1.

2.

3.

4.

Storage equip't Overall rating for collec. type:	Good	Adeq	Poor	Unac.
Racks				
Containers				
Sufficiency of space for objects				
Access for moving, inspection, etc.				
Small overspill to floor				
Access adequate				
Moving equipment				
Action needed?:				

Environm. control Overall rating for coll. type:	Good	Adeq	Poor	Unac.
Temperature control				
Humidity control				
Dust pollution control				
Gaseous pollution control				
Monitoring				
Light control				
(Air conditioning - Y / N)				
(Local heat, humidity control - Y / N)				
Action needed?:				

Object protection Overall rating for collec. type:	Good	Adeq	Poor	Unac.
Containers				
Acid free or suitable mounts				
Objects supported by packing, etc.				
Dust or dirt contamination				
Pests or bird ingress				
Action needed?:				

Fig. 8.1 Stores assessment form. Although detailed and comprehensive, this can rapidly be filled in. Actions are to be noted at all points

also consulted the recent survey of science and industry collections in Yorkshire and Humberside (Kenyon, 1992), which had assembled this sort of information.

The Head of Conservation would be the person to draw together the results and draft the report, so she strongly favoured a uniform format for assessing the stores, with minimal text. The American formats, although recording much useful information, seemed rather wordy. However, a very useful feature of the National Parks Service Special Directive was that major deficiencies of stores had to be declared, and progress on rectifying them reported each year. The Yorkshire and Humberside survey was the result of a consensus of many people in the surveyed museums; it offered a format that was quick to complete and analyse, but it omitted information about the store building itself, which is an extremely important factor. Therefore, a new Stores Assessment Form was devised that combined, the conservators hoped, the best features of the existing variants (Fig. 8.1). To give the survey the maximum authority, the assessment elements were checked against the Museums and Galleries Commission's *Standards in the museum care of . . . collections* (e.g. Paine, 1994).

Assessing the stores using these new forms was a rapid exercise. After some experimentation, the Head of Conservation decided to supplement the written report with graphic summaries, as in Fig. 8.2.

The Head of Conservation felt that there was an opportunity here to encourage cohesion within the department as well as to broaden people's perspectives. A seminar was therefore arranged for the whole department, in which each section in turn presented their results and findings. This proved to be an excellent experience for some, but was perhaps more appreciated by the heads of section than by everyone. There proved to be an immense amount of material to digest – too much for a consensus view to form – and some conservators felt that it had resulted in little progress. However, with the results from the completed forms fortified by the many suggestions and observations that had arisen in discussion, the Head of Conservation was able to go away and write what she felt was a coherent and realistic strategy, one that it would be difficult for the museum to reject (see Chapter 10, Exhibit 10C). The conservators as a whole were now the best informed group in the museum on the general state of the collections, as was proper to their role.

Collections condition audits

A third area which may be the subject of special investigations and reports is the condition of the collections: how successful is the museum in discharging its duty to preserve them? This is dealt with in detail in the next chapter, Chapter 9.

Stores assessment data

Store name	Area m2	Volume m3	% Full	Collectn. type(s)	Building type	Maint-enance	Environ control	Storage equipm't	Object protect'n	Action needed
Anvil La yard	710	3,900		Large objs	G	G	A	A		Open air: unsatisfactory
Anvil La. 1.1	460	2,300		Large objs	G	G	A	G		
Anvil La. 2	47	150		Vehicles etc	A	A	A	A	A	Works need completion
Anvil La.1.2	39	105		Smll. objs	A	G	A	A		
Anvil La.1.3	18	49		Misc objs	A	G	A	G	G	Objects for disposal?
Anvil La.1.4	41	110		Models	A	G	G	G		Some objs to be boxed
Anvil La.1.5	115	300		Paper	A	G	G	G	G	-
Archive sort				Vehics	A	A	A	A	A	Open air: unsatisfactory
Brossay	223	583		Paper	A	G	G	G		Monitor
Drawing store	21	48		Films	A	A	A	A	A	Temp. store; upgrade/relocate
Film store	57	171		Library	A	A	A	A	A	Environm. control
Lib. plant rm	123	492		Library	A	G	A	A		Better containers
Library st	60	150		Photos	A	G	G	A	A	Better containers
Neg store 2	168	424		Paper	A	A	A	A		Unsuitable store
New Rd. 1	120	240		Misc objs	A	A	A	A	A	Risk of leak/flood
New Rd. 2	48	112		Misc objs	A	G	G	G	A	Sort + stock check
New Rd. 3	58	151		Library	A	A	A	A		Undertake maintenance
New Rd. 4	88	229		Paper	A	A	A	A		Improve housekeeping
New Rd. 5	105	410		Misc objs	A	G	A	G	G	Sep. office from store
New Rd. 7	36	140		Textiles	A	A	A	G	G	-
New Rd. 9	65	163		Photos	G	G	G	G	G	Monitor; improve containers
Photo negs.	91	228		Paper	A	A	A	A	G	Roof repairs
Pict/print	500	2,000		Rail equip	A	A	A	A		Open air: unsatisfactory
Stitch row	1,600	1,600		Veh equip	A	A	A	A		Open air: unsatisfactory
Totals:	**4,793**	**14,055**								

Data sorted by object size

Store name	Obj size	Collectn. type(s)	Building type	Maint-enance	Environ control	Storage equipm't	Object protect'n	
New Rd. 9	S	Textiles	F	E	E	F	E	E
Anvil La.1.5	S	Models	F	E	E	E	E	F
Anvil La.1.3	S	Smll. obj	F	E	E	F	E	F
New Rd. 7	M	Misc objs	F	E	E	F	E	E
New Rd. 3	M	Misc objs	F	E	E	E	E	F
New Rd. 2	M	Misc objs	F	F	E	E	E	F
Anvil La.1.4	M	Misc objs	F	E	E	F	E	E
Anvil La.1.2	M	Misc objs	E	E	E	E	E	F
Photo negs.	P	Photos	E	E	E	E	E	E
Archive sort	P	Paper	F	E	F	E	E	F
Drawing store	P	Paper	F	E	E	F	E	F
Pict/print	P	Paper	F	F	E	F	F	F
Library st	P	Library	F	E	E	E	E	F
Film store	P	Films	F	E	F	F	F	F
New Rd. 1	P	Paper	F	F	E	F	F	F
Neg store 2	P	Photos	F	E	F	F	F	F
New Rd. 4	P	Library	F	F	E	F	F	F
Lib. plant rm	P	Library	F	E	F	F	F	F
New Rd. 6	P	Paper	F	F	F	F	F	F
West Yard	L	Veh equip	F					E
East Yard	L	Vehics	F					E
Stitch row	L	Rail equip	F					E
Brossay	L	Vehics	E					F
Anvil La. 2	L	ehicles etc	F					E
Anvil La. 1.1	L	Large objs	E	E				E
Anvil La yard	L	Large objs	F					E

Storage good to adequate

Storage poor or unacceptable

Shaded areas designate poor or unacceptable standards of storage.

54% of stores are good to adequate, including all newly established ones. These stores are occupied mainly by medium to small objects.

46% of stores are in some aspects poor or unacceptable. These stores are occupied mainly by large objects and by paper, library and film

STORAGE QUALITY:
E Excellent
F Fair
◻ Poor
◻ Unacceptable

Fig. 8.2 Diagrams summarizing the results of stores assessments. This proved to be an excellent way of communicating with senior management

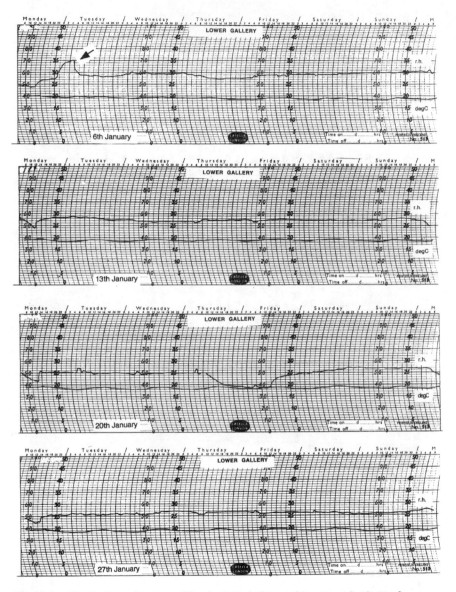

Fig. 8.3 *Recordings from weekly clockwork thermohygrograph charts for a gallery during January. The arrow indicates a distinctive peak in relative humidity, due to temporary failure of the chiller unit*

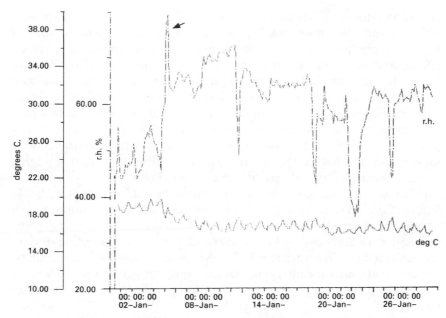

Fig. 8.4 *Chart from digital recordings using a Squirrel electronic data logger. The arrow indicates the same peak as in Fig. 8.3*

Environmental monitoring

Temperature and humidity were found in *The Survey* (Corfield *et al.*, 1989) to be recorded in about half of all the museums and galleries which responded. In the present most common method of data collection – the clockwork thermohygrograph – one instrument must be left in each location being recorded; and each instrument produces one paper chart per week, fortnight, or month, depending on the interval selected (Fig. 8.3). Instruments and systems that record digital measurements on electronic media are being used much more commonly (e.g. the Squirrel data loggers made by Grant Instruments, the Findlay Irvine monitoring system, the MEACO Museum Monitor, and a variety of building management systems). Some options are discussed in Saunders (1989). Figure 8.4 shows an example of a chart produced from a Squirrel data logger.

Light is usually monitored by single measurements taken with an electronic lux meter, rather than continuously. Standards are expressed in terms of a maximum level of lux or ultraviolet light, so this is often sufficient. Continuous recording is necessary if the object is lit by natural light, since the levels of this will vary and a single reading will not suffice (e.g. Staniforth, 1990). Continuous readings also make the

alternative form of standard, for kilolux-hours per year (Thomson, 1986: 30 and 268), more feasible to administer. Other simple ways of logging cumulative light exposure are described by Tennant *et al.* (1982), and Kenjo (1986). Instruments are becoming available to continuously or cumulatively log light exposure (e.g. the Elsec and Hanwell instruments, manufactured respectively by Littlemore Scientific Engineering Co. and Exeter Environmental Services). Cumulative light exposure can also be monitored by the Blue Wool Standard test (BS 1006: 1978), in which pieces of textile dyed with colourants with known fading characteristics are exposed. These can give a highly graphic picture of the effects of light on an object.

Pollution, whether gaseous or particulate, is seldom measured; *The Survey* (Corfield *et al.*, 1989: 81, Q. 5.1) recorded only fifteen museums out of 938 as doing this. Some simple test strips for measuring some pollutants are described in Kenjo (1986). Other passive sampling devices are described by Grzywacz (1993). The Museum of London has employed passive monitoring for nitrogen dioxide using diffusion tubes. The tubes are sent to a laboratory for analysis. Hackney (1984) has reviewed other methods of monitoring gaseous pollution.

Pests. An excellent example of pest monitoring and its use is given in Florian (1987). The variables recorded included those for time, geographical location and insect species. All were used to diagnose the problem, eradicate active infestations, set up new procedures for prevention, and design ongoing monitoring.

Presenting and using environmental data

Analysis over time

Temperature and humidity may be recorded either in analogue form by a recording pen on a paper chart (Fig. 8.3), or else as digital measurements taken at set intervals (printed out as a chart, Fig. 8.4). In the case of analogue thermohygrograph records, each chart contains a wealth of data (and one can quickly accumulate a filing cabinet full), but it is extremely difficult to make much general sense of this. In management terms, we need answers to questions such as:

- For what proportion of the time is the environment within/outside the set parameters? (this monitors whether set standards are being attained.)
- What is the variation per hour/day/week/year? (fluctuations are sometimes more damaging than even sustained levels at an inappropriate relative humidity or temperature.)

● Is there a diurnal or other regular pattern to variations? (If so, there may be a cause that can easily be corrected.)

The first and second questions can potentially be answered if measurements are recorded digitally instead of graphically, since computer software is supplied with the instrument with which to analyse the data. The software that is supplied by the digital instrument manufacturers facilitates graphic presentation (e.g. Squirrel-soft, supplied by Grant Instruments), and will give some statistical information. None of the software supplied with data loggers fully meets requirements as yet, although it is improving. To really undertake the necessary statistical analysis, the data needs to be downloaded into a spreadsheet and manipulated as an entirely separate operation.

Although records from clockwork thermohygrographs are very difficult to use to gain an overall picture over any length of time, they do have particular advantages, because the readings are continuous (i.e. analogue) rather than being taken at a series of fixed intervals as are those from electronic data loggers. For example, the clockwork thermohygrograph chart in Fig. 8.3 shows a record of a period in a gallery. The distinctively shaped peak (indicated by an arrow) to 70 per cent relative humidity at the beginning of the week '7th January' indicates a failure or cut-out of the heating and ventilating system chiller unit, but this could not be deduced from the data logger chart, Fig. 8.4 which simply shows a peak at that point (again indicated by an arrow). This illustrates a loss of information, because the readings on the thermohygrograph chart are continuous, whereas the data logger was recording at set intervals of half an hour. Although electronic data loggers can potentially save a lot of time, analogue instruments may still have their place, because of the richness of the information they offer to an experienced interpreter.

Thermohygrograph charts can be drawn on in various simple ways to give approximate answers:

Proportion of time within set parameters: visual estimates can be made of time outside parameters and regularly recorded as figures, and a summary chart (e.g. Figs 8.5, 8.7) can be drawn to give an idea of fluctuations over a longer period of time. Digitally recorded output can be presented in charts with the time axis compressed (e.g. Fig. 8.6a).

Variation per hour/day/week/year: normal paper charts are adequate for short periods; but a summary chart (see Figs 8.5 and 8.7) is needed if variation over a longer period is to be shown.

Monitoring recurrent variation: the same chart can be left in place: as several traces accumulate, trends become apparent.

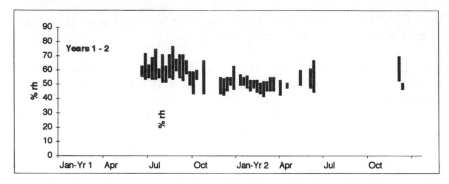

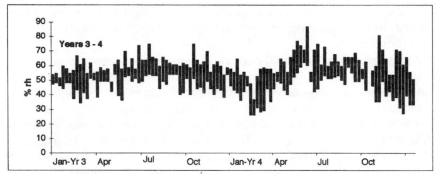

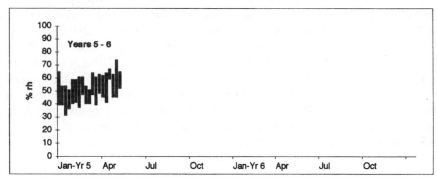

Fig. 8.5 *Chart summarizing weekly maximum and minimum relative humidity over five years*

The great plus point of thermohygrograph charts is that, because they have been so widely used for such a long time, they form a universal means of communication between curators, conservators and air-handling engineers alike. Summary max–min charts (Figs 8.5, 8.7) are an obvious derivation of the familiar thermohygrograph charts. The most effective forms of management information seem to be these or line graphs with the time (*x*) axis compressed (Fig. 8.6a).

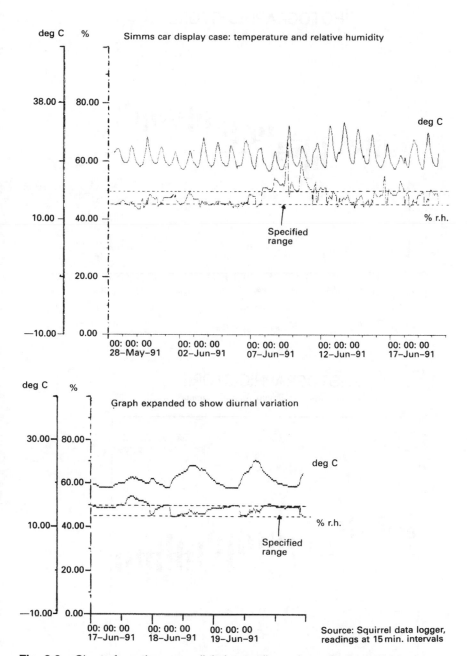

Fig. 8.6 *Charts from the same digital recording using a Squirrel electronic data logger. (a) Four weeks, drawn with the time (x) axis compressed. (b) Four days, drawn with the time (x) axis extended*

PHOTOGRAPHIC STORE
Weekly maximum/minimum relative humidity

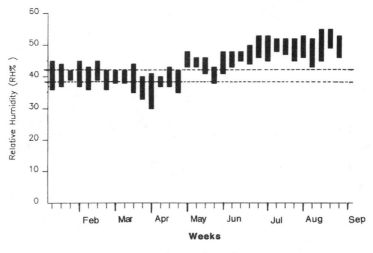

January - August 1991

PHOTOGRAPHIC STORE
Weekly maximum/minimum relative humidity

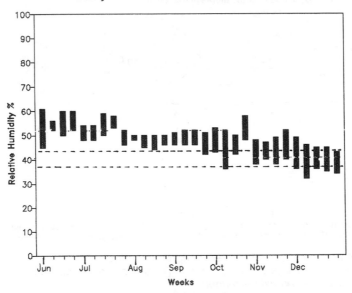

June — December 1991

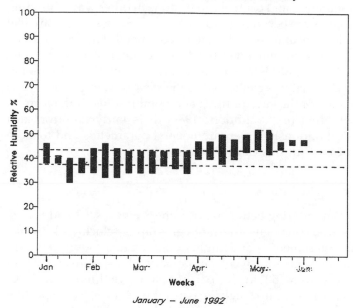

Fig. 8.7 *Chart summarizing weekly maximum and minimum relative humidity over three six-month periods. Seasonal fluctuation is clearly shown*

Analysis by area

Environmental monitoring can be displayed spatially, showing the state of the environment at a point in time in the form of a plan of the building (e.g. Saunders, 1989). Although useful for analysing causes and effects, this is less crucial for understanding the effects on objects.

In the case of pest management, it is recommended that observations are recorded not only by time of year but also on a building plan; a visual pattern quickly builds up (Florian, 1987). The same is the case in monitoring gaseous pollution: trends over time are of interest, since one would wish pollution levels to be decreasing, rather than increasing; but to understand what is happening it is also necessary to reveal pollution gradients by comparing levels in different areas: e.g. outdoors, in the entrance hall, deep within the display galleries, inside a showcase (Hackney, 1984).

Building management systems

Monitoring, presentation and control can be done in other ways. Building management systems are becoming more common. Such systems are like networked data loggers and control systems combined. The spaces in the building are monitored for whatever factors are of interest, as is the state of the plant and the controls. Every aspect of the plant can be individually controlled, provided that it is connected to the system. Computer screens can display the state of the environment at a point in time in the form of a plan of the building (e.g. Saunders, 1989). It is fairly new for such systems also to continuously log environmental parameters and to store the results over time, but this can now be specified.

Discussion

Is one method of monitoring better than another? Figures 8.3 and 8.4 are copies of charts from analogue thermohygrographs (clockwork instruments with hair hygrometers) and digital data loggers (Squirrel, Grant Instruments) for the same four weeks in January. The specified environmental parameters were 50 to 55 per cent relative humidity, 20°C. Although the traces look at first sight reassuringly level, close inspection shows that a high proportion of the time is outside specifications: up to nearly 60 per cent relative humidity for most of the week of 6th January, and down to 40 per cent relative humidity for most of a day in the week of the 20th January, with other sharp deviations from time to time. The charts, especially if seen one at a time at weekly intervals, do not permit an overall view of conditions, although they do provide a rich source of data.

In the Squirrel data logger (Grant Instruments) chart, for one of the same galleries during January (Fig. 8.4), the vertical scale has been expanded, giving a much more dramatic picture. The same features can be seen as on the analogue thermohygrograph trace, but in addition, the regular drops in relative humidity which occur every Monday (when the plant was switched off for maintenance) stand out clearly – on the normal charts they are less obvious because they occur at the beginning of the chart. This is a digital recording, and any area of the graph could be shown at an expanded scale for closer inspection.

The summary max–min graph (Fig. 8.5) shows the maximum and minimum relative humidity. It is a very effective means of indicating overall seasonal variation and departures from specified parameters, but it gives no indication of how long deviations from specifications lasted. Like the Squirrel data logger presentation (Fig. 8.4), it makes deviations from specification much more apparent than do weekly thermohygrograph charts.

The question is, which visual impression is closest to the effects of such deviations on objects? Work is only beginning on this central question: how much do environmental fluctuations matter? Is there a Pareto curve (80 per cent of the benefit comes from 20 per cent of the effort) for the benefits of a non-fluctuating environment? Padfield's theoretical data (1990) seem to show that in wood there is little response to short-term fluctuations. Michalski (1993) gives evidence that some objects can sustain prolonged drops of as much as 40 percentage points in relative humidity, but that others will be damaged by a fall of 25 percentage points. The effect of falls of much less than 25 percentage points he finds to be negligible. If, at any time in its history, an object has been kept for any length of time in a widely fluctuating environment, then most of the damage that can occur will already have done so. Only a few objects, particularly composite ones, and ones with a laminar structure such as paintings, will be damaged by drops in relative humidity. More will be damaged by biological activity arising from elevated relative humidity. As Michalski says,

> Drops of –40 per cent relative humidity do not constitute an emergency for loose skins, fur, textiles, costumes, metals, botanical specimens, or most archival material. In fact, it is a period of reduced decay. . . . For collections dominated by rigid organic materials (wood and paint), we must accept that the data support common sense, not magic numbers. Safe relative humidity is a broad valley ... if total control sacrifices reliability of the 25–75 per cent relative humidity limits, or other issues like fire and pests, I believe it is counter-productive to the total well-being of most collections.

Do we then assume that fluctuations such as that on 7th January, shown both on the thermohygrograph chart (Fig. 8.3) and on the Squirrel chart (Fig. 8.4) do not matter? In this particular case, the objects in these galleries had been exposed to many such fluctuations, and worse, over time. For example, on a previous occasion, the air-handling system failed completely at the height of the summer, and the galleries were exposed to humidities of 80 to 90 per cent for over two weeks. Rigorous inspection found only one case of damage to objects clearly attributable to this: some medieval coal, in which the sulphide mineral had decayed causing its total disintegration.

Case study: managing the environment

The Historic City Museum had about fifteen recording thermohygrographs producing either weekly or monthly charts. From these records, it was obvious that environmental conditions in some of the stores and

galleries were far from meeting generally accepted standards. Yet, although records had been kept for a number of years, it had proved to be almost impossible to bring about much improvement to conditions.

The problem fell into two parts. First was the nature of the buildings and spaces themselves. The museum building had been constructed in the 1920s. It was a substantial concrete and masonry structure in which ventilation was mainly natural, with mechanical air supply only to a few specific galleries. There was no possibility of large-scale investment in air-handling plant for most of the museum. Some of the stores were located in this same building, but others were in a substantial brick-built warehouse not far from the museum.

The second part of the problem was to do with people and organizations. The museum's buildings, plant and services were maintained and managed by the Buildings and Estates Department of the local authority. The services engineers were often found to be slow to act, and to have little interest in tackling the museum's problems.

It was decided that it might help the situation if a regular forum for communication were set up. A committee was therefore established, to meet quarterly to review problems (and successes!) and agree on and monitor action. As well as the engineers and the Head of Conservation, the museum's house manager was included, as she controlled the museum's own in-house maintenance budget.

The first thing to emerge was that the engineers had in fact never been given specifications for the museum spaces, apart from the few galleries with mechanical ventilation. Simple specifications of relative humidity and temperature were drawn up for each of the spaces for which the engineers were responsible.

Next, a conservator was designated Environmental Liaison Conservator. This person would coordinate environmental monitoring by the different conservation sections, monitor and analyse the results, and be a single channel of communication with the engineers. As well as contacting the engineers informally when necessary, she prepared summary charts for the two-monthly museum environment meetings, and reported on them (e.g. Fig. 8.7).

As soon as the state of the environment on the central site could more clearly be understood, a programme was set up to review the environmental control packages, particularly for the stores, and modify them or install new ones as necessary. The cost of this turned out to be much less than had been supposed: in the region of £3000 to £4000 per store if new equipment was needed.

Through these meetings and information, the museum was at last communicating its requirements clearly and creating a forum which decided on, planned, and monitored the necessary action. It would be

satisfactory to report a dramatic improvement in environmental conditions. It is true that some newly installed plant was brought up to correct operation fairly rapidly. But, in spite of much genuine cooperation by the local authority's senior representative, hardly any of the new equipment which had been planned had been installed eighteen months after it had been agreed. The environment in the galleries, never good, was deteriorating if anything still further.

The reasons for this apparent lack of success were several. The museum had no real power over the local authority, because the authority was also a major funding body for the museum. The local authority personnel suffered from organizational problems of their own, as well as a general underestimation of the need for engineering and technical expertise in the field of environmental control. The museum building was old, and the local authority was reluctant to invest money in a structure which it saw as having a finite life. Information may be necessary for effective operation, but alone it is not sufficient.

Nevertheless, the foundation of understandable, accurate and sufficient information and data on the environment will benefit the museum, both as the basis for firmer diplomatic action with the local authority and also if the maintenance and operation of the environmental control plant is contracted out under compulsory competitive tendering. It was of great benefit when planning and specifying the new store, as environmental records for areas with mechanical ventilation in the museum could be compared (unfavourably!) with those for a naturally stable off-site warehouse store. As a result, the museum was able to decide with some confidence that the expense of mechanical HVAC would not be necessary for the new store if certain structural design principles were adhered to. The building should if possible be a substantial masonry one; storage spaces should if possible be enclosed by offices, ceilings and roof spaces, and circulation corridors; and storage spaces should be as completely sealed as possible, so as to obtain the fullest benefits from the thermal mass of the building.

Tales of the environment

It is a cause of particular difficulty that architects and services engineers are familiar with environmental control by means of mechanical air handling, to the exclusion of all other possibilities. Stories about over-reliance on expensive mechanical and computerized systems are commonplace, and a few of them illustrate the principles described above.

Story 1: No connection

A small-scale ventilation system was designed and installed to control the environment in three large sealed showcases. A computerized building management system was set up for the whole building, with a monitor in each showcase, but the individual monitors for each case were not properly identified. The conservators in any case monitored the cases independently using Squirrel data loggers. They found that the environment in the cases rarely met the specifications. After two or three years with no improvement, an important loaned object had to be returned to its owner, and a trusted and reliable engineer was called in. He found the root of the problem to be that the air-handling ducts passing air from the ventilation plant to the showcases had never been connected to the plant.

Story 2: Not invented here

A medium-sized museum had always had problems with its air conditioning plant, which failed to produce the specified environment. To try to tackle this, the museum employed a consultant engineer to review the design of the part of the system for each gallery as it was redesigned. For one gallery, due to house particularly delicate objects, the engineer produced drawings which would fundamentally alter and improve the supply and extract systems. Having produced the design, he was unfortunately not called on to monitor the installation of the system, which was undertaken by sub-contractors. When he reappeared on the scene he was horrified to find his drawings in a torn dusty heap in the corner, with the redesigned system bearing no relationship to them. As installed, it would not work. The project suffered thousands of pounds' worth of delay while the worst mistakes were rectified.

Story 3: Separate spaces

The temporary exhibition gallery in a museum was renowned for its fluctuating and damp environment, despite supposedly having full air conditioning. When an exhibition including important borrowed paintings was planned, it was decided to make greater efforts to improve conditions. The engineers were asked to run the plant for a month before the exhibition to allow for acclimatization. They did so, but for two weeks, despite all their efforts, the environment fluctuated wildly. Eventually they investigated thoroughly and discovered that, during the construction of a previous exhibition, the air-conditioning control sensors had been completely enclosed in a sealed space against a poorly insulated outside wall.

Conclusions

There is a general and generic problem with the standard of expertise and people who work on building and services maintenance. This makes it extremely difficult to tackle environmental problems at their root, but with persistence and accurate information one can sometimes succeed. If you find an architect or a services engineer who really understands the principles of environmental control and is willing to be imaginative in their application, treasure them and never let them disappear into the wilderness.

Conservators need to be highly alert to developments in the understanding of the effects of the environment on objects. While they should stand firm in their expression of their expert opinion, they should make sure that they are expert, and be very aware of the different ways in which desirable conditions can be created. Conservators need to evolve preventive conservation into preservative conservation.

Conservators have often succumbed to the temptation to put their time and effort into monitoring the environment, rather than into investigating what real, simple improvements are possible through changing procedures and communicating with engineers and maintenance staff. The difficulty of effecting improvements, even though obvious, should not be underestimated. It is easy for conservators to be seen as encroaching on other people's patches, as indeed we do. Patience, persistence and time are needed. Always try applying brains and imagination, and the inherent characteristics of buildings and materials, to a problem before reaching for the mechanical environmental control plant. Always synthesize data into information before acting.

Finally, it is worth remembering that it is not changes in relative humidity and temperature that cause the worst damage to collections, but much more serious risks, such as grossly unsuitable storage – dirty, overcrowded, with buildings not even wind- and weather-proof; catastrophe when contractors are working in the building which houses the collections; or leakage or flood due to a badly chosen site or services routed through stores.

References

Association of American Museums (1985). *Museum Assessment Program: MAP I and MAP II questionnaires*. Washington DC: AAM.
British Standards Institution (1978). *BS 1006: 1978. Methods for the determination of the colour fastness of textiles to light and weathering, International Organization for Standardization Recommendation R105*. Milton Keynes: BSI.

British Standards Institution (1989). *BS 5454: 1989. The storage and exhibition of archival documents*. Milton Keynes: BSI.

Cassar, M. and Clarke, W. (1993). A pragmatic approach to environmental improvements in the Courtauld Institute Galleries in Somerset House. *ICOM Committee for Conservation, 10th Triennial Meeting, Washington, DC, Preprints*. Marina del Ray: Getty Conservation Institute/ICOM Committee for Conservation.

Cassar, M. and Keene, S. (1990). Using standards. In *Managing conservation. Conference preprints* (S. Keene, ed.) London: UKIC.

Caton, J. (1991). Setting standards. *Museums Journal*, January, 34–5.

Christoffersen, L. D. (1993). Resource-saving storage of historical material. *ICOM Committee for Conservation, 10th Triennial Meeting, Washington, DC, Preprints*. Marina del Rey: Getty Conservation Institute/ICOM Committee for Conservation.

Corfield, M., Keene, S. *et al.*, eds (1989). *The Survey*. London: UKIC.

Florian, M. (1987). Methodology used in insect pest surveys in museum buildings – a case history. In *ICOM Committee for Conservation, 8th Triennial Meeting, Sydney, Preprints*. Marina del Rey: Getty Conservation Institute/ICOM Committee for Conservation.

Getty Conservation Institute and National Institute for the Conservation of Cultural Property (1991). *The conservation assessment. A tool for planning, implementing, and fundraising*. Washington, DC.

Grzywacz, C. M. (1993). Using passive sampling devices to detect pollutants in museum environments. In *ICOM Committee for Conservation, 10th Triennial Meeting, Washington, DC, Preprints*. Marina del Rey: Getty Conservation Institute/ICOM Committee for Conservation.

Hackney, S. (1984). The distribution of gaseous air pollution within museums. *Studies in Conservation*, **29**, 105–16.

Kenjo, T. (1986). Certain deterioration factors for works of art and simple devices to measure them. *Int J of Museum Management and Curatorship*, **5**, 295–300.

Kenyon, J. (1992). *Collecting for the 21st century. A survey of industrial and social history collections in the museums of Yorkshire and Humberside*. Leeds: Yorkshire and Humberside Museums Service.

Mecklenberg, M. F. and Tumosa, C. S. (1991a). An introduction into the mechanical behaviour of paintings under rapid loading conditions. In *Art in transit, Conference proceedings, London*. Washington: National Gallery of Art.

Mecklenberg, M. F. and Tumosa, C. S. (1991b). Mechanical behaviour of paintings subjected to changes in temperature and relative humidity. In *Art in transit, Conference proceedings, London*. Washington: National Gallery of Art.

Michalski, S. (1990). Towards specific lighting guidelines. In *ICOM Committee for Conservation, 9th Triennial Meeting, Dresden, Preprints*. Marina del Rey: Getty Conservation Institute/ICOM Committee for Conservation.

Michalski, S. (1993). Relative humidity: a discussion of correct/incorrect values. In *ICOM Committee for Conservation, 10th Triennial Meeting, Washington, DC, Preprints*. Marina del Rey: Getty Conservation Institute/ICOM Committee for Conservation.

Museums and Galleries Commission (1988). *Guidelines for a registration scheme for museums in the UK*. London: Museums and Galleries Commission.

Padfield, T. and Jensen, P. (1990). Low energy control in museum stores. In *ICOM Committee for Conservation, 9th Triennial Meeting, Preprints, Dresden*. Marina del Ray, Ca.: Getty Conservation Institute/ICOM Committee for Conservation.

Paine, C., ed. (1992a). *Standards in the museum care of archaeological collections*. Standards in the museum care of collections, no. 1. London: Museums and Galleries Commission.

Paine, C., ed. (1992b). *Standards in the museum care of biological collections*. Standards in the museum care of collections, no. 2. London: Museums and Galleries Commission.

Paine, C., ed. (1993). *Standards in the museum care of geological collections*. Standards in the museum care of collections, no. 3. London: Museums and Galleries Commission.

Paine, C., ed. (1994). *Standards in the museum care of larger and working objects*. Standards in the museum care of collections, no. 4. London: Museums and Galleries Commission.

Saunders, D. (1989). Environmental monitoring – an expensive luxury? In *Environmental monitoring and control, Dundee, conference preprints*. Glasgow: Scottish Society for Conservation and Restoration.

Staniforth, S. (1990). The logging of light levels in National Trust houses. In *ICOM Committee for Conservation, 9th Triennial Meeting, Dresden, Preprints*. Marina del Rey, Ca.: Getty Conservation Institute/ICOM Committee for Conservation.

Tennant, N. H., Townsend, J. H., *et al* (1982). A simple integrating dosimeter for ultraviolet light. In *Science and technology in the service of conservation, Washington conference preprints*. London: IIC.

Thomson, G. (1986). *The museum environment*. London: Butterworth.

US Department of the Interior (1986). *Special Directive 80-1*. Washington DC: United States Department of the Interior.

9 Collections condition

It is arguable that the first duty of museums is to care for and preserve the collections, since these are the physical assets, owned by the public, for which the organization is accountable, and on which all other museum activities are based. Condition monitoring can be seen as an audit, based on clear definitions, which allows the condition of different collections to be compared one with another, between different institutions, or over time. Such audits should take as little valuable conservation time as possible, and the results will be be analysed and expressed numerically. Successive comparable surveys over time are the only obvious way to establish whether collections are deteriorating or not.

An important component of the conceptual system for conservation (Chapter 7) was the management processes, 'set criteria for efficiency, effectiveness and efficaciousness', and 'monitor processes' (Fig. 7.5). Table 7.3 related these processes to an information function, 'set standards for and monitor the condition of objects and collections'.

Surveying collections

Surveys can have a variety of objectives (Table 9.1). At least three types of survey are needed to provide a truly comprehensive view of collections preservation:

Preventive conservation assessments

In order to diagnose and eliminate the causes of deterioration, the preservation environment needs to be assessed in the broadest sense, covering institutional policies, procedures, available staff and skills, the history of the collections and space and physical resources for their preservation. Work on this has been completed in America. The Conservation Assessment, discussed above in Chapter 8, is intended to be used for 'planning, implementing, and fund raising' (Getty Conservation Institute and National Institute for Conservation, 1991). In this country, the Museums and Galleries Commission's Standards in the Museum Care

Table 9.1 *The objectives of surveys, factors relevant to these, and data that need to be collected*

Survey objective	Relevant factors	Data needed
Audit condition	Condition of individual objects Statistics on collections condition	Condition audit Damage types and severity
Identify causes of deterioration	Environment: space, enclosures, supports/mounts, growth of collection, humidity, temperature, light, contaminants, pests, provenance Use: display, handling, repairs/conservation, examination, running/demonstration of objects	Observations Environmental records: past, present Damage types and severity Records of use
Diagnose trend	Condition: past vs. present Likelihood and rate of future change i.e. vulnerability and stability Factors which have caused/likely to cause damage	Condition past (?inferred) Condition present Condition predicted future (= stability) Present and likely future environment Present and likely future use
Affect trend	Change environment (see above) Modify use (see above): display conditions, handling/use procedures, conservation procedures, running or demonstration Modify object: treat or restore	Most potent causes of deterioration
Assess resources needed	Space, buildings, plans (HVAC etc.) Equipment (racks, cupboards, etc.) Materials (for mounts, etc.) Time, skills Finance	Size of task (e.g. number of objects, volume, storage area, etc.) Nature of task (e.g. mounting, treatment, refit store, new store) Account/cost of resource (e.g. conservator/years, sq.ft. of storage)

Table 9.1 *(Continued)*

Survey objective	Relevant factors	Data needed
Assess benefits	Present use of objects, potential use, information potential, relevance to institution's purpose, monetary value, uniqueness, quality of workmanship, physical quality (e.g. wholeness), aesthetic quality	Present use (e.g. objects displayable, books readable, drawings accessible) Curatorial assessments of worth Numbers of objects being successfully preserved (i.e. in condition defined acceptable)
Recommend priorities	Institutional objectives Resources vs. benefits Consequences of 'do nothing'	Conservation/preservation policies Cost/benefit calculations using above data Vulnerability of objects/ collections Judgements re will deteriorate or not

of Collections perform this function. The stores assessments described above in Chapter 8 are part of a conservation assessment.

Collections condition audits

Data on the condition of objects and collections themselves – the subject of this chapter. These complement preventive conservation assessments.

Curatorial assessments

Curatorial assessments of the importance of the object as part of the collection: i.e. of its significance for the intellectual dimension of the collection. This sort of assessment is clearly essential when setting priorities for action to be taken as a result of condition surveys, and for allocating resources. Despite current concerns with the refinement of collections through disposals, the only published work so far found on this emanates from the Dutch government, on the Delta Plan, a national initiative to address the backlog of collections management work in Holland (Directorate-General for Cultural Affairs, 1992; Cannon-Brookes, 1994).

As well as these general audits, object-by-object surveys will still of course be required for other purposes. For example, to plan remedial conservation projects, one will need to know which *objects* are the highest priority, and for this an object-by-object survey is essential.

The observations made in sample surveys may be extended by instrumental or microscopic examination of objects in the sample: see for example the Library of Congress survey, in which the selected sample was tested for pH and fold strength (Wiederkehr, 1984).

Existing work

Most earlier published work on surveys concentrates either on detailed condition reports on individual objects or on every-object surveys of collections undertaken to decide which objects should have priority for conservation (e.g. Walker and Bacon, 1987). There are some general surveys of regions or collections types (e.g. Kenyon, 1992; Storer, 1989). Forms for collecting survey data are usually tailored to a particular type of collection, which makes it difficult to compare the condition of different collections. The first published report of a condition survey which collected the same categories of data for a diverse collection is to be found in Walker and Bacon (1987), an every-object survey for the Horniman Museum. Where only a sample of objects has been inspected, the selection has not been statistically designed but informal: e.g. every tenth object. However, a survey of the Library of Congress used statistically designed sampling to infer the condition of the twenty million books from a sample of 1000 (Wiederkehr, 1984).

Most reports cite only an analysis of objects by type and conservation condition grade; not, for instance, condition by damage. This is because it is scarcely feasible to cross-tabulate two or more data variables by hand. Many extant surveys have not yet had their data analysed at all. This does not mean that they are useless: the information is also used as a complete collections inventory, as a basis for future condition monitoring, and as an immediate source of information about environmental problems. In most cases the information collected informally by observing storage conditions and obvious causes of damage has been drawn on and used, both in survey reports and in taking action, at least as much as the survey data itself.

Collections surveys are required to answer not the question, 'which objects need conservation?', but the even more important question, 'is the institution succeeding in its basic duty to preserve the collections?' This can be seen as an audit, based on clear definitions, which allows the condition of different collections to be compared one with another, between different institutions, or over time. Such audits should take as

little valuable conservation time as possible, and give results which can be analysed and expressed numerically. Condition and damage can be categorized in standard ways that can apply to all types of collection. It is not necessary to examine every object in a large collection: statistical techniques can be used to design sample audits, as they are for sociological research, marketing, etc. Results can be calculated for the whole collection, and presented in simple and understandable ways.

Defining the data

Museum collections are extremely diverse, ranging from beetles to traction engines; flints to oil paintings; costumes to spacecraft. At first sight, it seems impossible that the condition of such a variety of objects could be described by a common set of terms. But it was found on studying surveys from different institutions that the terminology to describe 'condition' in different types of object was in fact quite similar.

Administrative data

These are the main terms used in analysing data and reporting results. Because museum collections are so diverse, even these seemingly obvious terms need to be defined to take account of collections which are often only partly inventoried, disorganized in store, and have no factual estimate of collections size.

Collection. An administrative unit within the overall collection of the institution. There can be collections and sub-collections within collections.

Store. A self-contained room in which collections are kept.

Store location. An important concept, on which the survey design rests. The smallest identifiable grouping of objects within a store, e.g. a shelf, a box on a shelf, a group of objects on the floor, each drawer within a cabinet of drawers. If a shelf has some freestanding objects, and others contained in a box, then the freestanding objects would count as one store location, the box another.

Object. The concept of objects-within-objects is a familiar problem in museum data definition: for example, is the object the tea set, or the individual cups and saucers? For condition audit purposes, the auditors decide what is most appropriate and record the rule they establish. Normally, an object made up of component parts is taken to be a single object.

Object identification. The inventory or acquisition number. Though desirable, particularly for repeat surveying over time, for a collections condition audit objects do not need to have individual numbers.

Descriptive of object. How much data are collected on this is optional, and may vary according to individual institutions' or collections' needs. It may include:

Simple name
Materials
Manufacturing processes
Type (e.g. photographic process)

Data which might relate to, but do not describe, condition may optionally be included here: fragility (the object may be fragile but in perfectly good condition); completeness; working or not. These terms do not necessarily reflect deterioration.

Describing damage

The selection of existing survey forms which had been collected contained altogether 77 different terms to describe damage and deterioration, many of which were synonyms. They can be grouped within eight broad terms (Table 9.2):

Major structural damage Chemical deterioration
Minor structural damage Biological attack
Surface damage Bad old repairs
Disfigurement Accretions

A survey which extended the framework described here defined the broad terms by listing the detailed ones they included. This survey also recorded the more detailed damage terms (relating to the condition of books) as sub-codes within the codes for the main headings (a Victoria and Albert Museum survey in 1991). For example, 'major structural damage' included: boards off; boards missing; spine off; spine missing; spine split; sewing broken; leaves detached; corners broken; boards severely misshapen; boards broken.

Describing condition

Condition grade 1	GOOD	Object in the context of its collection is in good conservation condition, or is stable.
Condition grade 2	FAIR	Fair condition, disfigured or damaged but stable, needs no immediate action.
Condition grade 3	POOR	Poor condition, and/or restricted use, and/or probably unstable, action desirable.

Table 9.2 The eight main terms under which types of damage can be grouped, and terms relating to some collections

| | Structural damage | | | | | | | |
	Major structural	Minor structural	Surface damage	Disfigurement	Chemical/ internal	Biological	Accretions	Bad old repair
General	Separate pieces/part; Loose crack; Large tear likely to spread; Large holes; Major splits; Parts missing; Mechanical disorder	Crack; Small tear; Puncture; Small holes; Small splits; Obviously weak; Loose attachment; Bent; Warped; Creased; Distorted elements e.g. feathers	Flaking/lifted paint, etc; Peeling; Paint/surface losses; Bruised; Cupped; Delaminated; Crazed; Dented	Scratched; Stained; Abraded; Discoloured; Faded; Tarnished; Colours bled	Crumbling; Friable; Desiccated; Exudations; Grease; Salts	Insect attack; Moth; Woodworm; Foxed; Rodent damage; Mould; Mildew	Dirty; Encrusted; Surface salts; Deposits; Greasy	Adhesive; Misalignment; Staples; Sellotape; Patches
Furniture	Very loose joint; Separated attachment;		Lifted veneer					

	Structural damage			Disfigurement	Chemical/ internal	Biological	Accretions	Bad old repair
	Major structural	Minor structural	Surface damage					
Paper	Very badly crumpled with split; Very badly creased with split; Very badly distorted/ rolled	Cockled; Crumpled; Folded			Acid; Yellowed; Chemically changed edges; Matt burn; Redox spots; Metal impurity			Tape; Sellotape
Books	Separated or nearly separated spine/cover				Acid paper; Red rot			
Textiles, fibre	Split seam; Badly creased with split; Seriously crumpled; Crushed	Shrunken; Detached fibres			Deteriorated silk; Acid dyes			Clumsy stitching; Alterations
Pictures			Cupped paint; Losses; Flaking paint; Lifted paint		Blanched; Deteriorated canvas			
Ceramics/ glass		Chipped; Small crack			Salt damage; Crizzled	Encrustations		
Metals					Corroded; Rusted			Solder

Condition grade 4 UNACCEPTABLE Completely unacceptable con-
dition, and/or severely weak-
ened, and/or highly unstable
and actively deteriorating, and/
or affecting other objects:
immediate action should be
taken.

'Action' means something done to the object itself, rather than to its
surroundings or environment.

There are several different aspects to 'condition', which have been used
in different (or even in the same) surveys (Buck, in 1971; Walker and
Bacon, in 1987; Keene 1990 and other survey reports):

- *Insecurity* (Buck, 1971, and the V & A in early surveys): mechanical
 stresses, stability or vulnerability
- *Disfigurement* (Buck, 1971, and the V & A): appearance of object
- *Conservation priority* (Horniman, Museum of London, British Museum,
 and others): how urgently is conservation needed?
- *Condition rating* (National Maritime, Public Records Office): e.g. good,
 fair, poor

All the factors listed are valid aspects of 'condition'. They can be
combined in the *definitions* of broad summarizing terms, as in Fig. 9.1. The

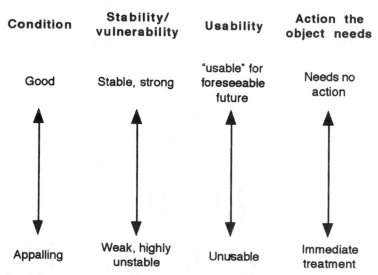

Fig. 9.1 *Aspects of the condition of an object*

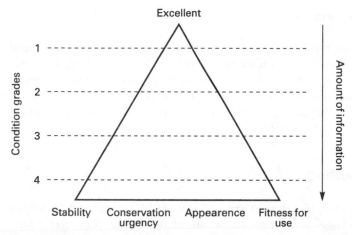

Fig. 9.2 *The amount of data needed to describe condition. The worse the condition of the object, the more description is needed*

worse the condition of the object, the more terms descriptive of deterioration are likely to be applicable (Fig. 9.2).

What conservators are really doing when they describe 'condition' is *predicting the rate at which an object is likely to change*, assuming that change in a museum object implies deterioration. The concept of 'stability', then, is central to the definition of 'condition'. Even when an object, although otherwise stable, is graded 'highly unstable' (or its equivalent) because of a detached fragment, which would be common practice, this is a prediction that the object will suffer serious change due to the fragment's permanent loss.

The condition of an object needs to be defined in the context of its particular collection. For example, a pot which is in separate sherds may be in GOOD condition as part of an archaeological archive, while the definition for an applied arts ceramic collection may place it in the UNACCEPTABLE category.

Data on damage will give information on why the object has been assigned its condition grade. For example, 'biological deterioration' combined with condition grade 4 implies pest infestation or active mould growth; grade 4 coupled with 'major physical damage' implies an insecure break or a detached part.

There is debate about the number of grades: between three and five. Four grades have been used in many institutions (British Museum, Horniman, Museum of London, National Museum of Wales). Allowing a fifth grade means that the majority of objects are assigned the middle, indeterminate grade, which does not give very useful information. Three grades do not allow sufficient discrimination between different grades of condition, and again have the disadvantage of an indeterminate grade.

Other possible data

Other useful data can be collected as part of the audit process. It would be simple to record the suitability of the object's store location. It is also easy to record what work is needed to render the condition of the object acceptable. If additional data are collected it is strongly advisable to design a restricted number of terms or categories, like those for damage or condition, so as to expedite the process of analysis.

The audit method

The basis of the sampling design arrived at is statistical method, by which we can learn what we want to know about the population (the whole collection) from statistics gathered about a sample (Rowntree, 1981: 83). If the sample is selected randomly from the population, then it is possible to predict the accuracy of the estimate about the population, and also how confident we can be that the results from the audit can be applied to the whole collection (the confidence level).

There are several advantages in using a statistical sampling method. Audits take less time, which is important, because conservators are in short supply, and auditing itself does nothing directly to improve the condition of the collection. Fewer objects, examined more carefully, will give more reliable results than many objects examined only cursorily. If large quantities of data are collected, it is very difficult to make sense of them, whether they are analysed by hand or by computer.

Audit procedures and sampling

There are six distinct stages in an audit:

1 Specify the objectives and scope of the audit, and decide on the time available.
2 Undertake a pilot audit, to establish the variability of the collection and quantify the task.
3 Analyse the pilot audit results, design the sampling procedure.
4 Collect the data (conduct the audit itself).
5 Analyse the data.
6 Report the results.

Audit specification

If the results of the audit are to be adopted and used ('owned') by the institution generally, it is most important that both curators and

conservators cooperate in as many stages as possible. Some obviously suitable tasks for cooperation are: to establish the objectives and scope of the audit, describe the nature of the collection, and note particular aspects of it which are of interest and which should be covered by the audit; to agree the administrative data which will be used in analysing the audit; to define the audit variables (what is 'an object' in the context of this collection? Does condition grade 4: UNACCEPTABLE need more precise definition?). The amount of time to be spent on the audit must be decided in advance; it is important to the statistical design.

Pilot audits

A pilot audit collects together the necessary information to design the sample and tests out the audit procedures. Necessary information will include information about the collection(s), information about how they are organized in store, quantifications of the size of the task (typically, how many store locations, and how many objects can be examined per day), and data on the statistical 'variability' of the collection (see below, Audit sampling design). It gives an opportunity to test out the means of data collection – whether paper forms or computer. It enables the data definitions to be tested in the context of the particular collection, and rules on their application to be agreed. For example, inexperienced auditors can find themselves to have set the criteria for condition grade 4: UNACCEPTABLE condition too low, so that they add 'even more urgent' classifications as the audit proceeds!

The pilot audit can be expected to take up to 20 per cent of the total time available for auditing (see Exhibit 9A, and Kingsley and Payton, 1994). It needs to be carefully thought out, so that all parts of the collection are covered evenly. The pilot audit procedure can be changed if necessary during its course (in the main audit the procedure that has been designed should be rigidly adhered to unless it becomes clear that the design is seriously faulty). The information required from pilot audits and the process of undertaking and analysing them is illustrated in Exhibit 9A.

Audit sampling design

The statistical method adopted is a two-stage systematic sampling procedure, with storage location as the first stage and individual objects the second. This allows samples to be designed to allow for different levels of between- and within-location variability. This is comparable to selecting every nth street, and within that street, every xth house to survey. The notation and formulae used are set out in Exhibit 9D; sampling design is discussed in detail in Keene and Orton (1992), and its

application in practice in Kingsley and Payton (1994). Exhibit 9A shows examples of survey designs.

How many objects in the sample?

It seems paradoxical, but the primary determinant of sample size is not the size of the collection, but its variability (Rowntree, 1981: 100; Cochran, 1963). Thus, it is incorrect to assume that surveying a particular percentage of a collection will give results that can be extrapolated to the whole. The factors that determine sample size are:

(a) The variability of the collection:
'Variability' in audit terms means the number of objects per location, and the proportion of objects in the different grades of condition within different locations. The more variable the collection, the larger the sample required.

For example, if most store locations contain one badly damaged object and nine in good condition that collection is not very variable. If the number of objects per location varies from 1 to 1000 then the collection is variable. Variability must be established from a prior pilot survey. The results of the pilot survey will show how large a standard deviation (i.e. ±20 per cent) would result from the analysis; if it is too large, then the time allowed may have to be increased.

(b) The confidence limits required and the standard deviation (range) in which the results are to be expressed, which are linked:
Confidence level is expressed as a percentage, such as '95 per cent confidence level, applying to objects in condition grade 4'. It indicates the degree of confidence in calculating the condition of the whole collection from a sample, as in 'we can be 95 per cent certain that between 79 and 105 objects are in unacceptable condition'. 95 per cent is a good level to choose.

(c) The amount of time allocated to the audit:
It is actually useful in designing an audit to allocate a specific amount of time for the process. Two person-months is probably enough whatever the size of the collection, i.e. one month if two people are doing the inspection, as is good practice. The time allowance should include a person-week for a pilot survey and a person-week for analysing and writing up the results.

The statistical design of the audit

The statistical design (i.e. every fifth object from every ninth store location) is calculated by applying the formulae contained in Exhibit 9D to the pilot audit results. A computer program has been written to

do this. The process is not very simple, however, and many audits thus have an informal design, i.e. one in ten objects. Informal audit designs are acceptable for small collections, but for those such as photography or libraries months of time could be wasted. Alternatively, most statistically designed audits turn out to use a sample of around 1000, as you will notice from opinion polls. The Library of Congress audit covered twenty million books in a sample of about 1000. The question here is, how should the 1000 be selected?

The objective of the sampling design can be expressed as:

To design the most effective way of selecting a sample of objects to inspect, given that x objects can be examined in the time available (figure from the pilot survey), in order to calculate the proportion of objects in condition grade 4, to 95 per cent confidence limits.' If there are too few objects in condition grade 4 condition, then condition grade 3 + condition grade 4 can be designated.

The aim is to achieve a balance between the sampling fractions f_1 (the proportion of the locations sampled) and f_2 (the proportion of objects sampled within each selected location) (Keene and Orton, 1992). For example, for an audit of a social history collection every fourth location was sampled, and within those, every eighth object, both counts starting from a randomly selected first location or object (Exhibit 9A, Audit designs). Or, for a varied collection including both single large objects and groups of objects, object types were separately sampled (Kingsley and Payton, 1994).

Whether the sample is statistically designed or informal, it is still very important to select objects at random. Only if they are, can statistics about the sample be used to calculate parameters for the collection. In an informal sample (say every tenth object) the first object must be selected randomly by drawing a ticket, etc., and subsequent objects must be chosen according to a predetermined systematic procedure. You can invent your own rules, but you must record them and stick to them.

Using an informal method with only one stage of sampling (e.g. every tenth object) has the advantage that it is very simple to extrapolate the results from the sample to the collection as a whole. Statistical techniques can still be used, if wished, to calculate the range and the confidence limit for the whole collection. The disadvantages are that considerably more objects may have been audited than necessary; scarce specialist time may not have been put to the best use; and unnecessary quantities of data may have to be analysed.

Data collection

There is a choice between recording audit data on paper or on computer. Paper records are permanent, accessible, and some analysis is easily done by hand (Figure 9.3 is a typical audit form). The disadvantage of paper is the bulk that quickly accumulates, and that statistical analysis beyond simple counts and percentages is in practice impossible.

Simple computer databases can provide an electronic form for entering audit records, which can then be listed and counted. Simple analyses such as percentages can be performed, using pre-designed report formats. Some typical results from the database offered in Microsoft Works™ are shown in Exhibit 9C.

Data analysis and presentation

Data from audits can be analysed in several main ways.

Descriptive information

The data analysed here are the administrative information which has been collected. These variables can by analysed in as much detail as required. For example, photographic collections might be analysed by type of object: negative, print, etc., and by photographic process. These data would be held in an inventory of the collection, but if an inventory does not exist they will be invaluable.

Information on fragility, completeness, whether in working order, etc. can be analysed if the need for this has been anticipated in audit data design and data coding. Though not directly relevant to condition, this information is useful for collections care and management generally.

Analysis: Simple lists.

Output: Lists of object types, stores, collections, etc. Because a sample only is collected, 'object type' has to be fairly broad; for instance, if 'object name' were to be analysed then lists would be too detailed to be meaningful, and many named objects would not be represented. Even so, 'object type' is a very quick way of producing an outline description of a collection.

Quantitative information

Sample audits are designed to enable quantitative information about whole 'populations' to be calculated from data about smaller samples.

COLLECTIONS
CONDITION
AUDIT

Condition grades:
1: GOOD: Good conservation condition, stable
2: FAIR: Disfigured or damaged, no immediate action
3: POOR: Probably unstable, needs remedial work
4: UNACCEPTABLE: Actively deteriorating

Damage categories:
MAJor structural damage
MINor structural-cracked, bent, loose
SURFace flakes, crazing, lifting
DISFigurement - stains, scratches
CHEMical - acid paper, corrosion, rubber breakdown
BIOlogical - mould, insect, rodent
OLD - sub-standard repairs
ACCretions of dirt, grease, deposits

Survey code: 1995-C Initials: SK Date: 21.7.98
Collection: COSTUME
Sub-collection: ACCESSORIES
Store: BH-1-36
Location: SC3 S4

Inventory no.	Object name	Materials	MAJ	MIN	SURF	DISF	CHEM	BIO	OLD	ACC	COND (1-4)	Remarks
1294-3b	Hat	Straw, silk	✓								3	
A5437	Hat	silk		✓							1	
A21052	Hat	wool						✓			4	live moth
A5549	Hat	wool						✓			4	"
1890-154	Gloves	Leather		✓	✓						1	
1995-SS	Gloves	wool		✓							1	
Totals for damage categories:			1	2	1			2				

Cond: 1 | 3 2 | 2 3 | 1 4 | 2

Fig. 9.3 An example of an audit form used to collect the data described here

Quantitative information can be derived about the collections, including:

- Numbers of objects in collections, sub-collections, object types
- Numbers of objects in stores
- Numbers of objects in different condition grades (therefore needing or not needing conservation)
- Numbers of objects which have suffered different types of damage
- Numbers of objects needing mounting or other particular types of work

and as a spin-off ...

- Numbers of objects lacking a valid inventory number.

The results of this quantitative analysis can be combined with information on resources, i.e. work rates – numbers of objects conserved/mounted/cleaned, etc. in a year; materials, such as amount of mount board required to cut *n* mounts; prices of boxes, to quantify the resources needed to improve the condition of collections to some target state.

Analysis: Counts of cases (object records) by different groups; statistics – standard deviation, maximum number, minimum number; cross-tabulations; application of the statistical formulae designed for audit analysis.

Output: Quantified lists, tables, histograms, bar graphs. Information on resource requirements: price of required packaging, conservator/years to treat all objects in condition grade 4, etc. For examples of tables and numerical output, see Exhibit 9C; the expression of these statistics as graphs is illustrated in Fig. 9.4, (a) and (b).

Comparative information

Both numbers and proportions of objects analysed by different variables can be used to make comparisons of collections size, collections condition, etc. The proportion of objects grade 3 and grade 4 combined may be used as an index of condition. Comparing proportions of damage types may assist in understanding the causes of deterioration.

Analysis: Cross-tabulations of object type (or other grouping: e.g. store) by condition grade, with percentages. Log-linear or contingency analysis to compare the condition of different object groupings. The chi-squared test of significance (if required). Percentages of objects with different types of damage.

Output: Tables and figures. Percentage and other bar graphs; pie charts. See Fig. 9.4, especially (c) and (d), and Exhibit 9C.

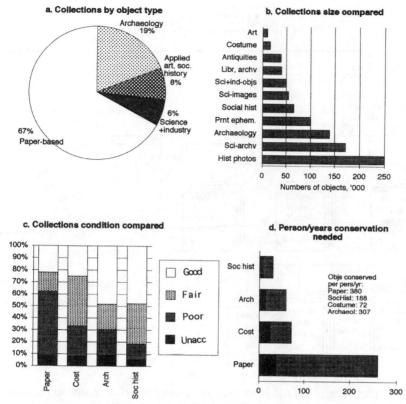

Fig. 9.4 *Some ways of presenting the results of collections condition audits*

Correlational information

Information on how statistics relating to condition grade correlate with those for damage factors will undoubtedly be of interest. It can be expected that the relationship will be indicative of the causes of deterioration.

Analysis: Scatter diagrams, correlation coefficient (if necessary).

Output: Tables, but principally graphs. For example, the table 'Condition grades by damage types' in Exhibit 9C shows that all the objects in condition grade 4, Unacceptable, have suffered major structural damage.

Conclusions on audit data analysis

All this is very simple information, invaluable for collections care and management, and planning conservation. However, it is characteristic of

Fig. 9.5 *The hierarchical nature of museum collections data. Large or complex institutions will have more organizational tiers in their collections*

collections information generally that it can be analysed in the same way at many different hierarchical levels (Fig. 9.5). This means that many separate, though similar, audit analyses need to be performed. These in turn result in piles of tables, diagrams, etc. It can be a daunting task to make full use of the information, to draw conclusions, and to quantify and plan work. It is also quite an undertaking to extract a general view. The complexity of actually making use of the information from audits is the main reason for urging that only really essential data be collected.

Reports of audits

The presentation of data and information from audits should follow the rules of good practice set out by Chapman (1986).

The readership of the report should be considered. If it is a detailed report to a curator or within the conservation department it can be full,

but if it is a high-level report to councillors or trustees it should be much briefer. Ask yourself, 'What do I expect to happen when the [trustees] have read this?', or, 'If I were a [trustee], what would I need to know so as to understand the significance of this report?'. A collections condition audit report could potentially include a lot of information, but much of it can be brief. Some areas, particularly those relating to the causes of deterioration, would be explored in depth through a complementary preventive conservation survey. To avoid duplication they should only be touched on in a collections condition audit report. See also Table 9.1.

Different collections often need separate, mini-reports of their own. The digestion and summarizing of many separate reports, even if they follow a common format, is (like really understanding the data) a considerable task.

Monitoring condition over time

If a new random sample of the collection were to be taken for each re-auditing exercise, few if any objects would be common to both audits. Any real change in the overall state of the collection might be masked by the variability introduced by the sampling procedures. The best way around this may be for subsequent audits to include a subset of the original sample in the new sample, probably about a third of the original. More detailed logging of data on the subset may be required in order to spot differences more easily. The subset would provide a benchmark against which the other parts of the audit can be measured. The subset itself would have to be randomly selected.

There is some work based on this, and on using particular types of object as tell-tales on condition. This is especially relevant for mineral or fossil specimens, many of which become unstable outside a particular range of relative humidities (SPNHCC-CC Assessment Sub-Committee, 1990).

Case study

The Historic City Museum conservators had carried out collections condition surveys from time to time, as part of their drive to set work priorities based on the needs of the collections. Although they had long realized that they only needed the minimum data, it was their practice to inspect every object rather than just a sample. Although the conservators knew that surveying was important, they found it very boring. One of the conservation sections had been particularly active, and over eighteen months they had surveyed around 5000 objects. One day, one of these

conservators was talking to a statistician working on the analysis of pottery for archaeology reports. They explored the concept of extrapolating the results from samples to a whole collection. The conservator described the results of the collections surveys. The statistician scribbled a few figures on the back of an envelope, and announced that if what they were interested in was the condition of the collection rather than each object then results just as reliable could have been obtained by surveying 500 objects out of the 5000. From that day forth, the conservation department was utterly convinced that sample surveys were the way for the future.

The sampling approach soon came into its own. In 1989, the department noted with great interest the publication of the Public Accounts Committee report (Committee of Public Accounts, 1989). It was highly critical of collections care in national museums. In response to this, a Strategy Proposal for the preservation of the collections was written and presented to the senior management (see Chapter 10, Exhibit 10B). The acceptance of this report authorized a comprehensive audit of the state of care of the Historic City Museum collections. Obviously, this had to be rapid: if it took years, everyone would have forgotten about the report. They decided that six person-months should be enough to broadly assess the condition of the collections, and get a better idea of their size. They managed to obtain extra funding for this amount of time. The additional parts of posts were divided equally between three conservation sections (the fourth had already completed surveying its collections).

Involving the Director and Deputy Director ensured that the results of the audits would be accorded due respect. The Deputy Director called a meeting for all curators, in which the Head of Conservation presented the project, and requested curatorial cooperation and assistance.

The audits and reports

Pilot surveys were carried out on all collections, so as to calculate how the time available should be used. Some of the audits had a formal statistical design (prints and drawings: 25 per cent of the objects in each of 40 solander boxes (2 per cent of the objects in the collection); and social history: every eighth object in every fourth store location). In others, an informal sample design was used (costume: every fifth object). Some pilot audits are described in Exhibit 9A.

The audits themselves were all completed within the given time, including analysing the results and writing reports on individual collections. Examples of some of the statistical results are shown in Exhibits 9B and 9C; of graphs, in Fig. 9.4. See also Kingsley and Payton (1994), for a description of a later condition audit.

The Head of Conservation undertook the task of understanding and summarizing the contents of twelve individual (though succinct) reports and their data. This experience caused her to resolve that audits on this scale should collect only the minimum data necessary. As she eyed the twelve box files full of paper audit forms, and tapped the same column of figures into her calculator for the third time just to be sure, she also resolved that audit data should thenceforth either be collected using laptop computers or else be transferred to them immediately as part of the audit task.

Consequences

So that the results for each collection could be seen in context, reports on individual collections were only issued to curators once a summary report had been compiled by the Head of Conservation. The summary report was circulated to all curators, with a copy of the relevant individual report. A meeting was held for collections staff, in which the conservators felt that the world was now composed of two sorts of curator: those who were aggrieved because they felt that the audit results criticized the way they had cared for their collections; and those who were aggrieved because their collections had not yet been audited. It was pointed out that an honest recognition of problems, based on factual evidence, would help the museum to obtain the resources to remedy them and to prioritize work. A presentation of the audit results was subsequently made to the Board of Governors.

Having realistic figures for the size of the collections, and estimates of the size of the task of caring for them, had a major impact on the senior managers in the museum. The need for collections care was pushed higher up the museum's corporate agenda. Collections size tables have appeared in every annual report since they became available (and estimates have not changed much!). However, using the results to assess the actual amount of conservation resources required, in order to argue for increased resources, proved to be difficult. The statistical formulae are quite complex (see Exhibit 9D) and no computerized method of applying them has yet been developed, although this would not be difficult. In any case, there was clearly so much work to be done on each collection that simply to translate the analysis into arguments for a certain number of additional staff would be unrealistic. The results were therefore incorporated broadly into the first draft of a paper on strategy for care of collections.

The conservators concluded that *having the data available* carried nearly as much weight as did the actual statistics.

Conclusions

A lot of time and effort has been put into surveys: time which could be spent on treating and caring for collections. In the past, very large amounts of data have been collected, and too little use has been made of them. Major reasons are that surveyors launch into form design and data collection – surveying itself – without evaluating sufficiently carefully what it is they want to discover, and without undertaking a trial, or pilot, survey to try out the process from start right through to analysis and report stage. Without an overview, information at individual object level assumes more importance to the surveyor than information about collections. Yet it is information at collections level that really enables us to manage their preservation.

References

Buck, R. D. (1971). What is condition in a work of art? *Bulletin of the American Group-IIC*, **12**(No.1).

Cannon-Brookes, P. (1994). The 'Delta Plan' for the preservation of cultural heritage in the Netherlands. *Museum Management and Curatorship*, **12**, 303–7.

Chapman, M. (1986). *Plain Figures*. London: HMSO.

Cochran, G. W. G. (1963). *Sampling techniques*. New York: Wiley (2nd edn).

Committee of Public Accounts (1989). *Management of the collections of the English national museums and galleries. First Report. House of Commons: Session 1988–89*. London: HMSO.

Directorate-General for Cultural Affairs (1992). *Delta Plan for the preservation of cultural heritage, Fact Sheet C-11-E 1992*. Ministry of Welfare, Health and Cultural Affairs, P.O. Box 5406, 2280 HK Rijswijk, The Netherlands.

Getty Conservation Institute and National Institute for the Conservation of Cultural Property (1991). *The conservation assessment. A tool for planning, implementing, and fundraising*. Washington, DC.

Keene, S. (1991). Audits of care: collections condition surveys. Storage. In *Preprints of the RAI Conference*. London: UKIC.

Keene, S. and Orton, C. (1992). Measuring the condition of museum collections. *CAA91: Computer applications and quantitative methods in archaeology* (G. Locke and J. Moffett, eds), Oxford: British Archaeological Reports.

Kenyon, J. (1992). *Collecting for the 21st century. A survey of industrial and social history collections in the museums of Yorkshire and Humberside*. Leeds, Yorkshire and Humberside Museums Service.

Kingsley, H. and Payton, R. (1994). Condition surveying of large varied stored collections. *Conservation News*, **54** (July), 8–10.

Rowntree, D. (1981). *Statistics without tears*. Harmondsworth: Penguin Books.

SPNHCC-CC Assessment Sub-Committee (1990). Defining standard procedures for assessing the condition of a fluid-preserved collection. In *ICOM Committee for Conservation, 9th Triennial Meeting, Dresden, Preprints*. Marina del Ray, CA: ICOM Committee for Conservation Getty Conservation Institute.

Storer, J. D. (1989). *The conservation of industrial collections*. London: Conservation Unit/The Science Museum.

Walker, K. and Bacon, L. (1987). A condition survey of specimens in the Horniman Museum: a progress report. In *Recent advances in the conservation and analysis of artifacts*. London: Summer Schools Press.

Wiederkehr, R. R. V. (1984). *The design and analysis of a sample survey of the condition of books in the Library of Congress. Library of Congress Report*. Washington DC: Library of Congress (unpublished, but whence the introduction on the methodology is obtainable).

EXHIBIT 9A: Two pilot surveys in the Historic City Museum

Social history collection

An extremely mixed collection, number of objects unknown, a large proportion not on inventory. Objects ranged from jewellery to domestic items to vehicles, in eight different stores.

This survey was to be undertaken through a fixed term contract. Two person-months were available in total, totalling 44 person-days. Resources were allocated as follows:

Pilot survey:	4 person-days (including 1 day analysis and report)
Survey:	35 person-days
Analysis and reporting:	5 person-days

30 person-hours were allocated to the pilot survey. Half a day was allocated to each of eight stores. In each store, all the objects in a few store locations judged to be typical of the store were surveyed. In total, 684 objects were examined in 42 store locations. As well as surveying the locations, the surveyors drew a sketch map of the store showing the arrangement of racks, etc., and counted the total number of store locations.

1. Time spent on pilot survey (predetermined): 30 person-hours
2. Number of storage locations surveyed in the time: 42
3. Number of objects surveyed in the time: 684
4. Total number of storage locations (as counted in pilot survey): 2993
5. Mean number of objects per location: 16
6. Approximate total number of objects in collection: 49 000 (mean number per location × total number of locations)
7. Number of objects that could be surveyed in the time allocated for the survey: 171 objects per day × 35 person-days = 5985 (number of objects surveyed per person/day × person/days for survey)

Applying the formulae in Exhibit 9C to the detailed results of the pilot survey, the sampling design arrived at was to sample one location in 4, and within each location one object in 8. To ensure a random selection, a sequence is decided on for the store locations, for example, always start at the left hand end; work through each

rack bay by bay; in each bay of racks, start at the top and work down. A number between 1 and 4 is chosen at random (by drawing a ticket, or from random number tables) and the first store location is chosen by counting that number from the first one. Similar rules are developed for selecting objects within a store location (shelf, drawer, box, or free-standing).

Results (percentages of objects per condition grade):

	Grade 1 GOOD	Grade 2 FAIR	Grade 3 POOR	Grade 4 UNACCEPTABLE
Pilot survey:	60%	46%	15%	1%
Full survey:	47%	34%	12%	6%

Collection of works of art on paper

A well-organized collection of about 10 000 inventoried objects, kept in 684 solander boxes.

Time allocated for survey:
Pilot survey: 1 person-day
Full survey: 9 person-days
Analysis and report writing: 3 person-days

Pilot survey: 1 person-day. All objects in each of 6 boxes were surveyed.
Variability: 8 to 48 objects per box
Mean number of objects per box: 29.23
Survey rate: 37 objects per hour
2154 objects (20% of the total) could be surveyed in the time available

However, applying the formulae resulted in a survey design of 1 in 4 objects in each of 40 solander boxes: only around 272 objects, or 2% of the total.

Results (percentages of objects per condition grade):

	Grade 1 GOOD	Grade 2 FAIR	Grade 3 POOR	Grade 4 UNACCEPTABLE
Pilot survey:	5%	52%	35%	8%
Full survey:	6%	22%	56%	13%

Actual time for survey (22.2 objects surveyed per hour):
Pilot survey: 1 person-day
Full survey: 2 person-days
Analysis and report writing: 3 person-days

Exhibit 9B: Examples of results from collections condition audits in the Historic City Museum

Population statistics for the collections

Social history collections
Sample design: 1 in 4 locations; in each location surveyed, 1 in 8 objects.
Total objects calculated by: Total store locations/number of locations surveyed × number of objects surveyed × 8

	Store	Total store locations	Locations surveyed	Objects surveyed	Approx. total objects
Small objects	General	797	215	506	15 006
Small metals	Metal St.	42	12	27	756
Machines	West St. Gr.	473	137	367	10 137
Furniture etc.	West St. 1st	144	46	63	1 578

Costume and textiles collection
Sample design: every fifth object

	Store	Total store locations	Locations surveyed	Objects surveyed	Approx. total objects
Women's	Costume store	n/a	n/a	765	3825
Men's				266	1330
Accessories				693	3465
Children's etc.				175	875

Exhibit 9C: Examples of output from a simple database input and analysis program (Microsoft Works™)

LIST AS INPUT

sub-coll	Location	count	acc no	name	maters	CON	ma	mi	su	bi	ch	di	ol	ol	ac	work	remarks
toys	24t-sh3-rhs	12	87.171/7	cash register	stee;pain;pl	1									1		
toys	24t-sh5-rhs	10	nn	yo yo	stee;string;	1											
toys	24t-sh5-rhs		85.131	worm in appl	plas;meta;card	2			1								sellotape
toys	24t-sh7-mid	36	A.23501	ball	leat	3		1	1								seams broken
toys	24t-sh7-mid		82.218/6	cube	ston;pain	2											
toys	24t-sh7-mid		80.496/27	bead	glas	1											
toys	24t-sh7-mid		A.21901	ball holder	ivor	1											
toys	24t-sh8-r-ba	10	18835	ball	wood	1			1								
toys	26t-sh3	49	85.308/5	john bull prin	card;wood;me	1									1		
games	26t-sh3		85.524/12	game, wembley	plas;pape;ca	2		1			1						box broken
games	26t-sh3		81/486/25	game, twist	plas;card	2		1									box broken
toys	26t-sh3		84.375/6	kingfisher	felt;plas;ca	1											
toys	26t-sh3		84.413/28	basket weaving	plas;card	1											
toys	26t-sh3		84.447/18	citadel	card;plas;pa	1											
toys	26t-sh3		84.447/8	citadel giant	card;plas;pa	2		1									
dolls	box on floor	12	nn	doll	text;cera;me	2		1							1		box broken
toys	orange cr/fl	13	72.4/17	toy piano	text;wood;me	2						1			1		crumpled
toys	top of cupbs	6	82.117	model gallows	wood;meta;gl	2			1			1			1		textile frayed
models	modsl-sh2-t/	10	nn	2 horses	wood;pain	4	1								1		v. fragile
models	modsl-sh2-t/		nn	carr. + people	wood;pain	4	1								1		v. fragile

(cont. . . .)

Locations in audit: 20

Locations with enough objects to inspect: 19

Objects inspected: 60

STATISTICS BY STORE LOCATION
Counts and row per cents.

Location	Sub-coll	Count	Samp	Cond1	Cond2	Cond3	Cond4	Damage types							
								MA	MI	SU	BI	CH	DI	OL	AC
17t-sh4-fr	dollfur	22	2	0 0.0%	1 50.0%	1 50.0%	0 0.0%	1 50%	1 50%	0 0%	0 0%	0 0%	0 0%	0 0%	1 50%
17t-sh6-fr	dollfur	52	7	3 42.9%	2 28.6%	0 0.0%	2 28.6%	2 29%	1 14%	0 0%	0 0%	0 0%	0 0%	0 0%	2 29%
18t-sh2	dollfur	11	1	0 0.0%	1 100.0%	0 0.0%	0 0.0%	0 0%	1 100%	0 0%	0 0%	0 0%	0 0%	0 0%	1 100%
20t-sh1-rh	models	80	10	7 70.0%	3 30.0%	0 0.0%	0 0.0%	0 0%	0 0%	3 30%	0 0%	0 0%	0 0%	0 0%	0 0%
22t-sh1-rh	models	6	1	0 0.0%	0 0.0%	1 100.0%	0 0.0%	0 0%	0 0%	0 0%	0 0%	1 100%	0 0%	0 0%	0 0%
(cont.)															
Totals:		471	60	29 48.3%	22 36.7%	4 6.7%	5 8.3%	7 12%	9 15%	11 18%	0 0%	4 7%	3 5%	1 2%	22 37%
				Cond1	Cond2	Cond3	Cond4	MA	MI	SU	BI	CH	DI	OL	AC

STATISTICS BY SUB-COLLECTION

Sub-coll	Count	Samp	Cond1	Cond2	Cond3	Cond4	Damage types							
							MA	MI	SU	BI	CH	DI	OL	AC
doll fur	85	10	3 30%	4 40%	1 10%	2 20%	3 30%	3 30%	0 0%	0 0%	0 0%	0 0%	0 0%	4 40%
dolls	12	1	0 0%	1 100%	0 0%	0 0%	0 0%	0 0%	0 0%	0 0%	0 0%	1 100%	0 0%	1 100%
games	0	2	0 0%	2 100%	0 0%	0 0%	0 0%	2 100%	0 0%	0 0%	0 0%	0 0%	0 0%	0 0%
models	238	32	17 53%	10 31%	2 6%	3 9%	4 13%	1 3%	7 22%	0 0%	3 9%	1 3%	1 3%	13 41%
toys	136	15	9 60%	5 33%	1 7%	0 0%	0 0%	3 20%	4 27%	0 0%	0 0%	1 7%	0 0%	4 27%
Totals	471	60	29 48%	22 37%	4 7%	5 8%	7 12%	9 15%	11 18%	0 0%	4 7%	3 5%	1 2%	22 37%

TABLE OF CONDITION GRADES BY DAMAGE TYPES
Counts and row per cents.

Condition grade	Damage types								Totals
	MAJ	MIN	SURF	BIOL	CHEM	DISF	OLD	ACCR	
1	0	0	1	0	0	0	0	7	29
	0.0%	0.0%	3.4%	0.0%	0.0%	0.0%	0.0%	24.1%	
2	1	8	7	0	1	3	0	11	22
	4.5%	36.4%	31.8%	0.0%	4.5%	13.6%	0.0%	50.0%	
3	1	1	2	0	2	0	0	1	4
	25.0%	25.0%	50.0%	0.0%	50.0%	0.0%	0.0%	25.0%	
4	5	0	1	0	1	0	1	3	5
	100.0%	0.0%	20.0%	0.0%	20.0%	0.0%	20.0%	60.0%	
Totals:	7	9	11	0	4	3	1	22	60
	11.7%	15.0%	18.3%	0.0%	6.7%	5.0%	1.7%	36.7%	

Number in condition grades:

				CHEM	DISF	OLD	ACCR	
				C1	C2	C3	C4	
Per cent.:				29	22	4	5	
				48.3%	36.7%	6.7%	8.3%	

Locs. sampled: 19
Locs. with too few objects: 1

Number of objects examined: 60
Tot. objects in all locs. in survey: 471

Average objects per location: 23.55
Maximum num. objects per location: 108
Minimum num. objects per location: 3
SD for counts of objects/location: 27.462

Exhibit 9D: Statistical formulae for the design and analysis of collections condition audits

FORMULAE FOR SURVEY CALCULATIONS
by Clive Orton

1. Notation

	Population	Sample
Number of locations	N	n
Number of items at ith location	M_i	m_i
Total number of items	M_o	
Proportion of items at ith location		
which fall into chosen category	P_i	p_i
Number of such items	Y_i	y_i
Proportion of such items overall	P	p
Number of such items overall	Y	y

Sampling fractions are:

(locations)	$f_1 = n/N$
(objects within locations)	$f_2 = m_i/M_i$ (chosen to be the same for all locations)

Other notation:

Sum of all such items	Σ
Estimate	$\char`\^$
Mean	$-$
q is calculated as	$1 - p$

2. Estimating the number of items

If the survey does *not* cover all locations, $n < N$ and we do not know M:

Then we estimate M by $\hat{M} = N(\Sigma m_i/n) = N\bar{m}$

The standard deviation of \hat{M} is given as the square root of its variance, which is

$$\text{var } (\hat{M}) = (1 - f_i)N^2\text{var } (\bar{m}) = (1 - f_i)N^2\frac{\Sigma(m_i - \bar{m})^2}{n(n - 1)}$$

$$= \frac{N(N - n)}{n(n - 1)}\Sigma(m_i - \bar{m})^2$$

3. Estimating the proportion of items in a chosen category

We estimate P by $\hat{P} = \Sigma M_i p_1/\Sigma M_i = p$, since we use 'self-weighting' samples (i.e. $m_i/M_i = \text{const.}$)

Adapting a formula given by Cochran (1963: 302) leads to

$$\text{var } (\hat{P}) = \frac{1 - f_1}{n\bar{M}^2}\frac{\Sigma M_i^2(p_i - \hat{P})^2}{n - 1} + \frac{f_1(1 - f_2)}{n^2\bar{m}\ \bar{M}}\Sigma M_i\frac{(m_i)}{(m_i - 1)}p_i q_i$$

For any survey, where every location is sampled so that $f_1 = 1$, the first term disappears.

I used the formula for a simple sample,

$$\text{var} \,(\hat{P}) = (1 - f_2)pq/(m - 1).$$

This formula underestimates the true variance, and hence the s.d., if there are correlations between the condition of items at the same location. I therefore chose to ignore the correction factor $(1 - f_2)$ to compensate for a possible low level of correlation.

4. Estimating the number of items in a chosen category

This question is best approached indirectly, using $\hat{Y} = \hat{P}\,\hat{M}$.

Then $\text{var}\,(\hat{Y}) = \hat{P}^2 \,\text{var}\,(\hat{M}) + \hat{M}^2 \text{var}\,\hat{P}$

noting that $\text{var}\,(\hat{M})$ can be obtained from section (2) above
and $\text{var}\,(\hat{P})$ can be obtained from section (3)
and that if *all* locations are sampled,

$$f_i = 1 \text{ and var } (\hat{M}) = 0.$$

5. Survey design (from Keene and Orton, 1992)

We sample a proportion f_1 of the locations, with equal probability, and then a proportion f_2 of the objects at each location. Since the proportion f_1 is the same for all locations, this is a *self-weighting sample*. To estimate the overall proportion P we use the *ratio-to-size estimate*

$$\hat{P} = \Sigma M_i p_i / \Sigma M_i = p$$

(hence the term *self-weighting*). A formula for the variance in the general case is given by Cochran (1963: 302). By defining a dummy variable

$y_{ij} = 1$ if object j in location i belongs to the key category,
$\quad = 0$ otherwise, we have $p_i - y_i$, and this formula becomes

$$\text{var}\,(\hat{P}) = (1 - f_1)\Sigma M_i^2 (p_i - \hat{P})^2 / n\bar{M}^2(n - 1)$$
$$+ f_1(1 - f_2)\Sigma M_i(m_i/(m_i - 1))p_i q_i / n^2 \bar{m}\bar{M}$$

6. Designing samples for specific surveys

The task consists of striking a balance between the sampling fractions f_1 and f_2, depending on the relative variability between and within locations.

If all objects at a location are in similar condition, but the locations differ widely, we would need a high value of f_1 but a low value of f_2.

The overall size of the sample depends on the resources available and the time needed to survey – so,

fixed overhead per store:	c_0
overhead per storage location:	c_1
time per object:	c_2

Further,

average number of objects sampled per location:	\bar{m}
within location variance:	s_2^2
between location variance:	s_b^2

The overhead c_0 does not enter the equation directly, but must be subtracted from the total time available before the size of the sample is calculated. Factors c_1 and c_2 are best estimated from overall work rate figures, using linear regression.

Then, Cochran's formula (1963: 314) for optimal allocation:

$$m_{\text{opt}} = (s_2/\sqrt{(s_b^2 - s_2^2/\bar{M})})\sqrt{(c_1/c_2)}$$

10 Directions and strategies

A clear sense of direction and an agreed framework for action are widely thought to be among the most important factors for success in organizations. There is an interesting divergence of views, however, on exactly what is desirable by way of strategic planning, and on what can be achieved by means of plans and strategies. Many writers draw a distinction between longer term missions and value systems and short-term plans and targets. There is an argument that continually striving to meet targets is one of the causes of the ills that our Western, Protestant, work-orientated society brings: we might be better employed in developing long-term relationships. But objectives play such a dominant part in our culture that most of us would feel disorientated without them.

Terminology

There is little consistency in what different authors, or managers, mean when they use different terms. This is what is meant by the terms used here.

Strategy: an overall pattern of action for a long time ahead by which an organization means to achieve its high-level objectives. There are connotations of competitiveness.

Objectives: major or minor, long- or short-term, for the whole museum or for individuals, these are the things it is hoped to achieve. For example, to bring all stores up to the Museums and Galleries Commission's Standards for the care of collections would be an objective. A strategy might serve high-level objectives, or objectives might be set in pursuit of a strategy.

Policies: the rules on how the organization intends to behave in principle in most circumstances. For instance, an object will not be lent unless loan conditions are met by the borrower.

Procedures: how things are to be done generically: i.e. loan procedures set out the actions and the sequence required if any object is to be lent.

Plan: a course of action for either a specific project or for a work group for a shortish period of time (say up to two years). A plan will consist of a series of specific actions with indications of time and deadlines.

Targets: specific time or numerical quantities or tightly defined objectives to be met by means of a plan.

Goal: used by other authors with a variety of meanings.

Statements of purpose

A statement of purpose (often known as a mission statement) is a written encapsulation of the overarching aim of an organization. The proponents of mission statements claim that, if formulated through a process of consensus, they give a sense of direction to an organization. Klemm *et al.* (1991) review the history, content, and increasing prevalence of mission statements. The concept, they say, seems to have first arisen in the late 1950s, supported by Drucker in the 1970s, who stressed the need for a business to define its purpose. We have seen above (Chapter 3, Management and information) the powerful support that the need for an organization to make its purpose and values explicit has received from Peters and Waterman (1982), Ohmae (1982), and others. The concept is variously interpreted, the focus varying from underlying values to more specific objectives about scope, functions, etc. Klemm *et al* (1991) found that of 59 top European companies they surveyed, two-thirds had both mission and strategic objective statements. But of these, 70 per cent had drawn them up in the previous four years, so it is not clear how greatly their existence had contributed to success.

Mission statements have certainly caught on in museums. In 1987, the Museum of London held a series of public lectures by the directors of the major national museums. Every one of them had a mission statement, and they were swiftly followed by English Heritage, the Museum of London itself, and no doubt many others.

From the employee's point of view, such statements offer apparently firm ground on which to base working policies and procedures. But it is difficult to evaluate their real usefulness. Mission statements are in some museums being altered shortly after they have been written (at least one museum is onto its third version in as many years; English Heritage is onto its second in five years). While the intention may be that a mission statement will express priorities, at least for the medium term, and thus reduce the conflict between the different objectives in museums, it can also become yet another focus for such conflict. Many museums already have a 'mission' – the legislation, local government policy statement, etc., by which they are established, which expresses the intentions of the 'owners' of the museum: Parliament or the local authority.

The statutory functions or basic remits of the governing bodies of most publicly funded museums are on these lines:

1 To care for, preserve and add to the objects in their collections.
2 To secure that those objects are exhibited to the public and made available to persons seeking to inspect them in connection with study or research.
3 Generally to promote understanding and appreciation ... of [specific area or subject] both by means of the Board's collections and by such other means as they consider appropriate.

Some examples of mission statements for some museums with these statutory obligations are:

The British Museum: To hold in trust for the Nation, and in perpetuity, those parts of the national collections in its care.

The Science Museum: To promote the public's understanding of the history and contemporary practice of science, medicine, technology and industry.

The Museum of London: To make the history of London and its people, in all its diversity, intelligible to all.

Mission statements are for the whole organization rather than its parts. But it is obviously feasible for statements of purpose to be drawn up by the various operating units of an organization. This may carry the risk that units will pay more attention to their individual objectives than to that of the organization itself, especially if those units are controlled by professionals, who adopt standards set by external groups (Griffin, 1987, citing Mintzberg, 1983). However, institutions such as museums are essentially in the information business, and need 'knowledge workers'. They have no choice but to employ highly trained professionals. Debate in professional groups can often be wider ranging and deeper than in individual institutions, and outside professional standards help to counteract the inward-looking inertia which has afflicted some museums. Furthermore, professional bodies can influence public opinion, in the case of conservation, rather successfully.

A statement of purpose and role for conservation, then, is best founded on the organization's legislative remit. It could be expanded along the lines of one of the root definitions derived from the soft systems analysis, and supplemented by a description of the role of conservation, drawn from the objectives that have arisen from the analysis. This high-level statement should be developed and finalized in discussion with all the members of the conservation staff, and then sent out for general comment by curators and other relevant groups. It should be formally adopted by some senior management forum. The processes of formulating and adopting the statement will give the

major part of the benefit. An example of such a statement is given in Exhibit 10A.

Strategy and planning

A strategy sets out the framework by which longer term objectives can be reached. It will form the basis for more detailed short-term planning. A

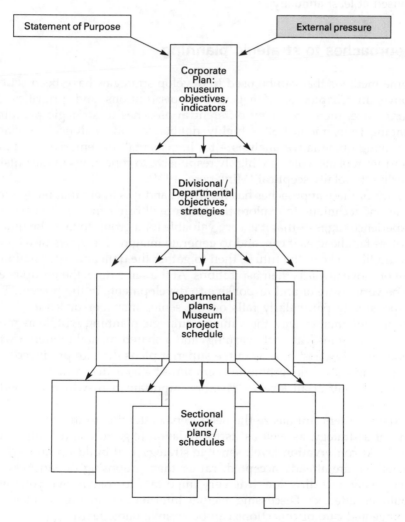

Fig. 10.1 *The relationship of statements of purpose, strategies, and plans*

strategy may be based on visionary intuitive feelings about the way the world will be, or at the other extreme it may be the outcome of a highly analytical process. The relationship between longer term strategy and more immediate planning is depicted in Figure 10.1.

Strategies particularly look a number of years ahead into what will give the institution a competitive advantage or better achieve its purpose in the future. Although a strategy may have a long-term objective, five years ahead is a maximum time-scale for practical strategies; indeed, it will often be found to be too long, since the world will change long before Year Five is reached. Plans even for two years ahead will need to be revised at least annually.

Approaches to strategic planning

Some methods that can be used to develop strategies have been set out above, in Chapter 5, Management tools: options and priorities. To summarize, there are many different approaches to strategic planning, ranging from 'moonshot' – highly deliberate and analytical, probably involving quantitative analysis – to 'incremental' or 'emergent' – fairly short-term plans which are highly responsive to conditions in the outside world – to totally sceptical (Mintzberg, 1994).

Each of these approaches has its virtue, and it is likely that using more than one technique to explore the future will bring the greatest benefit. Experience suggests that it is very valuable for a group to take the time to look as far ahead as it can, and to generate imaginative views of where it would like to be in the future, then to gather the data and information to test or move towards their aspirations. At the same time, the group needs to be very aware of and responsive to developments in the present. This responsibility particularly falls on the senior manager or leader of the group. Put another way, the value of strategic planning will lie as much in promoting institutional 'learning' and a shared mental model of what should be done and how as in the superior plans that are produced. The manner in which the technique is employed – by *diktat* from above or by involving staff at all levels – is more important than which method is employed.

Many writers emphasize the need to pay attention to the implementation of a strategy, as well as its formulation (e.g. Hay and Williamson, 1991). At conservation level, sensible strategy will build on and extend plans that are already accepted, rather than proposing departures in a completely new direction. It is very important to consult everyone who could be affected. Discussing factual information on the problems of storage and care of collections can be an invaluable learning process for the whole institution, if it can be persuaded to put time into this.

Strategic planning in museums

A strategy must take account of what the museum must do, but this will normally be taken care of by shorter term plans and day-to-day operational work. Strategic planning will more usefully be for the higher rungs of the organization's 'ladder of choice': what could we do that would give us a real advantage (Farbey, Land and Targett, 1993) (see Chapter 5, Options and priorities, Strategy development and Fig. 10.2)? But publicly funded museums are not like commercial companies. A major difference is that most of their funding comes not from the customers who most obviously and directly benefit from their services, but from local or national government. Museums have to keep an eye not just on the people who come through the door this year, but on the needs of users in a hundred years' time, and on those who pay for the service through taxes but do not physically visit. There are very few things that a publicly funded museum *must* do in order to survive. Especially in the context of collections conservation, the lowest rungs hardly exist. There are only sporadic pressures on museums (from national and district auditors and from peer opinion) to care for their collections.

Performance in areas such as visitor numbers is more likely to determine whether the museum thrives, but the major influence is probably the state of the local authority or other funding body's finances. The director's personal commitment to professionalism is more likely to determine whether priorities lie with the collections or elsewhere than is any perception of strategic advantage.

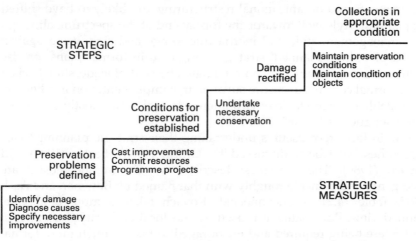

Fig. 10.2 *A strategic staircase towards the preservation of collections*

The Museums and Galleries Commission is pursuing an objective of fostering a commitment to high-quality collections care, and thus strengthening those bottom rungs of the ladder of choice. Their strategy for achieving this has several strands, for example, the Museum Registration scheme, in which museums must meet certain standards, including those for collections management and conservation (Museums and Galleries Commission, 1988), and their Standards in the museum care of collections series (Paine, 1992a,b, 1993, 1994). Their objective, however, is only valid in the context of a *Weltanschauung* in which museums are provided as part of a public service provision that is seen as a necessary good, and hold collections towards that end. In a different world view, if only the minimum essential services are to be provided publicly, then the existence of permanent public collections could become a net liability, not an asset. Museums, in seeking to gain strategic advantage, should perhaps be looking up the ladder for innovative ways in which the whole body of the collections can be made useful: otherwise, as many a trustee or councillor has asked, why are we keeping them?

Consulting Bowman and Asch's Table 14.2 (Bowman and Asch, 1987, Ch. 14), and placing museums as 'professional bureaucracies' (Griffin, 1987; Mintzberg, 1983, Ch. 10), we may predict that 'unconnected' strategies will have been found in museums in the past. These originate in enclaves: actors loosely coupled to the rest of the organization produce patterns in their own actions in the absence of, or in direct contradiction to, central or common intentions; strategies are emergent organizationally whether or not deliberate for the actors (Bowman and Asch, 1987: 366, 370).

This may sound familiar! However, changes in the environment and power structure of museums, arising from governments' accountability requirements and organizational restructuring, are likely to have shifted the planning style well towards the formal end of the spectrum, although their management style and inertia due to age and size weigh against formal planning. 'Planned' strategies originate in formal plans: precise intentions exist, formulated and articulated by central leadership, backed up by formal controls to ensure surprise-free implementation in a benign, controllable or predictable environment; strategies are mostly deliberate (Bowman and Asch, 1987: 366, 370).

How in fact are museums undertaking their strategic planning? Past approaches have been discussed by Griffin (1988), Foster (1985) and Kovach (1989). The processes described by Griffin and Foster are 'emergent', and coincide roughly with that named by Bowman and Asch (1987, Table 14.2) as unconnected; Kovach takes a more deliberate, planned view. Both national museums and local authority museums in the UK are being required and encouraged to take a much more formal approach, national museums through the corporate plans required by the

sponsoring government ministry (currently the Department of National Heritage (the DNH)).

Corporate plans

For several years now, government-funded museums in the UK, as in Canada, the USA, and Australia, have been required to produce corporate plans (Griffin, 1988). A corporate plan is produced annually. It covers the five years ahead, rolled forward each year.

Corporate plans for the national museums perform a number of functions. They are strategic planning documents, in that they set out plans for a rolling five-year period, with detailed objectives year by year. They are bids for finance, in that they contain proposals that can only be realized if funding is made available. They are reporting documents, with progress reported against the previous year's objectives. With the arrival of performance indicators, corporate plans also report the museum's performance against these. They are thus the nearest equivalent to a business strategic plan for those museums which produce them. Their format varies greatly, from text based with qualitative reports on performance, to strongly numbers orientated, with quantitative targets and measures.

A corporate plan should include broad strategy and some top-level plans for managing the preservation of the collections, since this is a primary function of a museum. When developing a conservation strategy, one objective should be to have a summary of it included in the corporate plan.

Strategy proposals

A strategy might be a 'hidden agenda', articulated only within the department. But there comes a point where, if the organization is to commit resources of finance and staff, a formal strategy proposal will have to be presented at a senior management level. It is in the strategy proposal that the results of formal analytical methods will be used, if they are. If bids for funding or agreement to major initiatives are sought then a strategy is likely to need a strongly analytical foundation. A strategy proposal should take account of as many factors as possible. It should set out alternative ways forward and recommend one or more, or perhaps that more information be sought. It should be used to inform senior management and gain their approval to general directions in which to work, so that more detailed planning can follow. As many interested parties as possible must be involved in its development, so that all the potential stakeholders 'own' it and do not disclaim responsibility when it comes to be implemented.

Strategies for conservation

Conservation departments are relatively small, relatively new, and many have a fairly analytical style in how they manage their affairs. In them, a formal, analytical planning style may usefully be developed. However, if the strategic planning process is too far out of step with that of the rest of the organization then it may suffer 'organizational invalidity': hostility or lack of credibility. If a strategy developed like this is to be accepted, then it will need to be presented very carefully. However, if the organization is being pushed in this unfamiliar direction the new approach may be welcomed if it is launched diplomatically. Conservation strategies may be more likely to command confidence if they are incremental rather than 'moonshot'. In practice, this would mean developing plans for one or at most two years ahead, and building confidence by regularly reporting progress against plans to senior management. This may sound very low key, but such an action can be seen as quite revolutionary if an organization is not used to consciously planning its affairs. Gradually, plans can be presented in more strategic terms for longer periods. Outside pressure for greater accountability from the museum can be used to accelerate the process: suddenly, a department with clear plans and monitoring becomes not an oddity but an asset.

It is not always necessary to be so cautious as the Museums and Galleries on Merseyside's bold plan to develop a new conservation centre shows. This plan was chosen in preference to less radical alternatives as the result of applying 'options appraisal', a consciously analytical and quantitative planning technique which is promoted and required by the DNH and the Treasury. A form of options appraisal was also used in determining a large investment in a new collections storage facility for the Science Museum.

A conservation strategy could be expressed as a strategic staircase (Fig. 10.2). The first step, to define preservation problems, could prompt a programme of stores assessments and collections condition audits (see Chapter 8, Information for presentation, and Chapter 9, Collections condition). The steps thereafter, establishing conditions for preservation and rectifying damage, may well not be serial across all the collections, but be undertaken in parallel for particular collections or stores. There may well be a series of internal papers, to raise institutional consciousness, to get agreement to broad directions, to develop more detailed plans and to report progress. Each step should lay the foundation for the next step, and reinforce the idea that something serious is being undertaken.

Case study: strategies for conservation

In late 1988 the Auditor General's report, *Management of the collections of the English national museums and galleries*, was published. This was followed in the new year by the grilling of the directors of the Victoria and Albert and British Museums by Parliament's Public Accounts Committee. The Historic City Museum conservators were thrilled to see the ensuing headlines in the national newspapers: 'A case of arts for oblivion', 'Museums fail to care for nation's treasures', 'Museum treasures decaying', 'MPs warn of disastrous failure', 'Museum admits disastrous failure' (see Keene, 1991). Clearly, this was the moment to try some emergent strategy making for the Historic City Museum collections. Although the conservators knew well enough what the problems were, there was no time to quantify and analyse. What was needed was a plan to plan, which would elicit the agreement of the senior management to some practical steps forward, and prepare the ground for a subsequent fuller approach. A succinct report (see Exhibit 10B) was rapidly written, and presented to the Director and the senior management team.

Although it had been written in a short space of time, the report was carefully considered. It drew attention to the museum's legislative remit, and to the fact that other museums had been checked up on and publicly found wanting. It pointed out that the museum, however, was not unique in having problems. It stated that the situation was serious, but that the museum already had some plans (the stores improvements) to address defects. It recommended several practical actions that should be taken, which would need staff time, and therefore management consent, but not at this stage extra funding.

The acceptance of the first strategy report prompted the development of the collections condition audits (see Chapter 9) and the stores assessments (see Chapter 8).

Based on the results of the condition audits and stores assessments, the process of drawing up the fuller Strategy for the care of collections began. A whole-day seminar of the Conservation Department was held. The objectives derived from the soft systems analysis were reviewed; with slight amendments they were taken to represent the desired future state of affairs. The information gathered in the collections condition audits was then matched against the key success factors which had been identified in the systems analysis (see Chapter 7, Table 7.3). Each conservation section then reported on its respective stores survey, illustrated with slides.

The record of the discussion was used to draw up alternative courses of action. This resulted in a new draft strategy proposal (summarized in Exhibit 10C). This was carefully titled a Discussion Paper, so as to allow for input both from senior management and from curators and other

museum departments. Important features were that it built on existing plans for stores moves and improvements rather than proposing a radical new set of plans, and the clearly identified need for greater input and attention to care of collections work by senior management.

The paper was broadly accepted by the senior management team, and the Deputy Director arranged a meeting for both curators and conservators, so that input from all sides could be sought. This wider meeting was a fairly stormy occasion, since the curators felt that criticisms of shortcomings were aimed at them. In defence they cited many incidents where, they said, conservators had exacerbated or ignored problems. However, the meeting ended with agreement that, whatever the cause of previous problems, this was now in the past, and that the newly outlined strategy was a practical way ahead. Both curators and conservators agreed on the fundamental importance of proper budgets for stores and storage equipment, and of the support of senior management for collections care.

The new strategy can be seen as a strategic staircase (Fig. 10.2).

Case study: review

Discussing detailed factual information on the problems of storage and care of the whole of the collections was an invaluable learning process for the whole museum. The processes provided the whole Collections Division with an unrivalled overview of all the collections, not just the ones each Section was familiar with. The defensive attitude of curators might have been mitigated had they taken a greater part in the condition audits and stores assessments. On the other hand, this might just have delayed the process. Also, it was a positive senior management policy that the conservation department should adopt a high profile, active stance, and the conservators' assertive action in undertaking the surveys and presenting the reports served to underline that they meant to use their new powers. It was important for the conservators to establish the attitude of management and the extent of their powers in advance: had they not had support they would have had to adopt a much more conciliatory approach. This would probably have been effective with some curatorial departments, but not with others, and it would certainly have been very time consuming.

Conservation policies

Policies should translate the organization's guiding purpose, values and mission into statements which lay out the rules on how the organization intends to behave in principle in most circumstances. Policies can be

difficult to distinguish from strategies. For example, it may be the museum's policy that objects in the collections should not be avoidably deteriorating. One strand of a strategy to achieve this might be to vacate stores which do not meet requisite standards, but this strategic measure could also in some contexts be described as a policy.

Policies should refer to accepted standards or guidelines. In the UK, there are two major sets of museum standards: the UK Museums Documentation Standard (Grant, 1994), which sets out many of the principles for collections management, and the Standards in the Museum Care of Collections, being drawn up by the Museums and Galleries Commission (e.g. Paine, 1994). As well as these, there are relevant standards for libraries (e.g. BS 5454) and archives, and for the storage of photographs and other media. Standards are discussed in greater detail in Chapter 8.

Measuring performance

The performance indicators which are used by an organization have the potential to greatly influence its priorities and directions. Performance indicators have been in common use in museums since, in Autumn 1991, the government department for museums, the then Office of Arts and Libraries, requested national museums to produce performance indicators starting from 1992–93. The response from museums has been patchy, some adopting them with enthusiasm, others taking the view that performance measures were too crude to be usefully applied in museums and galleries.

For collections care, it is important to find performance measures that carry as much weight as those for public programmes, which have the advantage of high-profile measures such as visitor numbers and financial performance.

Measuring performance in preservation

One scheme of indicators for museums is described by Ames (1988). He follows Handy's useful recommendation: every number should be a proportion of some other number (Handy, 1988: 129–30). Ames advocates using the amount of finance devoted to different activities as the main measure, this being, he says, the most objective assessment of a museum's true priorities. His proposed measure for care of collections is 'Conservation budget as a proportion of number of objects in the collection.' Although conservators might enthusiastically support such a measure (if more meant better), it does not measure the actual preservation of the collections.

In Australia, a report on performance measurement was published in 1991 (Cultural Heritage Branch of the Department of the Arts, Sport, the Environment, Tourism and Territories, Australia, 1991). It proposes measures against a specified 'outcome'. Though straightforward and easy to administer, these measures still miss the real point: are the collections being preserved?

Outcome: The collection, preservation, documentation and management of natural and cultural heritage of significance to Australia

Criteria:

1 A collection policy appropriate to the objectives of the institution.
2 A comprehensive collection in conformity with the collecting policy.
3 An appropriately documented, maintained and preserved collection.

Measures:

1 Percentage of the collection adequately controlled; conserved; documented; housed.
2 Degree of endorsement and/or complaint about the collection.
3 Percentage of collection lost or damaged.

Bud, Cave and Hanney (1991) set out another scheme, for the UK, with a different terminology. They identify preservation as one of only three areas to be measured, and suggest three practical indicators:

● per cent of objects adequately stored
● cost of storage per item
● per cent of objects in good condition

'Cost per item' is not really useful, because it will vary wildly according to the size of the object and environmental requirements, and penalize better storage; but the other two indicators go straight to the point.

The Auditor General's report on collections in the national museums reviewed storage conditions; the conservation backlog; and the lack of information on the scale of the problem relating to collections conservation (Comptroller and Auditor General, 1988). But when the UK Office of Arts and Libraries launched their performance indicators scheme in 1991 (Office of Arts and Libraries, 1991), with a report from a study by the management consultants Coopers Lybrand Deloitte, the performance indicators for collections care were unfortunately far less specific than those for other museum operations. Two indicators were identified:

1 A clear high-level statement on the institution's policy for collections care.
2 Objectives for necessary action, assessed against the policy by applying a three-dimensional analysis, the dimensions being the use of the collections, the standard of curation, and the collection unit.

Instead of specific measures for collections preservation, success was to be assessed by an external peer review group, referring to the institution's plans and targets as above. Leaving the measurement of performance in this important area so general gives it no quantitative weight to balance the simplistic measures that can be applied to display and public programmes. This is unfortunate, when conservation and preservation are the subject of so much quantitative measurement, and of well-established standards, especially for the storage and display environment. For example, the two UKIC surveys of museum facilities, in 1974 (UKIC, 1974) and 1989 (Corfield *et al.*, 1989) present information on proportions of display and storage areas which are monitored, which have a controlled environment, etc. Experience suggests that peer review carries considerably less weight than do quantitative measures, despite the problems associated with these.

Much better is the performance indicators scheme set out by the Audit Commission, the local government watchdog. The precursor report, *The Road to Wigan Pier* (Audit Commission, 1991), suggests reporting two very useful measures:

- Number and proportion of objects held under suitable storage conditions.
- Progress in providing suitable storage conditions (e.g. number and proportion of objects transferred to suitable stores during the year).

The Commission's Audit Guide for museums, the arts, cultural activities and entertainment, sets out comprehensive indicators for collections care, and these are reproduced in Exhibit 10D.

Performance indicators in practice

When UK museums themselves were surveyed for current practice in 1993, the Museums Association found that over 80 per cent of museums supply performance information to their governing bodies (Museums Association Public Affairs Committee and University of Leeds School of Business and Economic Studies, 1994). The report found that performance indicators are also used in strategic decision making; in satisfying external information demands; in monitoring the use of resources and supporting bids for resources; and in identifying areas for management attention. Respondents were offered a selection of ten 'commonly used' indicators, none of which related to collections care. The four key indicators were found to be cost per head of population; cost per visit; income as a proportion of gross costs; and documentation backlog as a proportion of the total size of the collection. In fact, in spite of its identification as a key area for concern by both the Auditor General and

the Audit Commission, the care of collections is not mentioned at all in the survey.

Discussion: performance indicators for conservation

In the words of a *Guardian* journalist, writing of the push for accountability in public services,

> what matters is not the activity of these agencies [the Health Service and the Department of Social Security], but the standard of health and the level of poverty. (*The Guardian*, 1989)

What truly matters for conservation? One way to analyse this, widely cited in management literature but not adopted in any of the published papers seen, was put forward as long ago as 1979 (Rockart, 1979). This technique is first to understand what the organization is truly doing; from this, to set out objectives; then, to identify the factors which are critical for success. From these factors, measures are easily derived. A comprehensive scheme is set out in Exhibit 10E: this could form the basis for an annual report on conservation, with objectives 1 and 2 included in a corporate report.

None of the museum schemes proposes as a measure the number of objects treated. This is sensible, as figures on this should immediately prompt the question: *why do all these objects need treatment*? More relevant would be to ask how many objects do not need treatment: more useful is to measure damage prevention (widely accepted to be a much more effective use of resources) by assessing adherence to standards. The actual condition of collections can only be assessed if 'condition' can be categorized in some way, such as the scheme described in Chapter 9, above.

Performance measurement could be seen simply as 'how we keep on course for success in our strategies', and if used only in an internal monitoring process this is more or less what it would be. What makes a difference is if numerical measures predominate, if they are used in targets, and if they are used in external reporting. Proponents of the market and competition-driven model of the world say that opening up the affairs of museums to at least semi-public scrutiny is exactly what will raise standards. Sceptics maintain that performance measures fail to address the multiple objectives and multiple criteria which apply in not-for-profit and public service organizations. This has given rise to 'Goodhart's Law': if a measure is used as a target, or plan, or objective, it ceases to be a good measure. It is really very encouraging to observe that the ingenuity of the people affected by formal schemes far exceeds that of the designers of the schemes. Simple figures can always be subverted, if

indeed they do not promote exactly the opposite of what their creators intend: the real world is far too rich and interesting a place to fit into the impoverished perceptions of political theorists.

Conclusions

This chapter has reviewed the ways in which museums and conservators can address the high-level matters which set the framework for success in conservation and give conservators and all those concerned with conservation the sense of direction that they need. Two general views exist. Perhaps people do need a rallying cry, a summit to strive for. On the other hand, Checkland and Vickers, among others, argue against the goal- and target-orientated view that dominates affairs in our Western world. Instead, they say, what is important is to take the long-term view, to foster and maintain relationships over time. Instead of having constantly changing *targets*, our long-term *strategy* should be to achievement balance with our partners and our world.

> To get the job or marry the girl is indifferently an end, a means and a goal; it is an opportunity for a new relationship. But the object of the exercise is to do the job and live with the girl; to sustain through time a relationship which needs no further justification but is, or is expected to be, satisfying in itself. (from Sir Geoffrey Vickers, *Freedom in a Rocking Boat*, 1972)

Even Peters and Waterman, those fashionable gurus, say that if asked for 'one all-purpose bit of advice for managers' they would be tempted to reply, 'Figure out your value system. Decide what your company stands for' (Peters and Waterman, 1982, Ch. 9). This is not the approach of short-term goal-orientated performance league tables. And W. E. Deming, the founding architect of total quality management, gives fourteen points for management if they are to achieve true quality. Point 10: 'Drive out slogans, exhortations and numerical targets.' Point 11: 'Eliminate quotas or work standards, and management by objectives or numerical goals.' Deming cites 'deadly diseases' that afflict Western management style, including:

1 A lack of consistency of purpose
2 Emphasis on short-term goals (especially profits)
3 Evaluation of performance, merit rating or annual review
4 Mobility of management
5 Management only by the use of visible figures, with no consideration for unknown figures. (from Munro-Faure and Munro-Faure, 1992: 292–3; Aguayo, 1990.)

These quotations illustrate that the view which is currently fashionable in the UK is not the only one that can be sustained, and that it is rejected by some of the most respected and successful management writers around. The surveys cited in Chapter 3 illustrated the extremely broad divergence of view on management style in different countries. The best approach can be expected to be a mixture of techniques and approaches. For real motivation, people need a sense of direction, but they also need values; encouragement to work hard shows that their contribution is important, but they also need to feel that they are in some degree in control of their work. Finally, they need performance measures, perhaps proposed and initiated by managers, but developed by the managed and used for them as well as for their managers as a means of monitoring progress towards the agreed ends.

References

Aguayo, R. (1990). *Dr Deming: the man who taught the Japanese about quality.* London: Mercury Books.

Ames, P. J. (1988). A challenge to modern museum management: meshing mission and market. *Int. J. of Museum Management and Curatorship*, 7, 131–57.

Audit Commission (1990). *The Audit Guide: museums, the arts, cultural activities and entertainment.* London, HMSO.

Audit Commission (1991). *The road to Wigan Pier?* Audit Commission Local Government Report 1991, no. 3. London: HMSO.

Bowman, C. and Asch, D. (1987). *Strategic management.* Basingstoke: Macmillan.

British Standards Institution (1989). *BS 5454: 1989. The storage and exhibition of archival documents.* Milton Keynes: BSI.

Bud, R., Cave, M. *et al.* (1991). Measuring a museum's output. *Museums Journal* (January), 29–31.

Comptroller and Auditor General (1988). *Management of the collections of the English National Museums and Galleries.* National Audit Office Report. London: HMSO.

Corfield, M., Keene, S. *et al.*, eds (1989). *The Survey.* London: UKIC.

Cultural Heritage Branch of the Department of the Arts, Sport, the Environment, Tourism and Territories, Australia (1991). *Report on the outcomes of a consultancy to develop performance indicators for national collecting institutions,* by C. Scott.

Farbey, B., Land, F. *et al.*, (1993). *How to assess your IT investment.* Oxford: Butterworth-Heinemann.

Foster, R. (1985). Programme planning. *The management of change in museums. Proceedings of a seminar held at the National Maritime Museum, Greenwich* (N. Cossons, ed.) London: National Maritime Museum.

Grant, A., ed. (1994). *SPECTRUM: the UK museum documentation standard.* Cambridge: Museum Documentation Association.

Griffin, D. J. G. (1987). Managing in the museum organization: I. Leadership and communication. *Int. J. of Museum Management and Curatorship*, 6, 387–98.

Griffin, D. J. (1988). Managing in the museum organization. II. Conflict, tasks, responsibilities. *Int. J. of Museum Management and Curatorship*, **10**, 11–23.

Handy, C. (1988). *Understanding voluntary organizations*. Harmondsworth: Penguin Books.

Hay, M. and Williamson, P. (1991). Strategic staircases: planning the capabilities required for success. *Long Range Planning*, **24**(4), 36–43.

Keene, S. (1991). Audits of care: collections condition surveys. In *Storage. Preprints of the RAI conference, London*. London: UKIC.

Klemm, M., Sanderson, S. *et al.* (1991). Mission statements: selling corporate values to employees. *Long Range Planning*, **24** (3), 73–8.

Kovach, C. (1989). Strategic management for museums. *Int. J. of Museum Management and Curatorship*, **8**, 137–48.

Mintzberg, H. (1983). *Structure in fives*. New Jersey: Prentice Hall International.

Mintzberg, H. (1994). *The rise and fall of strategic planning*. Hemel Hempstead, Prentice Hall.

Munro-Faure, L. and Munro-Faure, M. (1992). *Implementing Total Quality Management*. London: Financial Times/Pitman Publishing.

Museums Association Public Affairs Committee and University of Leeds School of Business and Economic Studies (1994). *The use and value of performance indicators in the UK museums sector*. London: Museums Association.

Museums and Galleries Commission (1988). *Guidelines for a registration scheme for museums in the UK*. London: Museums and Galleries Commission.

Office of Arts and Libraries (1991). *Report on the development of performance indicators for the national museums and galleries* (Coopers Lybrand Deloitte, consultants).

Ohmae, K. (1982). *The mind of the strategist*. Harmondsworth: Penguin Books.

Paine, C. (1992a). *Standards in the museum care of archaeological collections*. Standards in the museum care of collections, no. 1. London: Museums and Galleries Commission.

Paine, C., (1992b). *Standards in the museum care of biological collections*. Standards in the museum care of collections, no. 2. London: Museums and Galleries Commission.

Paine, C., (1993). *Standards in the museum care of geological collections*. Standards in the museum care of collections, no. 3. London: Museums and Galleries Commission.

Paine, C. (1994). *Standards in the museum care of larger and working objects*. Standards in the museum care of collections, no. 4. London: Museums and Galleries Commission.

Peters, T. J. and Waterman, R. H. Jr (1982). *In search of excellence*. London: Harper and Row.

Rockart, J. F. (1979). Chief executives define their own information needs. *Harvard Business Review*, **57** (2, March/April), 81–93.

United Kingdom Institute for Conservation (1974). *Conservation in museums and galleries*. London: UKIC.

Vickers, G. (1972). *Freedom in a rocking boat*. Harmondsworth: Penguin Books.

Exhibit 10A: Conservation: statement of role

- To monitor the preservation of the collections by periodic audits of condition
- To conserve and clean the objects in the collections, so as to maintain their historic and physical integrity, and ensure their best possible appearance when on display
- To monitor the environment and other damage prevention measures, and take or initiate appropriate action
- To research and develop treatments for these collections, especially the particular materials and objects in the museum's collections
- To advise on and monitor the effects of display or demonstration on objects; to maintain such objects
- To provide and organize training for staff and for others in the museum in conservation, preservation, and the protection of objects
- To contribute to all the museum's activities as effectively and efficiently as possible

Exhibit 10B: The Historic City Museum's first conservation strategy paper

The Historic City Museum

STRATEGY PROPOSAL: THE PRESERVATION OF THE COLLECTIONS

1. Purpose of this paper

This paper has been written for the consideration of the Director and Deputy Director, following the Auditor General's report, to anticipate what the findings might be should this museum be similarly assessed. It presents a summary of the situation and recommends further action to be undertaken within the next two years.

2. Context: the present situation

At present a very high proportion of the collections can be estimated to be actively deteriorating, due to:

- Overcrowded and unsuitable stores with poor or no environmental or dust control
- Displays in which the design actively promotes deterioration
- Acquisition policies which have until recently taken no account of whether there is space to house or resources to care for additions to the collections
- Too few staff to treat objects to reverse deterioration or to otherwise care for them.

This situation must be of serious concern: the Museum is clearly not performing its duty '. . . to preserve and care for the collections'. In this it is not alone. The recent report from the Auditor General, discussed by the Public Accounts Committee, has highlighted similar deficiencies in the national museums, and this has drawn widespread attention in the press.

3. Conclusions

Substantial improvements to the care of the collections are already planned, but they need to be extended. We should capitalize on the current climate of public concern by assessing our problems, extending our existing plans, and costing the implementation, in order to make our own response to these public reports.

4. Recommendations: action needed

The Museum should take advantage of this climate of opinion to develop a clear strategy for preserving its own collections, and then to seek additional funding to achieve this. Several of the improvements outlined below are already planned or are being implemented. However, other improvements, for instance the resources needed for remedial treatment, have not been planned. We now need to draw together these lines of action into:

- A clear strategy for improvements as a whole, with a coordinated plan for implementation
- Quantification of what needs to be done
- Realistic costings for both resources and staff

5. Outline strategy

Management: ensure that the preservation function is represented at all levels of the museum's management

Storage: vigorously develop existing plans for improved collections storage

Displays: when galleries are rebuilt, take advantage of this to incorporate best conservation practice in the design. Undertake a Galleries Refurbishment programme, working through existing galleries to upgrade displays and treat objects

Acquisitions: develop much tighter acquisition policy and assess resource implications before decision is taken to acquire

Remedial conservation required: identify priority areas in collections through sample condition audits; estimate work required; undertake more detailed condition surveys of targeted collections; quantify resources needed

Resources: Quantify staff requirements for both galleries programme and also preservation programme; cost; develop proposals; seek funding.

Conservation Department

Exhibit 10C: The Historic City Museum's second strategy paper (summary)

THE HISTORIC CITY MUSEUM: STRATEGY FOR THE CARE OF THE COLLECTIONS

Summary

This discussion document builds on its predecessor, the Strategy Proposal for the Preservation of the Collections (1989). Since then, the Condition Audit of the collections has been completed; the collections have been

quantified; the New Stores Plan has been approved and is under way; and the Condition Audit has been supplemented by a detailed Stores Assessment Survey. The present strategy report is the basis for developing practical, detailed annual plans for improving the condition of the collections, which will be built into the Museum Plan.

Recommendations

A prerequisite is for the museum to define or adopt standards, for both preventive care and for the condition of the collections.

Collections care needs greater commitment and input from senior management. This should take the form of a Care of Collections committee, chaired by the Deputy Director. This will balance the work of the effective and active Publications and Exhibitions Committees.

To complement the Collections Condition Audit, a Storage Survey has been undertaken covering each collections store. Detailed results and recommendations are available. Actions have been listed and progress can be monitored.

Our proposals for how to move forward use the plans for stores moves as a basis for action. Broadly, as each collection is moved the objects should be cleaned and repacked, and improved storage equipment purchased.

The storage space on the main site should be completely reviewed, and collections moved to more suitable stores where necessary.

Programmes of archival packaging, etc. for the paper collections should be established, concurrently with work on the three-dimensional object collections.

For remedial conservation treatment, specific projects should be set up, targeted at those collections shown to be priorities in the Condition Audits, but selected to take account also of their curatorial importance.

More staff time, and thus resources, will be needed for collections care, from the conservation, technicians, objects administration and curatorial groups. There needs to be a substantial budget for storage equipment and materials. Consideration should be given to contracting out certain large-scale tasks (e.g. making archival boxes, garment bags and padded hangers).

Conservation Department, 1994

Exhibit 10D: Possible performance indicators for collections management

(Those relating to conservation and preservation)

Objective	Possible measures
Storage (includes objects on display)	Number, proportions and value of the collections stored in suitable conditions
	Number, proportions and value of exhibits deteriorating because of unsuitable conditions
	Number and value of objects transferred to suitable conditions
	Cost of storage
	Proportion of the collection physically checked each year to ensure in a satisfactory condition

Source: Audit Commission, 1990

Exhibit 10E: A scheme of performance indicators for conservation

PERFORMANCE INDICATORS FOR CONSERVATION

OBJECTIVE 1: To maintain and improve the physical condition of the collections

Establish a programme for condition audits
Measures: Schedule for auditing condition established and adhered to Audits undertaken vs. plan

Maintain collections condition
Measures: % of objects per collection in stable or good condition. Change in % over time for each collection

Treat objects needing remedial treatment
Measures: Numbers of objects in worst condition treated vs. target

Develop improved treatments
Measures: Research and development projects completed vs. plan

OBJECTIVE 2: To prevent deterioration by ensuring an appropriate environment

Establish suitable environment: existing areas
Measures: Achievement of set standards

Establish suitable environment: new galleries or displays
Measures: Number of new displays or galleries vs. number in which conservation specifications were met

Maintain good standards of storage
Measures: Total number of stores vs. number reaching standard

OBJECTIVE 3: To contribute effectively to museum activities

Meet deadlines for exhibition preparation
Measures: Number of events vs. deadlines for preparation of objects for display, etc. met

OBJECTIVE 4: To raise awareness of preservation needs, and of the concepts and methods of conservation, of other professionals and of the public

Communicate through professional and other lectures
Measures: Number of lectures given by conservation staff

Encourage visits to the laboratory
Measures: Number of visits by individuals or groups to the laboratory or workshop

Take on students
Measures: Number of students taken on; source

OBJECTIVE 5: To make the most effective use of resources for preservation

Control use of time
Measures: Planned use of time vs. outcome

Work on top-priority objects
Measures: Of objects treated, % which were top priority for importance and need for treatment

OBJECTIVE 6: To acquire and maintain the necessary skills

Attend relevant courses, conferences, etc.
Measures: Number of courses, etc., attended: total, and per person*

Outside views of quality
Measures: Number of competitive grants obtained; source, publications in refereed journals

11 Planning and monitoring work

General directions can be set and broad strategies developed, but how do we get to where we want to be? At an operational level, objectives or targets need to be set for the work required to achieve strategic aims; plans need to be developed for the year or two years ahead; or perhaps projects need to be agreed and accomplished. Resources have to be allocated. Progress against plans needs to be monitored and reported. Operational plans for conservation have to interleave work for a museum's various front-of-house or curatorial projects with that for preventive conservation.

Because developments such as new galleries or exhibitions require capital expenditure, planning for interpretation activities in museums is often well developed. The need to attract visitors, coupled with the preference of curators for public activities, often means that interpretation takes over resources for cooperative inter-departmental work, while activities focused on the care of collections have a lower priority. The way to counteract this is to give plans for collections care activities a higher profile, to get actual projects and targets agreed. If you do not state what you wish to do, and exactly how it is to be achieved, then you have no hope of gaining support and cooperation.

Planning work and communicating plans

The best basis for planning work overall will be a strategic framework, on the lines discussed in Chapter 10. Once overall objectives exist, it is easier to set out the tasks that need to be undertaken to achieve them. But make no mistake – planning is hard work, needing time, concentration by managers, and discussion with all those who are doing the work. And unless progress is monitored and consequent action taken, planning is largely pointless, and will lead to disillusionment. Figure 11.1 illustrates the relationship of strategy, planning, monitoring and reporting.

There many approaches to work planning and scheduling. Three will be discussed here: development planning; management-by-objectives; and project planning. Development planning combines a view of broad

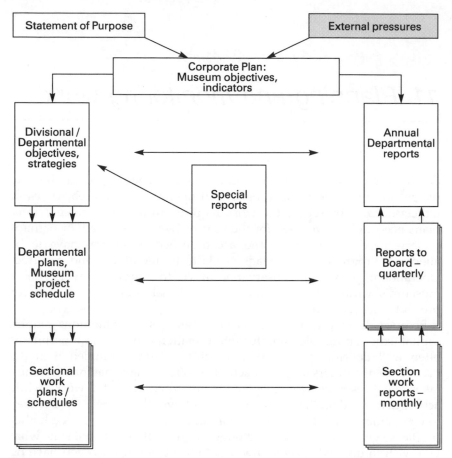

Fig. 11.1 *The relationship between strategy, planning, and monitoring*

objectives with more detailed plans for a few years ahead. In management by objectives, a detailed list of objectives for a time period, usually a year, is negotiated and agreed with each member of staff, in a cascade from the most senior to the most operational. Project planning is more and more familiar in museums, in areas such as exhibition production. It can be used more generally, however, if work is defined as chunks which are then treated as projects.

The problem with using general objectives arises when they are not translated into detailed work plans for individuals. Without a detailed plan for a year or so ahead, it is difficult for individuals to see how exactly they are contributing to general progress, however enthusiastically they may subscribe to the vision. The problem with management by objectives is the converse: the focus on individuals can mean that

CONSERVATION DEVELOPMENT PLAN, 1995-1998

Planning area	General aims	1995	1996	1997	1998
Policy development and implementation	Fully agreed conservation policies	Develop new policies with Collections Coordination Committee	Implement policies in NMSI		Review and revise policies
	Develop collects. care strategy: • Conservation requirements • Storage and preventive needs	Begin condition audits - Working City and Archaeology collects. Conduct stores assessment surveys	Collecs. condition audits - Appl A collecs Assess results, develop strategy Report, get action agreed	Collecs. condition audits - Costume, Paper Monitor action	Strategy for collecs conserv'n agreed - project staff bids Re-survey stores
	Appropriate policies re procedures for loans and acquisitions Good partnership with curators	First strategy report	Revise procedures, with Registry	Update strategy report	
Operations priorities	Effective work scheduling Improved work flow management	Improve and extend cooperation with other Divisions, e.g. Projects			
	Priorities: balance display projects with collections care	Tokyo loan (May) Galleries refurbishment - early 19cent. — Planning Prehistoric gallery Toys exhibition Feeding the City exhib. Steven Prior exhibition Costume Gallery + Theatre cases	Conservation of objects Conservation and installation	Conservation and installation Royal Robes exhibition?	
Preventive conservation	Develop overall approach to preventive conservation and cooperation from other Divisions	Pest control programme: monitor and develop Set up object transit store Identify priorities for gallery and stores environmental surveys	Develop conservation specifications Monitor environment in museum and develop improvements (with Estates Department)	Implement	
	Input to stores moves	Stores move planning + preparation	Metals + general stores Implement Implement	Paper store	
Staff	Have an agreed promotions policy Planned training programme	Develop policy Identify training requirements			
Public profile	Research	Effects of open display on objects Paper on new store to storage conf.			
	Promote and develop better understanding of conservation of social history collections		Possible UKIC conference on composite objects conservation		

Fig. 11.2 A development plan for conservation, looking several years ahead

general directions are lost sight of, and this can lead to a very short-term view, unless the process of longer term strategies and planning is also apparent.

The means by which plans, of whatever type, are communicated is important. What use is a plan unless you tell people what it is? This may sound obvious, but it is amazing how reluctant people can be to divulge their plans, presumably in case they meet with opposition. There is a place for circumspection, of course, but this is in the essential, but different, realm of organizational politics, not in planning actual work. The format for presentation is important, too. Lists or text do not encourage an overview: graphic or tabular representations are much better for the higher levels of planning for more than a year ahead.

Development planning

This describes a format-based technique. It is quite widely used in schools, and sometimes in the national museums' corporate plans. Development plans are for organizational groups rather than for individuals; individual work plans should be based on them. They combine a view of broad objectives with more detailed plans for a few years ahead. Development plans may be communicated through tabular formats. They should be drawn up with as much general cooperation as possible, and reviewed and revised yearly at least.

Historic City Museum's conservation development plan, shown in Fig. 11.2, matches plans to general objectives. It combines a comprehensive and fairly detailed plan for the coming year with a less detailed look at priorities for the three years ahead.

General schedules

Table 11.1 is a checklist showing the start dates for major projects and work programmes that the Historic City Museum conservation department is concerned with over a two to three year period. It is a good way of checking with other players – curators, for instance – whether they are working to the same date. It allows newly proposed projects to be quickly and easily assessed against existing commitments. It does not show ongoing work such as environmental monitoring, checking displays and stores, etc., that is not on a project basis. However, tasks that are conservation led, or to do with preventive conservation, are included, such as the galleries refurbishment, because they have been established as projects. The work schedule is also illustrated in Fig. 11.3, this time using a graphic representation.

Table 11.1 *Schedule of conservation tasks and projects in order of start date*

The Historic City Museum
Conservation Start Dates Schedule 1995–97

Project	Start date	Finish date
Tokyo loan	Ongoing	End May '95
Galleries refurbishment – end of early 19th C.	Ongoing	April '95
Prehistoric gallery reconstruction	Ongoing	1st Dec. '97
Toys exhibition	14 Aug '95	1st Jan. '96
Jewellery exhibition dismantling	Jan. '95	Jan. '95
History Dept. study collects. projects	Jan. '95	July '95
Feeding the City exhibition	1st Sep. '95	1st Dec. '96
Working City collections survey	1st May '95	1st Aug. '95
Stores move: preparation: Applied Arts	1st May '95	1st Jan. '96
Steven Prior exhibition	1st May '95	1st Aug. '95
Theatres case	1st May '95	1st June '95
Stores move preparation: Paper collections	1st Aug '95	1st May '96
Feeding the City – objects for publication	1st Oct '95	7th Dec. '95
Galleries refurbishment: Imperial City	1st Jan. '96	1st Jul. '96
Costume gallery cases	1st Oct. '95	Jun. '96
Tokyo loan return	7th Nov. '95	1st Dec. '95
Collections move: Metals and General Stores	1st Jun. '96	1st Aug. '96
Galleries refurbishment: late 19th C. (textiles)	1st Feb. '96	1st Aug. '96
Galleries refurbishment: 20th C. City	7th Aug. '96	1st Feb. '97
Late 20th C. gallery – objects for catalogue	1st Oct. '96	1st Jan. '98

Management-by-objectives

Whereas development planning shows the big picture, management by objectives focuses on the individual person. Starting with senior managers and cascading down, each member of staff agrees with their manager a list of tasks to be worked on or completed for a period of time, usually a year. Objectives should include measures, targets and deadlines, although these can be quite difficult to devise and are often not included. It can be difficult to cover properly ongoing work that a person does – environmental monitoring for example – that does not lend itself to division into specific objectives, although improvements can be planned, such as more regular analysis and presentation of results in this example. Management by objectives is often used in conjunction with performance assessment and performance related pay. Progress should be assessed at two or three interim stages each year.

Management by objectives can be a good way of gaining control of a work group where work has not been explicitly defined. It is criticized for being heavy on time and paper, and for embodying a mechanistic view of

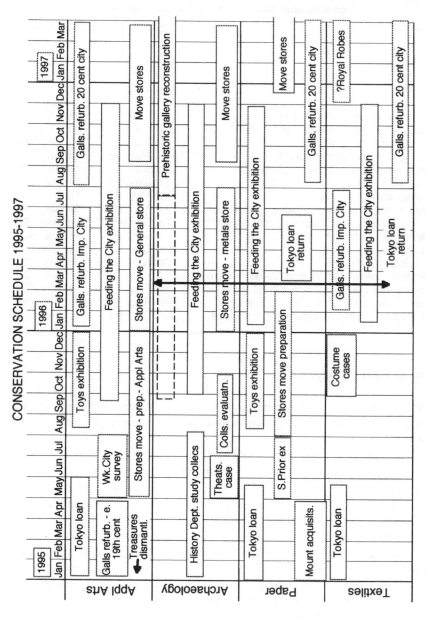

Fig. 11.3 *An overall conservation work schedule, graphically represented*

life. There can also be problems with coordination between different groups, since the emphasis is very much on the work of the individual. It is a perfect excuse for inflexibility, as in 'it's not in my objectives'. Still, if strict control over individual work is required, management-by-objectives is about the only way to achieve it. It is particularly useful when someone is starting a job – a simple 'to-do' list is very reassuring – and, conversely, if disciplinary action is contemplated or under way.

Project planning

Project management is becoming a way of life in museums. It is a convenient way to organize all sorts of work, not just exhibitions, and to establish control of the work agenda and resources. Project planning implies that a task is defined, a plan to complete it is set out, agreement is given, and resources committed. Progress on the project tasks and the use of resources then need to be monitored.

Exhibition schedule: Gantt chart

	Jan	Feb	Mar	Apr	May	Jun	Jul	Aug	Sep	Oct	Nov	Dec
Briefing and design												
Start: exhibition concept	▮											
Preliminary object list	▬▬											
Conservation design brief			▬									
Brief designer			▬									
Final object list				▮								
Design exhibition				▬▬▬								
Production and construction												
Object conservation for catalogue photography				▬▬								
Specs. for construction, appoint contractors					▬▬							
Photography for catalogue					▬▬							
Write text and captions						▬▬▬▬						
Object conservation for display						▬▬▬▬▬						
Construct exhibition							▬▬▬▬					
Design + make mounts								▬▬				
Print catalogue									▬▬▬▬			
Make graphic panels, labels									▬▬			
Installation												
Gallery commissioning tests									▬▬			
Install graphics										▬		
Install objects										▬		
Exhibition opens											▮	

Key: Activity: ▬▬▬▬ Deadline: ▮

Fig. 11.4 *A project bar (Gantt) chart for a typical sequence of activities necessary to put on an exhibition*

Project planning encompasses some useful concepts and tools. Software packages are available that can assist, and might well be useful in scheduling conservation work programmes. There are also some useful and generally applicable project management tools.

Bar charts (sometimes called Gantt charts, after their inventor). These simply show the duration of tasks within a project in a similar manner to the work programme chart in Fig. 11.3. A project bar chart is shown in Fig. 11.4. Connecting lines can show if the beginning of one task depends on the completion of another.

PERT charts. These show the sequence of different tasks within a project, and where one depends on the completion of another. An example is shown in Fig. 11.5. From this, one can also work out the critical path: the string of dependent tasks that add up to the time a project must take.

Project monitoring and scheduling. There are two ways of approaching this. One is driven from calendar dates: the project tasks are planned over

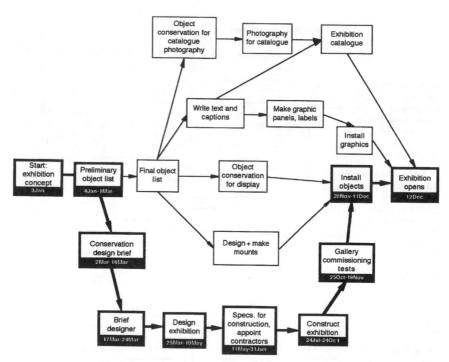

Fig. 11.5 *A project PERT, or critical path, chart. This shows how each activity depends on others being completed. The critical path (the activities that add up to the longest time period) is shown in bold. Start and finish dates could be attached to the other activities*

time, and progress on them is monitored on planned dates, either at set intervals or on identified stage completion dates. On a complex project, this is usually best achieved at regular project meetings, where problems can be identified and future action planned at the same time. The other project scheduling approach is event driven: key events are identified and target dates are set for their completion. Naturally, these approaches can be used in combination.

Some ways not to run a project successfully are: have a project plan, complete with chart, carefully drawn up at the outset, and then ignore it, taking no steps to monitor the project and taking no action to correct its course. Or run the project in isolation from the real world, rescheduling the project dates every time progress slips. Both these scenarios may sound implausible, but they really are not uncommon. A published report on the Stock Exchange automated settlement project, Taurus, which wasted many millions of pounds, identified the 'reschedule it' syndrome as the prime cause of its failure. It is absolutely crucial to take early slippages seriously, but this is psychologically quite difficult, as one usually wants to be optimistic about a project one is running, especially in the early stages. A really useful basic guide is Brown, 1992.

Allocating resources

The allocation of staff and financial resource requirements can also be planned. In conservation, by far the greatest proportion of money goes on staff (probably over 85 per cent). A possibility is to allocate percentages of staff time to work, whether ongoing requirements or projects. Logging the actual use of resources against that planned can be a powerful management tool. For example, the museum might decide that 50 per cent of conservators' time should be spent on preventing damage to and improving the condition of the collections, rather than on improving the appearance of objects for exhibition. Logging actual time spent against such aspirations can be most revealing (Fig. 11.8). Planning the use of staff time can be extremely time consuming, however, although detailed assessment of the time that tasks will take is the basis of estimating for commercial conservation jobs.

To plan the use of time, one can either ask each conservator, or manager, to estimate how much time each of the range of tasks and activities known to be coming up will require, and total up the predictions, or else take the total time available and allocate it between the known tasks.

The first approach will almost certainly result in a requirement for about twice the time available. The second approach runs the risk of work expanding to fill the time available. In practice, a manager will develop an instinct for whether there is too much work to be fitted in,

or too little to occupy the work group's time fully. Either way, monitoring the actual time spent (discussed below) will gradually improve the management of the available resources (defined as matching the plans to the actual outcome), though at the expense of increased management overheads.

Monitoring and reporting

Monitoring conservation processes

The processes of conservation are the actual work that goes on in order to meet the objectives of maintaining the collections, ensuring the best possible appearance of objects on display, and adding to knowledge about them. These processes thus include scientific examination, conservation treatment, and 'preventive' activities such as mounting prints on acid-free board and environmental monitoring.

Monitoring and reporting can be quantitative or text-based. There are some aspects of conservation work for which numbers matter, if used in the right way. For conservation, two obvious quantitative measurements are numbers of objects conserved and amount of time spent on different activities. But experience shows that, to tell anything useful, quantitative work logging must be very specifically designed for the purpose. The broader the group of people the categories of time use cover, the less useful the results. It is only useful to know how many objects have been conserved if one knows also what objective prompted the work: collections maintenance, exhibition (a), exhibition (b), programme (z), and how badly the objects needed treatment. Two hundred prints may have been deacidified and mounted, but perhaps there were three priceless watercolours that were a much higher priority.

Computerized conservation records systems, if used, can be designed to produce many of the necessary data, but it can be preferable for people to gather and report information on paper, using the data from the computerized records to check from time to time. Having to record and report on how they are spending their time has a motivating effect on staff, but only if the results are promptly analysed and fed back to them, and if the resulting information is used in ways that benefit them. If everyone is involved in reporting the necessary information this promotes a thorough understanding of the results.

If quantitative reporting is not felt to be appropriate then written reports can also help focus the minds of the staff and inform their managers. Such reports should have a structure of headings based on the work group's objectives, otherwise they will be difficult to relate to plans.

Monitoring the use of resources

Information on time can, of course, be used to calculate information on the cost of different activities.

The use of conservation time is monitored in some museums (e.g. Ashley-Smith, 1990, Figs 4 and 5). In Museum Service laboratories, as in private practice, staff record the use of every fifteen-minute time block. In a museum, it will be normal for about 50 per cent of an employee's time to be used on 'core' activities (management and administration, liaison, training, research, and for conservation, environmental and preventive conservation), leaving about 50 per cent for specific projects or activities. Time sheets can record either the absolute amount of time spent on different activities, in whatever level of detail is required, or else the percentage, if only a broad brush approach is needed. The trouble with time sheets is that they have to be analysed, and this can take appreciable administrative time. It may be found useful only to monitor the use of time for defined periods at intervals, or just to monitor time spent on particular activities which are of interest, such as loans or exhibitions or specified projects.

Presenting and using management information

Presenting information

Conservators are extremely good at keeping records on the various aspects of conservation, to the point where the quantity of data becomes embarrassing. But when it comes to making sense of this mass of data they are less successful.

To be effective as management information, data must be presented in forms that address the relevant questions, either to inform decision making or else to help to assess progress against objectives, and that are easily and quickly understood. In *Plain figures*, Chapman (1986) gives a view of how this can best be done. There is a choice, she points out, to be made between words, charts or tables for presenting information; for numerical information, charts or tables are usually necessary. The design of tables will depend on whether the data is presented to demonstrate a point, or for reference. Charts are always for demonstration. Both charts and tables must always be explained by a verbal (written) summary. It is good practice first to analyse the data; then to write the verbal summary; then to design the tables or charts to clearly illustrate the points being made. Chapman gives detailed instructions on good design. Further advice on the design of charts and graphs is given by Tufte, *The visual display of quantitative information* (1983).

Reedy and Reedy (1988) review the use (and briefly the presentation) of statistical analysis in published conservation papers: most published work falls short of good standards both in the statistical techniques used and in presentation.

Feedback

Whether reports are quantitative or text based, it is absolutely essential that they are rapidly digested and fed back to those reporting, and that some use is seen to be being made of the data produced. Otherwise, staff will conclude that they need not produce reports, since they are not used. Examples of the graphic presentation of information on conservation work are shown as Figs 11.6, 11.7 and 11.8.

It could be particularly useful to produce an annual report that summarizes progress over the year. An annual seminar for staff to review progress and plan ahead is an excellent way of encouraging a coordinated view of the future and of motivating staff.

In fact, though, the most useful information does not emerge unless data are collected over several years. If strategy is set for three to five years ahead, then this is the sort of period which should be reported on. Even exhibition projects usually extend over more than one year. This sort of information will be of great interest to the Department's staff, not always in the way they expect. For instance, it can emerge that more time than had been thought has been spent on conservation initiated projects, and if so this will help to dispel the impression that conservators often have that they have no control over how work time is allocated, and to build confidence that conservation-led projects can make a real difference.

Report writing and presentation

Information acquired is only useful if it can be digested and communicated effectively. Reports for senior managers should look smart and be well laid out. They should be brief and succinct. It is essential to start by asking oneself: what do I want to happen as a result of this report? and to place oneself in the senior managers' mental shoes. What do they know already, that they need not read again? What are they interested in knowing? The ultimate aim of most reports is to obtain more resources, whether of finance, of staff posts, or of commitment of time from other parts of the organization.

The contents of a report should include:

- an executive summary, usually not more than a page long
- a brief statement of the purpose of the paper

- a paragraph or two giving the background and context
- the report itself, illustrated if possible
- conclusions
- recommendations

Tables or detailed analysis should be attached as appendices, or even produced as a separate report to be available if required.

Case study: work planning and reporting

The Historic City Museum conservators had developed positive views on work monitoring. Most of the excavations carried out by the museum's Archaeology Division were funded from grants from the developers of city sites. Contract posts for the conservation of the finds could be covered by such funding, but only if the need could be justified in detail. Therefore, the Archaeology Conservation Section kept detailed figures on numbers of objects needing conservation and on the rate of work, and used them in negotiation, with fair success.

The museum was taking on more exhibition projects generally, and this meant more work for conservation. At the same time, the Department's positive steps to plan strategically and monitor the condition of collections had given them an excellent view of what needed to be done to care properly for the collections. How could the Conservation Department persuade the museum generally to see that conservation-led work was as important as exhibition-led projects?

The conservators thought that if they translated their strategic plans into defined projects, targeted at particular tasks or areas of the collection, they might be able to get these accepted as part of the museum's general plans. The main conservation projects were the galleries refurbishment project, aimed to improve the condition and care of some of the most important objects, and improvements to the care of the stored collections, linked to the stores move. The amount of time to be devoted to these projects was estimated and they were built into the museum's overall planning schedules. As time went on, however, the conservators began to feel that exhibition and loan projects were eroding the time available for collections care. They began to monitor the use of time and the reasons for treating objects in great detail, and to report carefully selected statistics.

Productivity

One of the easiest outputs to quantify in conservation is the number of objects treated. This information is so misleading that it should only be

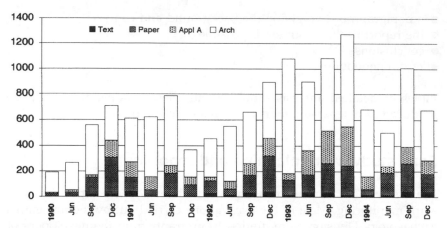

Fig. 11.6 *Numbers of objects conserved in the Historic City Museum over several years*

used with great circumspection. Some of the obvious flaws are that small objects can be treated more quickly than large ones; and objects which are quickest to treat are often those for which treatment is least urgently required. The Paper Conservation Section found that objects in the worst grade of condition took nine times as long to treat as did those which only needed cosmetic improvement. The true measure of the museum's success in preservation was, they realized, the number of objects that do not need treatment!

Still, numbers matter. Using figures on the number of objects conserved over several years (Fig. 11.6), the conservators could show that on average it only cost the museum about £100 to treat an object (calculated by taking the wage plus materials cost and dividing by the total number of objects per year). Work output had greatly increased over the previous few years, thus justifying the two extra conservation posts they had been given.

What generated the work?

This question is crucial to conservation, because unless they are specifically targeted, few museum projects are likely to result in the treatment of the objects that need it most. The charts in Fig. 11.7 analyse the Historic City Museum conservation output according to the project that initiated it. From Fig. 11.7a, it was satisfactory to note the number of objects treated for the conservation-led galleries refurbishment. Until they saw the analysis, the conservators had not realized how successfully they had pursued their own agenda. Archaeology conservation can easily be seen as working on objects only for a site archive, but in this case the Archaeology Section was able to demonstrate that a large proportion of

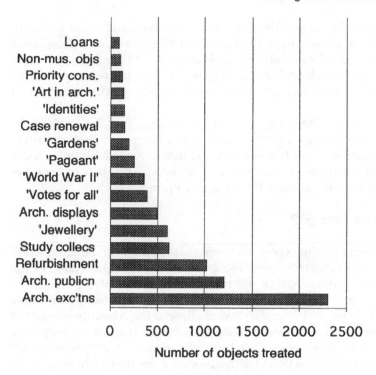

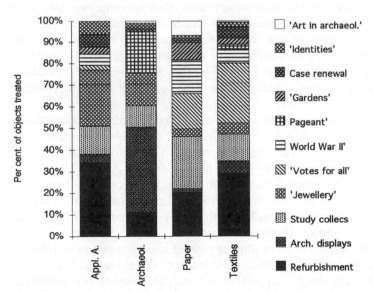

Fig. 11.7 *Analysis of numbers of objects treated for different projects. (a) Total objects treated for each project. (b) Proportions of objects treated by each conservation section, by project*

work had been for off-site displays, for developers and other publicity. Two exhibitions were extremely object-intensive: the hundreds of items treated for the *Jewellery* exhibition look set to be outnumbered by those for *Votes for All*, which with many objects yet to be treated was forming a substantial proportion of work for both the Textile and Paper Sections.

From the bottom chart, Fig. 11.7b it can be seen that the work of the Paper Section was more evenly spread over different projects than was that of the other sections. It was often said that every exhibition includes items of paper, and this seems to be well founded. The work of the other sections had been dominated by one or two projects each.

Where did the time go?

Very simple data on time spent and objects conserved can be analysed in some quite sophisticated ways. Figure 11.8a shows how conservation time was spent. About half of the total time was available for different types of activity or project, after 'core' activities (liaison, preventive conservation, leave and vacancies) were allowed for. About two-thirds of conservation time was spent on display projects: loans and temporary exhibitions. One third of project time was spent on conservation-led projects: the study collections themselves and the refurbishment of the permanent galleries.

In Fig. 11.8b, the actual use of conservation time is compared with what had been planned a year previously. More time had been spent on temporary exhibitions (8 per cent of time planned, 19 per cent of time spent), and less on the conservation of the study collections (16 per cent planned, 10 per cent spent). None of the other variations was far outside the 5 per cent departure which it is realistic to expect from the planned use of time.

The use of conservation effort as measured by numbers of objects conserved is shown in Fig. 11.8c. By far the most objects numerically had been treated for the archaeology collections. This activity had received extra funding as part of the archaeology service. After that, it was exhibitions that prompted the treatment of most objects, which are seldom the objects that most need treatment. This question can be further explored if objects treated can be analysed by their condition grade, as established in condition audits or surveys.

In Fig. 11.8d, proportions of objects treated and proportion of time are compared for each activity. The highest ratio of objects treated to time was found for the archaeology interim collections, where many types of object are treated in batches, and for the galleries refurbishment, which was a conservation-led project. The lowest ratio was for exhibitions, where there is a lot of essential liaison, input to display design, etc.

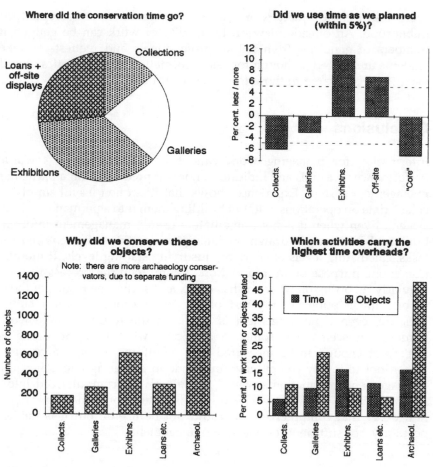

Fig. 11.8 *Analysis of numbers of objects treated and time spent over a year*

By monitoring numbers of objects and time spent on projects the conservators could put the case for extra staff to be allocated for particular projects. In particular, they could argue that if sponsorship funding was sought then it should cover conservation costs, too.

Planning for skills and quality

How can the objective 'Ensure trained people' be monitored? It is easier to monitor input than output. Someone may attend a conference, follow a course, but has it done them any good? Essentially, it is reputation that is being monitored here. Peer judgement of expertise is expressed if

articles on technical matters or conservation treatment are accepted for publication. An outside view of the quality of work can be gauged if numbers of enquiries from fellow professionals and requests to take students are logged, although for real information these statistics would need to be compared to those for other institutions.

Conclusions

Information for managing work cannot be directed solely towards performance measures and indicators; nor is it predicated on a particular management system. Experience shows that it is often useful simply to collate data on operations, without building them into a permanent, rigid, system. Even when it is not immediately useful, management information can be frequently drawn on for, e.g. estimating time required for tasks; calculating levels of charging; justifying staffing levels. If motivation is one purpose of an information system, then the process itself of regularly reporting on what one has done, and seeing the results of those reports made public to the rest of the work group, exerts a subtle pressure, even if no judgement is made on the results. People work harder if it seems that someone considers what they are doing is important enough to be measured and monitored. This is a possible reason not to totally computerize information gathering and collection. 'Management information systems' is the term for computerized information systems, but what we need is information for managing. This is not to say that computerization would not be useful, but it is neither necessary nor sufficient for effective management.

References

Ashley-Smith, J. (1990). Managing conservators. In *Managing conservation, Conference preprints* (S. Keene, ed.), London: UKIC, 16–20.
Chapman, M. (1986). *Plain figures*. London: HMSO.
Reedy, T. J. and Reedy, C. L. (1988). *Statistical analysis in art conservation research*. Marina del Rey, CA: Getty Conservation Institute.
Tufte, E. R. (1983). *The visual display of quantitative information*. Cheshire, CT: Graphics Press.

12 Computerizing conservation information

The workability of a system's design is the most important consideration for the end user. The traditional approach – getting the complete technical system design right first, making some attempt to add on 'user friendliness' then implementing it, all too often does not achieve the results desired. (Willcocks and Mason, 1987: 86)

Information systems development: an overview

The development of new, large-scale information systems has had a bad press during the early 1990s. Several large-scale developments have ended in ignominious collapse, with many millions of pounds being wasted. The Wessex Health Authority, the London Ambulance Service, and the Taurus system for share dealing are some notable examples. It is astonishing that despite this, and despite the difficulty of making any quantitative assessment of the benefits of new information technology, organizations continue to invest large sums of money in such systems. It is perceived that computerized information is not just an optional extra; it is seen as being fundamental to competitive advantage at all levels and to survival. Museums are no exception to this. As the proper management of the ever-expanding physical collections begins to be tackled, so a new challenge has to be met: how to justify their existence and make the information they embody available to a much wider public. Information technology is the only feasible way to address both these issues.

How then can museums avoid the deep, wide pitfalls awaiting their hard-won resources?

Layzell and Loucopoulos, writing in 1987 (p. 20), observe that users are mostly dissatisfied with the late delivery, excessive cost, and unreliability of the delivered product. They identify the source of the problems as a lack of rigorous analysis, and prescribe its wider use and more systematic application.

Structured analysis methods are now widely used, as indeed they were in 1987, but as we see, the problems have not gone away. Checkland, Land, and many other authors identify the necessity to fully understand

the whole organizational context before the information required within it can be specified. Further, there is the difficulty, even the impossibility, of developing rigid specifications before their interpretation can be seen. For example, the first stage in information systems analysis is often called 'problem definition'. Goals for the system are identified, and user requirements specified (Layzell and Loucopoulos, 1987: 11). And yet:

> The classic software life cycle says little about users other than assuming that users' requirements are specified. The problem is that users often find it difficult to specify their requirements before a system is implemented. Even where they are specified, users often want to change their minds after a system is implemented. (Thomas, 1990)

Land's planning and evaluation methods (1976; Farbey, Land and Targett, 1993), Mumford's socio-technical analysis (1983), and Avison and Wood-Harper's Multiview approach, which incorporates soft systems methodology (1990), are some techniques developed in the hope of avoiding these ubiquitous problems. Research has shown that incremental, user-driven development is more successful than are 'moonshot' approaches. In incremental development, users discover what would be useful to them, they request its provision either by development or by purchasing packages, and they thus remain firmly in charge of their computerized aids.

All this scepticism is likely to be little comfort to those in museums who are involved in computer systems development. Most systems designers' only response to widely-publicized failure seems to be to try even harder to apply a more thoroughly structured approach. Systems designers have mostly not been trained in 'soft' analysis methods, and it is true that these can sometimes command little confidence among hard-headed managers. It takes considerable skill at running meetings to launch into what can be seen as the free-fall, directionless business of soft analysis. And what non-systems professional is going to insist on a diversion that may delay the project, and which is clearly alien to the very expensive analyst's preferred mode of work? In fact, experience suggests that a session of soft systems analysis could be a rapid way of enlightening the analysts.

Information systems analysis

Information systems analysis embraces a variety of methods (Hawryszkiewycz, 1988, Ch. 15; Layzell and Loucopoulos, 1987: 22–8; Willcocks and Mason, 1987, Ch. 4). These can be grouped into two broad areas. 'Hard' methodologies embody a linear, logical, often

strictly pre-formatted approach, leading from problem definition through systems design to implementation. 'Soft' approaches, of which soft systems analysis is one example, recognize that the needs of the organization are not necessarily the ones which appear obvious; they focus on the need to understand the organization, its people, and its purpose before designing its information flows (Willcocks and Mason, 1987, Ch. 4). The 'Multiview' approach explicitly combines the two strands (Avison and Wood-Harper, 1990).

Hard, or structured, analysis

These methods take as their starting point a defined 'problem' or task in information handling or processing, which it is thought can be solved or eased by improving the handling of data and information, especially by using computers (Hughes, 1984; Naughton, 1983: 7–10). At the outset, a definition of the task and of the desired results is agreed between the organization or individual commissioning the work, and the consultancy or employee undertaking it. A series of defined analytical steps, often using preprinted forms to assist in quality control, is followed in a prescribed order, with the object of producing a system (or choice of systems) to gather the data for and produce the defined information, or expedite the identified procedures, as efficiently as possible (Willcocks and Mason, 1987, Fig. 4.1; Layzell and Loucopoulos, 1987: 22–31). SSADM (structured systems analysis design method) and the related project management scheme known as PRINCE, are widely used examples of the hard approach.

Soft analysis

In soft approaches, the initial assumption is that the situation or problem is not obvious (Checkland, 1981; Naughton, 1983). Checkland's soft systems methodology, the most widely used and published variant, has been described and employed in Chapters 6 and 7. Another soft approach is Mumford's socio-technical analysis, in which users examine the impact and effect that computerized information will have on them and their work. Willcocks and Mason (1987, Ch. 4) discuss the different approaches.

Hard and soft approaches can be complementary, rather than alternative. For example, 'Multiview' begins with soft analysis as set out by Checkland, proceeds to a socio-technical analysis as developed by Mumford (1983), and thence to the hard analysis and design stages of functional, data flow, and entity relationship analysis. It goes on to place particular emphasis on the implementation stages, using prototyping to involve users in the development of the system.

Prototyping and evolutionary development

In designing the system itself, there are two other methods, prototyping and evolutionary development, which may be employed. These particularly allow users to contribute to systems development by letting them see how their requirements have been expressed in the system (Hawryszkiewycz, 1986: 16; Willcocks and Mason, 1987: 84–8). Prototyping and evolutionary development make use of sophisticated software, generically known as 'fourth generation language', or 4GL, that can translate analysis automatically into program code.

Prototyping (Hawryszkiewycz, 1986: 310–11; Layzell and Loucopoulos, 1987: 9; Willcocks and Mason, 1987: 86–8; Eason, 1982) is a sophisticated form of trial and error. The users of the system define their requirements, and a simplified system is created, with little fuss, to meet them. The system is tried out, and adapted and changed to better meet the specified requirements, which can be redefined as the users realize the possibilities of the system.

Prototyping can lead to poor control over cost and development times, if the emphasis is on 'error' rather than the expression of a component of a thought-out system. It is no replacement for a thorough analysis and logical data design. It could also be difficult to decide when to stop developing and concentrate on using and maintaining the system. However, there is obvious sense in using prototyping as part of the system development process, as advocated by Avison and Wood-Harper (1990, Sect. 14.3).

Evolutionary development (Eason, 1982; Hawryszkiewycz, 1986: 309–10; Willcocks and Mason, 1987: 84–6) is similar to prototyping, in that the information system is built in close cooperation with the users. In hard systems analysis each stage is 'completed' across the entire system, and the next stage proceeded to, in a rigid sequence. In evolutionary development, a broad framework is drawn up, parts of the system are developed until they are satisfactory, and other components or modules are added subsequently. Problems to be anticipated here are that as further components are developed there must be pressure to adapt those first built. The technical response to this would be that an extremely thorough analysis must be undertaken first – but this precludes the enlightenment that arises from experience.

Databases

A computerized information system for conservation and other collections information is an example of a database. A database can be envisaged as a sort of table, or multiple tables, similar to, respectively,

Conservator	Conservation section	Object identity	Object name	Object description	Treatment date	Treatment	Procedure

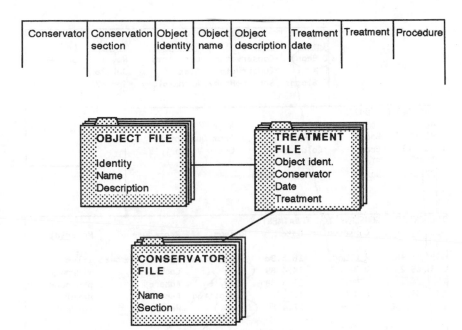

Fig. 12.1 *(a) The main data for a flat file conservation records database. (b) Diagram showing the card indices that might be compiled for conservation records. These would be reflected in a relational database*

either a tabulated list or a card index or series of card indices (Fig. 12.1). A computer database consists firstly of a database management system (DBMS), and secondly of the data themselves. The data are input, organized and retrieved by means of the DBMS.

Basic database management systems are designed to be used to build whatever the user requires. The simple database for analysing the results of collections condition surveys of which examples are shown in Chapter 9, Exhibit 9D, was set up using the Microsoft Works™ database facility. Many large and well-known software companies produce and market such systems, which include Informix, Ingres (much used in libraries), Oracle and Sybase.

What kinds of database are there?

At the present time, two types of database generally predominate: flat file, and relational (Veryard, 1984: 58–62). In a flat file database, all the data are held in one single file, as in a single card index: the Works™ database is an example of a flat file. An example of a simple flat file of conservation records might include the data shown in Fig. 12.1a.

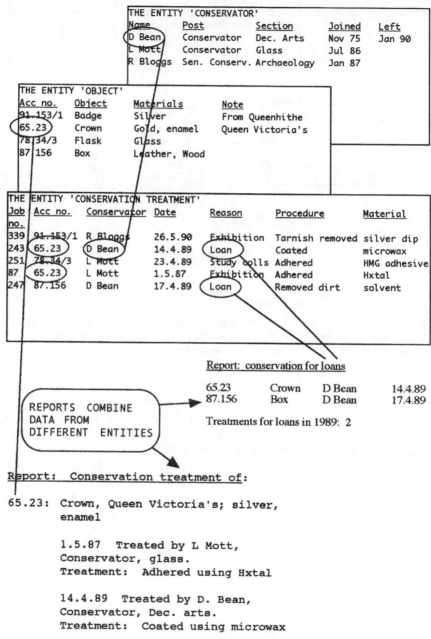

Fig. 12.2 *Some of the tables (entities) that would make up a conservation records relational database, and their relationship*

Each of these fields would have to be completed for each record. Problems would arise when the same object was treated more than once, or when a separable part of an object, perhaps made from different materials, was treated as a separate task: would a new card be completed or would the new treatment information be added to the existing card? Although a card index could be adapted without too much difficulty, a flat file database would have greater problems.

A relational database can be envisaged as a number of card indices, each with a different primary field, e.g. objects, or conservators. These can be linked together in use by using cross-references, making a much more complex, but flexible, information structure. In the computerized equivalent, the information would be held in separate 'tables'. Figure 12.1 shows this diagrammatically; Fig. 12.2 illustrates some details of how this works. To record information about a particular treatment, all that would need to be entered would be:

Conservator name – the key to the 'conservator' information
Object number – the key to the 'object' information
Data for the *'treatment'* file

The benefit of this is that much less information is duplicated when a record is entered. Information about the conservator is entered once only, into a file showing all conservators, the sections to which they belong (if relevant), the period during which they worked in the museum, and other relevant information. Information on the object is again entered once only, hopefully by curatorial or other finds or objects staff. The conservation data become just another piece of important information about the object. This saves time and computer memory, and cuts down on possible errors. When it comes to retrieving information, elements of the different 'card indices' can be selected, combined, and reported as required.

A third type of database is known as 'hierarchical': a well-known example is the Museum Documentation Association's MODES collections software. One type of hierarchical database is founded on a view of information developed by Richard Pick, in America. Pick-based systems are favoured by some for museum data management, because they reflect more readily the somewhat complex, hierarchical structure of collections data (objects which are members of collections or of subject classes; parts of objects; parts of parts of objects; object parts kept in different locations, etc.). The problem with Pick-based systems is that, although the concepts are undoubtedly ingenious and applicable to museums, they are out of the main thrust of database management development, which presently focuses strongly on relational databases. This means that Pick-based systems have a small user base, and there is little investment in them. It

is difficult and expensive to transfer hierarchically organized data to relational databases.

The advantages of flat files are that they are easy to understand, set up and maintain; it is claimed that they allow for more sophisticated operations to be carried out on the data they hold. On the other hand, relational databases are presently very widely used, because they allow for greater flexibility. Flat file structures do not cope easily with the repeating information which conservation records often contain, for instance the several different materials of which an object is composed, or the several parts of an object which may receive different treatments.

Existing systems for conservation records

It is increasingly common for conservation records systems to be computerized. A few computerized conservation records systems have been commercially, or semi-commercially available, but these have not been at all widely adopted. Some museums have developed their own stand-alone conservation records systems: the British Museum and the Museum of London systems can handle records from a variety of different types of object. There are numerous other in-house conservation records systems, but most of them cater for specific types of collection (pictures or archaeology, for example) and are narrowly focused on the needs of a particular organization. There are also comprehensive collections management software packages, but few of these have well-developed conservation records modules. Any package will need customizing and setting up for the organization's specific requirements. Most conservation systems development projects seem to founder on lack of consensus among conservators of different disciplines about terminology and what data are to be recorded.

The LASSI project will give a further impetus to the standardization, or at least compatibility, of computerized records systems. LASSI is a consortium of museums which are jointly specifying and initiating the development of a new collections management software package. The package will include a widely applicable conservation records module. There will be overall a strong collections management orientation, and conservation will be placed right in the mainstream of other museum collections operations.

Whether it is intended to use an existing package or to embark on a purpose-built development, the museum will need to make sure that what it gets meets its needs. It should specify its minimum and maximum requirements in some detail, and review candidate systems against these. An example of a Catalogue of Requirements for conservation is given in Exhibit 12A.

Developing an information system

Stages in systems design projects will normally be: *investigation; specification; design; development; installation; operation.* There is prolific literature on information analysis and database design. It will be useful for at least one person who is primarily a system user rather than a system provider to be familiar with the general concepts, as part of the problem is that many organizations have little idea of what the process of development will involve. The general nature of systems design is described by Daniels and Yeats (1984); Layzell and Loucopolous (1987) review some of the various approaches.

Defining information requirements

A high-level overall look at requirements is an essential prerequisite to detailed information analysis. This might be by means of a soft analysis, or it might be through a business analysis stage as used by the database management software house, Oracle. More detailed information requirements will normally be defined by the analyst interviewing users and potential users and studying examples of the written and computerized forms they currently use. These methods really derive from the days when computer systems were replacing paper-based processes.

User requirements can be expressed in several formats. A business analysis will be a text description of the objectives and constraints of the organization. A soft systems analysis might take the form of those in Chapters 6 and 7.

Specification and design

The organization's general requirements need to be translated into a detailed specification of the data the system must hold, and what it must do with those data. Most structured approaches describe the data from several different viewpoints, intending in this way to capture all the dimensions of the required system. Examples of most of these are shown in the case study, below. Some of these viewpoints are:

Requirements Catalogue	A detailed description in plain English of what the organization requires of the system
Business system option	A high-level description of the scope of the system, with references to the Requirements Catalogue
Data flow model	A diagram which shows how data are generated, used and stored, and how they are passed around the system

Function model	A text description of the functions the system must perform, in a cascade of ever more detailed levels
Entity relationship model	A diagram which depicts the data entities (the 'tables' in the system, consisting of the nouns or objects) and, just as important, how they relate to each other
Data dictionary	A definition of each data entity and each connection between entities

There are many variations in the detail of how these and other techniques are used to define information systems, reflecting a number of different approaches which exist to specification and design. They are described by Layzell and Loucopoulos (1987, Ch. 2) and Daniels and Yeats (1984, 1988); a general structured method is set out by Hawryszkiewycz (1988). For entity relationship analysis, Date (1984) and Veryard (1984) are particularly useful.

System development

The analysis elements next have to be used as the basis for computer software. In developing the actual system, evolutionary and prototyping methods can come into their own. Prototyping may be used for a strictly limited purpose: to test the accuracy of the analysis by reflecting it to the user in the form of bits of system. Alternatively, it may combine this with actually developing the system. In the author's experience, however many times the analyst 'walks through' the data analysis it is impossible to assess whether one's requirements have in fact been reflected until one can test the system itself. For example, an analysis of conservation records rightly identified a 'conservation procedure' (such as 'disassemble the object'), but it was not until the system's operation could be seen that the conservators realized that the sequence of the procedures also needed to be recorded (1. disassemble the object → 2. remove dirt → 3. apply coating → 4. reassemble). Another unexpected effect was that the time taken for the system to search for existing object catalogue information increased the time taken to input records by 50 per cent, involving unacceptable delays, and a way round this had to be found.

Information requirements for conservation

Investigation

Information systems in general tend to serve one of two main purposes: operational, documenting flows of goods or services and finance in and

out of the system, process orders and invoices, etc.; or management information, producing information of the sort needed by managers to plan, monitor and control operations. Many are hybrids (Veryard, 1984: 14). Conservation information includes elements of production (pieces of work have to be completed to a standard and by a deadline), of management information, and also an important extra dimension: the building of and contribution to a permanent archive, or database, of information relating to the objects in the collections.

The investigation and problem definition stage for a generalized museum conservation records system has been undertaken by means of the soft systems analysis described in Chapter 7.

Requirements catalogue

Based on the soft systems analysis conceptual system (Chapter 7, Fig. 7.4), a Requirements Catalogue has been drawn up (Exhibit 12A). Although most of the requirements described could be useful, it would be unlikely for all of them to be implemented in the same system. Some of them would be impractical to computerize, or would work better if left as paper records or reports; some of them will be very low priority.

Entity relationship model

An entity relationship model is a more difficult concept. To continue with the card index metaphor, each 'entity' can be imagined as a separate card index. The data on the cards could be presented as a table of data, in which each card gives rise to a row of the table (see Fig. 12.2). Rows in different tables are connected by an identification

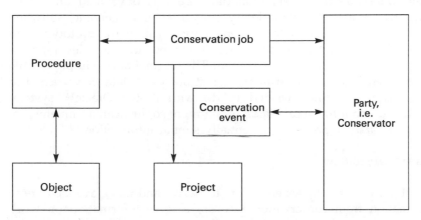

Fig. 12.3 *The main, high level, information entities in conservation records*

item unique to each. The logic of the tables is described in an entity relationship model for conservation, Fig. 12.3. Thus, the OBJECT entity contains its identification: its acquisition number, and its description: name, materials, etc. The entity CONSERVATION TREATMENT will also contain the acquisition number of the object, and also information about the treatment which has been applied to that object, with other details. A 'report' might show the number of the object, its name, and all the different procedures that it has been subject to over time (Fig. 12.2 and Table 12.3).

Functional analysis

Functional and entity relationship models are standard methods of 'modelling' (depicting and specifying) information. In a functional model, the functions which give rise to or require information are precisely described in information systems terms, with references to elements of other functions. Functions are set out hierarchically: those in the top level may be detailed, and lower levels in turn are further detailed. A function map, which summarizes the hierarchy of information functions, is shown in Fig. 12.4. This is far from being the 'correct' function map for conservation: there is no such thing as a single definitive analysis – each set of users has different requirements.

Case study: developing a conservation records system

A computerized conservation records system was developed in several stages in the Historic City Museum. A first, straightforward system was a flat file database using the then minicomputer's operating system, Xenix. Subsequently, a relational database was developed on a new computer, using the proprietary database management software, Oracle™. These stages could be seen as investigation and prototyping in the flat file system; and specification, design, evolutionary development and operation in the Oracle™ system. The original fairly simple flat file database enabled the department to test out what data they wished to record and what they wished to do with it; the Oracle™ system, developed about four years later, was a more sophisticated implementation of a database providing essentially similar information.

System objectives

The objectives of both systems were to derive and make available more information from conservation records; to give information on work management; and to integrate conservation records into the museum

Maintain the physical and historic integrity of objects and collections

1. Set, monitor standards for conditions	2. Set, monitor standards for environment	3. Analyse and examine objects	4. Record treatments	5. Plan work	6. Manage resources	7. Maintain skills	8. Provide management information
1.1 Record condition audit	2.1 Record environmental specification	3.1 Maintain record of observations	4.1 Record treatment proposal	5.1 Maintain list of projects	6.1 Maintain list of parties connected with conservation	7.1 Maintain list of conservation events	NOT DETAILED
1.2 Maintain record of condition audits	2.2 Record environmental measurement	3.2 Record procedure	4.2 Record conservation job	5.2 Maintain object project list	6.2 Record conservator and past	7.2 Record attendance at event	
1.3 Maintain condition records	2.3 Maintain environmental record	3.3 Record object record	4.3 Record conservation procedure	5.3 Make object project list inclusion	6.3 Monitor and report on use of time	7.3 Maintain record of publications	
1.4 Update condition grade	2.4 Record 'use' of object	3.4 Maintain list of records	4.4 Update condition grade	5.4 Record conservation job; update object project list status	6.4 Set budget and monitor expenditure	7.4 Record lecture, etc.	
1.5 Calculate condition index	2.5 Report environmental record for object vs. place	3.5 Report list of records		5.5 Report conservation jobs	6.5 Maintain equipment inventory	7.5 Record conservation event	
1.6 Report condition indices	2.6 Report environmental record for place	3.6 Report list of examinations				7.6 Record provision of conservation service	
1.7 Report objects by condition grade	2.7 Report 'use' of object	3.7 Report list of records for object					
1.8 Report damage factors							
1.9 Report condition records							

Fig. 12.4 *A function hierarchy map for conservation*

Table 12.1 *Issues identified during the design of the first, flat file, conservation records database, and their resolution*

Issue	Resolution
Should the system attempt to record data little by little, as the treatment progressed, or all at once when complete?	When treatment complete. Only limited number of terminals, and too time consuming to call up record several times.
Should the computer-based system entirely supersede paper-based records?	No. Computer could not include drawings; some treatments needed much detail. System should be an index to records.
What sort of format should be used – free text, controlled length fields, keywords?	Few advantages to free text, takes up much computer space and duplicates paper records. Controlled information preferred, keywords where possible.
What information would be required from the system?	See Table 12.3
What data should be included?	See Table 12.2
Should the existing paper record format be changed to make it more convenient to computerize?	Not necessarily, but in fact most sections redesigned their record forms in due course.
How would we control accuracy of data?	Conservators would input and check their own records.

system. For example, to pick out all silver coins treated using a particular method meant going through all cards manually. To count objects conserved during a time period and analyse the figures in different ways meant compiling complex tables of data on paper. The conservators also wished to know how work was generated: how many objects were treated for, e.g. exhibition projects rather than to preserve the study collections. The issues which arose and their resolution are summarized in Table 12.1.

Computer held data vs. records on paper

Neither system was supposed to replace paper records completely. Various factors were discussed:

Permanence is important for conservation records; paper and permanent ink have been well proven to last for hundreds of years.

Variability: the type of record varied from discipline to discipline, and even from object to object. For instance, textile conservation often requires an extended record with detailed drawings, photographs, test results and samples. In contrast, cleaning historical silver or treating archaeological copper alloy can mean dozens or hundreds of objects each with an identical, brief record.

Preferences: conservators in some disciplines strongly preferred their familiar and well-tested recording format.

It was concluded that, provided every treatment record included certain basic information, there was no reason why a variety of formats should not be used for the underlying paper records. The computer version would enforce the recording of the same basic information for every object treated, in a uniform format that would simplify analysis, information retrieval, and listing. In fact, all four disciplines eventually redesigned at least part of their paper records to make data input simpler, arriving at a similar or identical format in each case.

Phase 1: the flat file database

The flat file system was developed as a straightforward reflection of the existing paper-based conservation records system, with some management information reports. The significant step was that it unified four diverse paper-based records systems, for archaeology, applied arts, paper and costume and textile conservation, into a single system with common terminology that was found acceptable by the conservators in the four different disciplines.

Project organization. In a simple and effective approach to the first phase, the Conservation Department simply decided that they wanted a computerized conservation record system which would serve the needs of all four conservation sections. A working party was established, with representatives of the different sections plus a project leader. When the working party had defined the information requirements, which it did unaided, it explained these to in-house systems staff, who set up a recording system that served its purpose well for several years.

The data. The main items of data to be held were agreed, by reference to existing records kept by the different sections. They are listed and described in Table 12.2.

Terminology control. The very valuable exercise of deciding on the form of such important data as treatment and materials was completed for this system. Lists of defined terms were developed for materials and for conservation treatments (Exhibit 12B). There is a supporting dictionary for treatment terms which defines the meaning of each term and warns of terms that should not be confused with it (Exhibit 12C).

Table 12.2 *Data to be held in the flat file conservation records database*

Field name	Contents	Format
Owner	Museum department, or non-museum owner	Keyword
Accession number	Object identification number	Format checked
Simple name of object	(e.g. key, violin)	Free text up to 35 chars
Title	Mainly for pictures and drawings	Free text
Artist or maker	Artist, or maker of machine, etc.	Free text
Material	Up to 4 materials of which the object is made	Keywords
Conservator	Name of conservator who did the treatment	Keyword
Purpose	Reason for work – e.g. loan, exhibition, publication, etc.	Keyword
Outside conservation	Was work done by conservator outside the department?	Yes/no
Time	Total time taken for the job	Hours/mins
Recall date	Date to check the object (if any)	dd/mm/yy
Recall for	Reason for checking	Free text

The following fields repeated until input for that conservation job was terminated:

Part	Name of the part of the object	Free text up to 35 chars
Materials	Upt to 4 materials composing the part	Keywords
Treatment	The treatment used, e.g. REMOVED DIRT; DISASSEMBLED	Keyword
Method	Method and materials used to carry out the treatment, e.g. washed, water	Free text in agreed sequence

Evolution of the flat file database. The straightforward flat file records system was in use for nearly four years. It was popular with the conservators; in particular, input was very simple and fast, although output as developed was only adequate to serve the needs of checking records and recording the amount of work an individual had done. The system had a very considerable strength, however, in that it was agreed by all users that nearly all the necessary data for treatment records were

included, and in a convenient form. The only area which needed refining and slightly expanding was information on the purpose of work. Also, it was felt that conservation records were part of the information on objects, and as such should be part of a unified system. In the first system x-radiograph and some scientific examination records were held in separate computer files. As people used the different stand-alone systems, it became obvious to them that it would be more useful to have all the information on an object in the same system. This information would include:

Data generated outside the Conservation Department
● Archaeological finds inventories and catalogues
● The main Museum Accessions Register
● Curatorial catalogues of fuller information about objects

Data generated within the Conservation Department
● Records of technical examination
● Catalogue of objects x-radiographed
● Photographs and slides
● Samples
● Condition reports
● Collections condition surveys

Phase 2: the relational database project

Information technology was obviously developing rapidly, and, with a heavy collective sigh of resignation, the Historic City Museum embarked on a strategic systems appraisal. As part of this exercise, an entity relationship model and a functional model for conservation records were produced (Figs 12.3 and 12.4). At one point, frustrated by the low priority of conservation records in the development of the overall collections system, the services of professional systems developers from a professional software consultancy were engaged. The results were most disappointing. The analysis seemed to have been accurately expressed, but the system was not in practice usable, because it was too cumbersome and time-consuming. However, the conservators struggled on, becoming more and more expert in information analysis at the same time as they lowered their expectations of what the final system would do.

The conservation records system. The design of the system allowed for modules for treatment records, records of scientific examination, the x-radiograph archive, condition assessments, and conservator names and roles. Only some parts of the system were implemented. An important part of the system was a user manual containing a detailed description of the system and instructions for its operation.

Data development and definition. The data definitions, terminology lists, and keywords which had been fully developed in the flat file database were able to be used in the new system.

Input. It took much conservation time to build the input screen. For convenience it was necessary to include data input to several information tables (entities) in the one screen.

A very similar input screen for scientific examination was subsequently designed. It would have been exactly the same as for inputting treatment data, except that treatment procedures would have been replaced by details of the examination: examination type (e.g. visual, instrumental, etc.), method (e.g. microscope, FTIR, etc.), observations (e.g. white metal, etc.), conclusions (e.g. silver), inference (e.g. silver plated). A text section would have allowed for a brief report to be added to the catalogue information about the object.

Output and reporting. Remembering that reporting capabilities in the previous flat file system had been only rudimentary, a detailed specification was given for reports to be obtainable from the new system. The list of desired reports is shown in Table 12.3.

Discussion and assessment

Some valuable lessons were learned during the development of these records systems; ones which will be only too familiar to those who have had similar experiences.

Even the most detailed and careful analysis did not result in a usable system. When the analysis was first expressed as input screens, it was as a number of separate screens (for conservation job, object details, treatment). Before the system was in practice usable all these different screens had to be combined into one.

The system was in fact created in an evolutionary manner. The list of conservators and the treatment records were the components that were built first. These were extensively tested and improved. Using the first components meant that users could see how to build other desired components, such as scientific examination records and condition assessment records, in a very similar manner. This would not only make their development much simpler; it would make the system much easier to use, as users would be able to learn the general principles and format, and then apply them in the various areas.

Again from the operational point of view, when the system was first installed a conservator had to spend about half the total time needed to input a record waiting for the system to retrieve the object inventory data from the rest of the system. This was found unacceptable, and in practice the conservation records system is stand-alone, and is not after all part of

Table 12.3 List of reports, or output, required from the second, relational, conservation records database

Object and object history reports	Work reports	Project reports	Scientific examination
What work is recorded as having been done on an object?	Report a list of conservation jobs by a conservator/section during a period	Report a list of objects for a conservation project and count statistics	List of objects examined during a period
Report the current condition grade of an object	Statistics on the above, + graphs	Report a list of objects with a recall date falling within a period	Examined using a procedure during a period
When/how did I treat [a specified object]	Report a list of objects treated during a period	Report a list of conservation projects	Report the examination of an object: person, results
Report conservation jobs including a specified treatment during a period	Report a list of objects treated during a period by previous condition grade	*Condition reports*	*Records reports*
Report the inventory/catalogue details of [an object]	Statistics on the above	Report dates of audits of a collection/location	List slides with images of [wooden objects]
What museum events has an object been involved in?		Statistics on a survey of a collection/location	List records in which a specified object occurs
		Statistics on damage types	List x-radiographs by number, etc.

the main system (although it could easily be converted to be so). This shows the value of including a socio-technical analysis in the design phase, since this would have shown that input time was critical to success.

Even though there had been a working 'prototype', which dealt mainly with input, it was very difficult to give the output of the system – the reason for creating it – as much attention as designing the input screens.

Conclusions

The formal analysis products – the functional analysis and the entity relationship model – express a general view of conservation information. They can be used as the basis for communicating with professional analysts and can be drawn on in creating different conservation records systems or system components.

Ironically, as so often in compiling management information, it was the processes of working on and developing the system which could be said to have produced a major part of the benefit. The basic work of defining the data required, in the form of the term lists, and agreeing on the common format for information across all four disciplines, meant that all conservators began to record the essential information about their work. It became very apparent why this information was being recorded; furthermore, what was recorded was only that which was essential. Once it became possible to produce information about the source of and reason for undertaking conservation work – a vital management tool – the value of this was seen by all.

References

Avison, D. E. and Wood-Harper, A. T. (1990). *Multiview.* Oxford: Blackwell.
Checkland, P. (1981). *Systems thinking, systems practice.* Chichester: John Wiley.
Checkland, P. and Scholes, J. (1990). *Soft systems methodology in action.* Chichester: John Wiley.
Daniels, A. and Yeats, D. (1984). *Basic systems analysis.* London: Pitman.
Date, C. J. (1984). *Database: a primer.* Reading, Mass.: Addison-Wesley.
Eason, K. D. (1982). The process of introducing information technology. In *Organizations: cases, issues, concepts.* London: Harper and Row in association with the Open University Press.
Farbey, B., Land, F. *et al.* (1993). *How to assess your IT investment.* Oxford: Butterworth-Heinemann.
Hawryszkiewycz, I. T. (1988). *Introduction to systems analysis and design.* London: Prentice Hall.

Hughes, J. (1984). The hard systems approach. In *Complexity, management and change – applying a systems approach.* Course T301, Block 3. Milton Keynes: Open University Press.

Land, F. F. (1976). Evaluation of systems goals in determining a design strategy for a computer based information system. *The Computer Journal,* **19** (4), 290–4.

Layzell, P. J. and Loucopoulos, P. (1987). *Systems analysis and development.* Bromley: Chartwell-Bratt (2nd edn).

Mumford, E. (1983). *Designing human systems.* Manchester: Manchester Business School.

Naughton, J. (1983). Soft systems analysis: an introductory guide. *Course T301, Block 4. Complexity, management and change: applying a systems approach.* Milton Keynes: Open University Press.

Thomas, R. (1990). Satisfaction guaranteed? *Computer Guardian: The Guardian*: London, 3 May.

Veryard, R. (1984). *Pragmatic data analysis.* Oxford: Blackwell Scientific Publications.

Willcocks, L. and Mason, D. (1987). *Computerising work.* London: Paradigm.

Exhibit 12A Requirements Catalogue for a conservation information system

PRESERVATION

Collections condition audits

The system should be able to keep a record of condition audits of collections and prompt when a scheduled survey is due.

The system should be able to record a summary assessment of the condition of an object as a condition grade, i.e. good, fair, poor, unacceptable, and record other associated information in code or keyword form such as fitness-for-purpose and damage.

The system should prompt the altering of condition grades following conservation treatment (see under conservation treatment).

The system should allow any authorized user to enter a 'conservation alert' for an object, in the form of a flag and a concise remark, if for instance someone noticed that an object in a store needed urgent attention.

The system should be able to aid in condition assessment, by maintaining definitions of condition grade in terms of lists of particular types of deterioration that particular types of object may have suffered, such as, in the case of books: bindings completely off – the worst condition grade; with staining – fair.

The system should be able to undertake the statistical design of condition audit surveys.

Reporting and output

The system should be able to list and give counts of objects in a given conservation condition grade, generally by collection or object type, etc., and undertake other sophisticated listings, e.g. objects for a particular museum project vs. condition grade, condition grade vs. damage, 'fitness-for-use', etc.

The system should be able to report the current condition grade of an object.

The system should be able to report the dates of audits of a collection or of a location.

The system should be able to give statistics on a survey of a collection/location – condition grades, percentage of objects in a condition grade.

The system should be able to undertake the statistical analysis needed to apply statistics from samples to a whole collection.

The system should be able to list objects by damage category, fitness-for-use, or other audit category.

The system should be able to report statistics on damage types for objects in a collection/location.

Environmental conditions

The system should be able to record a policy on the standard for quality of store locations. This would consist of a series of ideal environmental specifications for different types of object, i.e. paper, textiles, metals, photographic negatives.

The system should be able to record an environmental specification for an object location, in terms of temperature, relative humidity, gaseous and particulate pollution, lux level, lux hours, (also storage equipment, fullness). In an hierarchy of store locations, the environmental specification for a location should by default be that for the location next up the hierarchy. The user should be able to pick a specification from the policy on standards, and customize it.

The system should be able to record an environmental specification for an object or a group of objects such as a collection in similar terms.

The system should be able to record a judgement as to whether or not the actual conditions in the location reach its specification or not. This could be in terms of quality of a number of defined characteristics, e.g. building characteristics, fullness, storage equipment suitability, environmental control, security.

The system should be able to record if an object is light sensitive, record the maximum permitted light exposure, and for such an object allow the user to record the length of time it has been exposed to light.

Reporting and output

The system should prompt the user to inspect a location and assess its quality against its specification.

The system should warn the user if a location it is proposed to move an object or a collection into has a specification or characteristics not up to the standard specified for it.

The system should warn if a light-sensitive object has reached a set proportion, say over half, its permitted light exposure.

The system should be able to list the specifications of a store location or an hierarchy of object locations and the record of their actual conditions.

CONSERVATION

Condition assessments and reports

The system should be able to record condition assessments of objects by allowing the user to select from a 'pick list' of standard terms.

The system should be able to record fuller condition assessments of objects, either as free text relating to object parts or in a hierarchical format, with a top-level record describing, for example, the basic and overall condition assessment, and a lower-level record describing the assessment in more detail in terms of the particular condition of particular parts. The user would also enter the reason for the condition assessment.

The system should prompt the user who updates a lower-level assessment of an object to update the associated higher-level assessment. Hierarchies could be customized for particular types of object.

The system should automatically add the assessor's identity and the date of the assessment to the details entered.

The system should maintain a 'pick list' of system-held general terms for condition, for use in constructing condition reports.

Reports and output

The system should be able to report the condition assessment for an object or for a defined group of objects, to conservators or to loans managers, etc.

Conservation treatment records

The system should be able to record treatment proposals for objects or in general for a type of object, including a diagnosis of the causes of deterioration and details of the proposed treatment, and its agreement by a conservator and a curator, and the estimated person-time (and cost?) for the treatment.

The system should be able to record a conservation treatment, in terms of a sequence of procedures carried out on an object and the parts of an object, the materials used, duration of procedure, etc. This could be at various levels of detail.

The system should prompt the person recording a conservation treatment to alter the existing condition grade (presumably for the better), but maintain a record of the previous condition grade.

Reporting and output

The system should be able to report conservation treatments and

other conservation operations (i.e. treatment, condition assessment, scientific examination) for objects by a maker/artist.

The system should be able to report a list of objects treated using a specified procedure or a conservation material during a period. This is because materials or procedures sometimes turn out to be deleterious in the long term, or to aid in resource management.

The system should be able to tell the user the accession number of an object from a distinguishing characteristic, e.g. the title of a picture, or show the user the treatment record from, e.g. the title.

Scientific examination

The system should be able to record details of an analysis in terms of the technique or instrument used, the results, the inferences from the results, the conclusions, and a brief free text summary report. The latter should be passed automatically to form part of the catalogue details of the object.

The system should be able to record the occurrence of an object in a physical record, such as a photograph, an x-ray, or a record of an instrumental analysis. Such a record may be created either in a 'conservation operation' or in a procedure which is part of a 'conservation operation'.

The system should be able to maintain a list of such physical records, including the type, i.d. number, date created, etc.

Reporting and output

The system should be able to list physical records of a particular type by i.d. number, or object number, originator, etc.

The system should be able to list physical records in which an object occurs.

The system should be able to list the scientific examinations undertaken on an object or a type of object or a collection and details about them, or to list simply the summary reports on them.

The system should be able to list objects scientifically examined using a specified procedure over a period, e.g. which objects have been x-radiographed?

The system should be able to list objects which have been scientifically examined by an outside party or laboratory during a period.

Working objects

The system should be able to hold a care/maintenance plan for an object.

The system should be able to support a default care/maintenance plan, to be used as a template for a plan for particular objects.

The system should be able to record whether an object is suitable for operation or not suitable for operation, and the reasons why.

The system should be able to record a list of people authorized to operate an object which is designated as being suitable for this.

The system should be able to support the maintenance of an Operating Log for working objects, containing a record of all operations (*cf.* other history of object use records – exhibition, loan).

The system should be able to record special conditions for operating objects, e.g. those of the Health and Safety Executive, and prompt for the necessity of applying these should the object be booked for use, loan, access, operation, etc.

Reporting and output

The system should be able to provide a list of all objects designated as 'working', as 'suitable for working', or 'not suitable for working'.

The system should be able to provide diary reminders for maintenance actions on all working objects.

The system should be able to prompt necessary action on an individual object's care programme, such as to undertake checks or work, e.g. lubrication or adjustment.

Manage conservation

The system should be able to record a 'conservation operation', this being anything undertaken on an object such as condition assessment, treatment, scientific examination, details to include: the person or outside firm who did the work, the date it was done, and the time, costs and other resources for the job.

The system should be able to maintain a list of museum projects or activities, details to include: start date, completion date, and scheduling status, i.e. future, ongoing, terminated, completed.

The system should be able to maintain a list of objects which are required for each project, and the conservation work status of the object: not needing treatment, needing treatment but not yet treated, treatment complete.

The system should be able to update the list of objects for the project automatically when treatment is recorded as complete.

Reporting and output

The system should be able to list all the 'conservation operations' that are recorded for an object.

The system should be able to list the museum projects that an object has been involved in.

The system should be able to show a list of objects for a conservation project by accession number.

The system should be able to show a list of objects for a conservation project sorted by conservation work status.

The system should be able to report on objects listed for all projects with deadlines before a specified date or within a particular time period.

The system should be able to give management information statistics such as number of objects worked on during a time period for a person or for a conservation group; number of objects worked on for a project.

The system should be able to list and count objects which have been the subject of conservation operations during a time period, by collection.

The system should be able to give statistics on above, and graphic output.

The system should be able to list objects treated during a period, by collection or object type.

The system should be able to show whether conservation has been directed to the most needful objects, by reporting a list of objects treated during a period by their condition grade prior to conservation, and calculate statistics on the above, with graphic output.

The system should be able to report conservation procedures which have been used over a period (but only where occurrences are greater than a certain number, say 50). This would aid in resource management, health and safety management, etc.

Conservation resource management

The system should be able to keep a register of outside laboratories, conservators, or firms.

The system should be able to keep a list of conservators' names against posts, to use in connection with recording conservation operations, the skill level of those doing the work, etc.

The system should be able to maintain an inventory of equipment, its maintenance requirements, etc.

The system should be able to report on equipment usage by analysing recorded procedures.

The system should be able to report on materials usage by analysing recorded procedures.

Exhibit 12B Illustrative sample from the list of defined terms and their abbreviations for conservation treatments and for object materials and for conservation treatments

INLA	= inlayed	RECV	= recovered	
LAMI	= laminated	REIN	= reinforced	
LIFT	= lifted	RELA	= relaid	
LINE	= lined	RELX	= relaxed	
LUBR	= lubricated	RENU	= renumbered	
MASK	= masked	REPL	= replaced	
MOUL	= moulded	RESH	= reshaped	
MOUN	= mounted	RETO	= retouched	
NEED	= needed	RINS	= rinsed	
NEUT	= neutralized	RMBA	= removed backing	
PACK	= packed	RMCO	= removed corrosion	
PADD	= padded	RMDI	= removed dirt	
PINN	= pinned	RMDU	= removed dust	
POLI	= polished	RMOT	= removed other	
REAS	= reassembled	RMRE	= removed old repair	
RECN	= reconstructed	RMSO	= removed soil	

BRON	= bronze	GOUA	= gouache	
CAIR	= cast iron	GRAS	= grass, straw, rush	
CALO	= calotype	GRP	= glass reinf. plastic	
CANE	= cane/bamboo	GUM	= gum	
CARD	= card	GUNM	= gunmetal	
CEAC	= cellulose acetate film	GUTT	= gutta-percha	
CELL	= celluloid	HAIR	= hair	
CEME	= cement	HALF	= half-tone	
CENI	= cellulose nitrate film	HAND	= hand-made	
CERA	= ceramic, unspec.	HARD	= hardboard	
CHAL	= chalk	HEMP	= hemp	
CHAM	= chamois	HLAI	= hand-made laid paper	
CHAR	= charcoal	HORN	= horn	
CHIN	= china	HWOV	= hand-made wove paper	
CLAW	= claw	INK	= drawing & writing ink	
CLAY	= clay, unfired	INTA	= intaglio print	
CLOT	= cloth, bookbinding	IRON	= iron	
COAL	= coal	IVOR	= ivory (all kinds)	
COIR	= coir	JET	= jet	
COLP	= colour print (photo)	JUTE	= jute	
COMP	= wood composite (ply, etc)	KAPO	= kapok	
CONT	= conte pencil	LACQ	= lacquer	
COPP	= copper (alloy)	LAID	= laid	
COPR	= collodion print	LDPO	= lead point	
COPY	= copy pencil	LEAD	= lead (alloy)	
CORA	= coral	LEAF	= leaf/papyrus	
CORK	= cork	LEAT	= leather	

Exhibit 12C Illustrative sample of definitions of treatment terms. The meaning of each term is defined, and warnings are given of terms that should not be confused with it

−REASSEMBLED: To put the component parts of the object back into place by mechanical means.

‡

−do not confuse: Reconstructed, clothed.

−rebound: see bound.

−RECONSTRUCTED: To join fragments or parts together using adhesive.

‡

−do not confuse: Reassembled, adhered.

−RECOVERED: To provide a new outer covering layer.

*ex. The book was recovered with buckram.

−REINFORCED: To adhere an additional physical support to part of an object.

‡

−do not confuse: Lined, supported.

−RELAXED: To cause the object to become limp and/or more flexible, by applying moisture or solvent vapour.

*ex. The parchment was relaxed by placing in a humidity chamber.

‡

−do not confuse: Dressed.

−RELAID: To reattach existing thin layers.

*ex. The India-laid print was relaid.

−REMOVED: To take away things not to be returned to the object, chemically or mechanically.

‡

−do not confuse: Disassembled, dismantled, bleached.

specify: REM-BACKING: To remove old lining or backing and its adhesive.

−

REM-CORROSION: To remove corrosion products.

−

REM-DIRT: To remove unidentified unclean matter

−do not confuse: Rem dust, rem-soil.

13 Future, present, past

Even the dogs may eat of the crumbs which fall from the rich man's table; and in these days when the rich in knowledge eat such specialized food at such separate tables, only the dogs have a chance of a balanced diet
Sir Geoffrey Vickers, *The art of judgment*

Information for managing the preservation of collections must take account of the three dimensions of time. For the future, we need plans, strategies, inspiration about the direction we are going in, and the means of predicting the fate of objects and what museum stakeholders will want. In the present, we all need information about what is happening to objects and to our plans. From the past, we need to know about what has already happened, so that we can analyse the causes of undesirable effects, and project from past to future.

Information for all

Information for managing is not useful just to managers. Everyone benefits from managing their work, and needs information to do so successfully. The information, then, must meet the three requirements set out at the start of this book: it must be based on values; it must serve objectives; and it must be useful to the people doing the work. As Handy says (1988: 121–2):

Proper systems are pathways not prisons, telephone wires not fences. They are the discipline which gives purpose to liberty, which allows one to be free yet part of a bigger whole. They cannot be left to chance because the principles on which they are built are not instinctively obvious.

Many writers stress that everyone doing the work needs information about it, for example, Peters and Waterman, from America, writing on excellence (1982: 266–70); writers from Japan, such as Ohmae (1982: 216–27) and Imai (1986), and from England, Handy (1988: 125–32). Information to allow conservators themselves, as actors in a 'merit-

ocracy', a substantial measure of control and feedback on their work will be even more important than usual: 'complex work cannot be performed unless it comes under the control of the person who does it', as observed by Mintzberg (1983). Practical conservation is highly fulfilling. When conserving an object, one receives instant and powerful feedback on the progress of the work, even though, if the wrong techniques or materials are used, the improvement one sees may be short term. So, if feedback on the wider value of their work is not available, the conservators will feel little commitment to the purposes of the organization, and can instead transfer all their loyalty and energy to the objects or collections themselves. This exacerbates the effect of the conflict which is inherent in the dual museum goals of preservation and display, and leads to the complaint commonly heard from managers of conservation, that conservators are only interested in practical conservation.

Information for the future

Values, strategies, plans, are how information can serve the future. Our crystal ball for discerning the fate of objects lies in standards monitoring and damage prevention. As in Michalski's scheme (1990), 'prevent, detect, contain, control, recover', risk avoidance is the first step: monitoring these measures is the second: recovery, i.e. conservation treatment, is a last resort.

Information in the present

Information about work is information about the present. How are the objectives to be achieved? What processes are necessary in order for the work to be done? How are resources to be provided? What are the constraints? Are plans and targets being met? There needs to be a regular, formal reporting cycle for both work and the use of resources.

Information from the past

Most present information only makes sense if it is seen as part of a flow of events. This includes budgetary information, productivity information, environmental information. The condition of objects in the future can only be predicted by interpreting their condition now in terms of changes they have undergone in the past. By looking at information as a continuous flow from the known past to the measurable present, we can predict and try to influence the future.

The value of information

It is not easy to evaluate the benefits of management information. It will seldom lead to any directly attributable and quantifiable improvement in performance. Nearly all the significant benefits are qualitative rather than quantitative; improvements to effectiveness rather than efficiency. Various writers, however, have proposed ways in which information for managing can be evaluated.

In Land's view, there are three major sources of information: the real world, which can be inspected; the informal system, information obtained by talking with people, which is the major provider of qualitative and evaluative information; and the formal information system, an artefact the purpose of which is to filter real-world data and present them in a relevant and easily understood form (Land, 1985; Land and Kennedy-McGregor, 1987). The latter forms the basis for his evaluation schemes. Another view on the function of information systems is offered by the cybernetics model developed by Beer. In this, an information system 'reduces the variety of the real world' (Beer, 1985, Sect. 2), thus enabling managers to see the state of the wood rather than that of all the different trees.

From these ideas we can see two potential problems with information systems: the wrong information may be chosen for the artificial approximation which is the system, and also, it may inaccurately or insufficiently depict the real world. These must be reasons why emergent systems, those that are developed gradually by the practitioners themselves, generally perform better than planned ones: there is simply more chance to get them right. There is a particularly high risk with computer generated information that it may not properly reflect the real world. Compiling and analysing figures oneself, aided by computers to be sure, gives an insight into their real meaning that is never obtainable from ready-generated tables.

Rockart and Delong (1988, Ch. 12) propose non-financial indicators of success for executive information systems, relating to the performance of senior managers: increase in productivity; improved mental model of the organization and its activities; power (well-informed, knowledgeable departments gain respect). These authors also note another substantial benefit of information systems: the increased ability of organizations to learn, and the consequent impact on the quality of operations. They cite a manager in a large computer company who looked at sales and production graphs each month with his line managers. In this way the managers learnt to see the expense of mistakes and the value of preventing them.

Benefits for people at the operational levels of the organization will include better motivation, commitment to objectives, and self-generated

improvements in work practice, all of which are likely to be assisted by good information on work performance. A further factor to consider is the robustness of the system: can it evolve through time as requirements change?

Evaluation

It takes time, energy and commitment to produce plans, monitoring and feedback over a sustained period of time. From time to time, we should stop and ask ourselves, 'Is it worth it?' Evaluation means addressing this question. There are five areas which should be examined.

Organizational development

Changes assisted or brought about; institutional learning. This will be achieved if the information meets the first of the three basic aims: that it is based on values.

One of the most valuable things that information can do is to bring about a state of better self-awareness by the organization, which will dispose it (i.e. all the workers in it) to make 'real, desirable changes' (Checkland, 1981). In evaluating this area, we might look for signs of changes in organizational structure or in work organization which address the issues depicted in the Rich Picture (Fig. 6.3).

As Rockart and Delong (1988, Ch. 12) note, well-informed, knowledgeable departments gain power and respect. If a department sets out its objectives, plans and monitoring information explicitly, it will achieve a reputation for efficiency. This will not attract universal approval. In museums, senior managers may well appreciate and make use of better management information, but many curators have art history backgrounds, and feel that a too-rational approach is alien to them and out of step with the corporate culture.

Robustness

Has the system continued in use; has it been adapted to meet changing needs? This will help to indicate whether the information is serving objectives, the second of the three major aims for management information.

Regular collection and provision of information will only be sustained if people find it worth the effort. One could say, therefore, that information systems evaluate themselves: if they are not useful then people will fairly quickly cease producing the data for them, and taking the trouble to analyse it and feed it back.

Staff motivation

Does the system make staff feel that their work is important, and thus worth an interest, or does it make them feel spied on and untrusted? In other words, is it useful to the people doing the work?

The information that will both indicate and affect staff motivation will be that directly related to output from what people spend most of their time doing: i.e. the level of activity – objects treated, lectures given, etc. It is not just information which will influence productivity, but the processes of obtaining it. Rockart and Delong (1988, Ch. 12) give a further quotation from the director of the company cited above: 'The chief value I got was the organization knew I was doing it. If the people below know you are taking an interest it affects their attitude.' To which could be added: if the people above you take an interest, it affects yours! You can foster that interest by providing small amounts of useful and interesting information about what is going on.

Efficiency

What is it costing to produce the information, in time or money? Time will be spent:

By conservators:
- On completing timesheets and work reports
- In conducting collections condition audits
- In collecting and analysing environmental monitoring information
- In conducting stores assessment surveys
- In reading and digesting the reports that result.

By middle managers:
- In collating and analysing timesheets and work reports
- In planning work more formally than might otherwise be the case
- In writing reports, e.g. to contribute to strategic planning.

By conservation senior management:
- In analysing and reporting both upwards and downwards on time used and progress against targets
- In spending more time than might otherwise be the case on planning and monitoring progress
- In planning, organizing, and writing up special reports, e.g. on the state of stores and preventive conservation, collections condition audits, and preservation strategy.

Some of this time will have to be spent whatever system of management is in place. Although some extra time will be spent on analysing, for example, environmental monitoring data, the usefulness of such data is very limited without such analysis. It will help if the use of information is developed in cooperation with all staff. The producers of the information can be relied on to design the system that works most efficiently and effectively for them.

Disbenefits

No endeavour results in perfection. Warning notes are sounded by some authors about the strait-jacket that can be imposed by too conscious a system of planning and control. There could be a danger if the system became fossilized, operated for the benefit of management only. It could be objected that time spent by senior managers on paper-based activities such as analysing and reporting might be better spent on keeping in close touch with the work of the department – on management-by-walking-about. This could be circumvented by the judicious use of computerized data collection and analysis, with a certain amount of clerical support.

A formal system of regular written or verbal information is not enough. Equally important is an informal information system: chats in corridors, chance meetings in the tea room, staff seminars. Land (1985) has identified the importance of this other information dimension. Each of the components of the information system – formal or informal – must address the need to give a sense of direction and purpose in the real, messy world, at the same time as organizing people to get a multitude of things done on time and to a high standard.

Case study

The components of the conservation information scheme developed by the conservators in the Historic City Museum have been described in examples in the chapters of this book. The Historic City conservation information scheme included the following elements, which can be related to the diagram in Fig. 11.1:

Museum management plan. The museum's Corporate Plan included specific references to the conservation of the collections and plans addressing improvements.

Values, purpose and objectives. The Conservation Department drew up a Statement of Purpose and Role which was presented to and agreed by the heads of the other museum departments (see Exhibit 10A).

Strategic planning. When the National Audit Office report on the management of collections in the national museums was published in 1988 the conservators in the Historic City Museum produced a strategy document which noted that many of the critical statements in the report could apply to the museum's collections (see Exhibit 10B). The document proposed a programme of information gathering and planning, which would assess the condition of the objects in the collections, their storage and care, quantify the size of the task and the resources required, and suggest ways forward. This was later developed into a second strategy paper, detailing how the museum should move ahead with improving collections care (see Exhibit 10C).

Special reports. To develop the second, detailed strategy paper, a special project was developed, and outside funding obtained, to audit the condition of the collections (see Case study, Chapter 9). The numerous stores were also assessed (see Figs 8.1 and 8.2).

General planning. The second Strategy Paper (Exhibit 10C) was produced as the outcome of a planning seminar for all the conservators. In line with the department's practical, pragmatic approach, the consensus was that conservation strategy should be incremental, building on plans for stores improvements that were already well established. In this way, the strategy was an emergent, incremental one.

Departmental plans. The format for these was developed over time (Figs 11.2 and 11.3). Development plans for a few years ahead were found to be a useful format. Progress was reviewed annually in a planning meeting for the whole department. The general work schedule (Fig. 11.3) was used to assess proposals for new projects, which were put forward in one or other of the museum's regular management committees – for publications, exhibitions and collections management. A schedule of tasks by start date (Table 11.1) was used to check with other departments whether their plans dovetailed with those for conservation.

Sectional and individual work plans. The department's overall Development Plan was used by each section to draw up its particular work schedule, and for objectives for individuals. However, objective setting for individuals was not carried out all at one time, but spread through the year, so although it gave individuals a sense of direction it was not a thorough-going scheme of management-by-objectives. The main focus of planning was thus on objectives for the group as a whole.

Work monitoring and reports. Each section reported monthly on work during the month, in considerable detail. Statistics included numbers of objects treated, time spent on different projects, lectures and publications, and visitors. The results were analysed and fed back in the form of updatable graphs (Fig. 11.6).

Quarterly management reports. Quarterly reports produced for the museum's governors were eventually able to include reports on time spent vs. that planned, as well as text reports on work for the period.

Annual departmental reports. These included a review against performance indicators (see Exhibit 10E), and an assessment of outcomes against plans (Fig. 11.7). These annual reports fed back into the Museum Management plan, which was developed in consultation with members of all departments.

Case study: evaluation

Because it set out its objectives, plans, and monitoring information so explicitly, the Conservation Department achieved a reputation for efficiency. The museum's senior managers appreciated and made use of better management information, but many curators had art history backgrounds, and felt that a too-rational approach was alien to them, and would stifle creativity.

Accountability was a major benefit from the information that was collected. The department was able to say how its time was spent, and this helped in getting vacancies filled, and indeed in ensuring its survival. The information gave it the ability to prioritize work, to organize it so that it fitted the time available, and to estimate accurately the conservation resources needed for projects the museum wished to undertake. The fact that information was collected made staff feel that their work was important and salient to the organization. In this way it improved morale.

Case study: the future

But change was being thrust upon the museum. Cuts to local authority finances were forcing a fundamental reappraisal of its objectives and of how it organized its staff. All of a sudden, the sort of information that the Conservation Department had been producing became not slightly embarrassing evidence that there were scientifically orientated persons around, but a major asset. The Conservation Department found itself able to provide real, hard evidence of the need for better care and management of the collections, based on statistics and rational argument. This was the sort of thing that councillors were used to taking notice of.

It became clear that the whole thrust of the museum's work had to change from collecting and field work to caring for, refining, and making use of the collections it already had. In the new structure, many more staff than before are allocated specifically to collections care. The structure in fact fits much better with the concept of a museum developed in the soft

systems analysis (see Fig. 6.6). The reorganization, and perhaps even more importantly the consequent adjustment of work priorities to include those relating to care of collections, can be seen as evidence of institutional learning.

In the new organizational structure, the management of the collections is the responsibility of an entire division of the museum. The erstwhile Head of Conservation, as Assistant Director for Collections Management, finds herself taking on new responsibilities, for storage, for documentation, and for accountability for the collections. It must be acknowledged that many of the curators, who previously retained substantial responsibility for the collections, remain sceptical that there are any benefits to be had from separating the care of collections from the understanding and interpretation of them. It is hoped that real progress on collections care, and the ability of the museum to account for its collections, will convince them that change is beneficial.

The museum is moving towards a new management technique: project based planning. In this, most work will be planned and carried out as projects, with specific objectives and targets. Staff will be required to commit themselves to achieving specific components of these projects, which would take up designated proportions of their time. The management information that the Conservation Department is already used to using will be invaluable to the new Collections Management Department. There will be continuing major benefits from having work monitoring information available, for planning work, evaluating the feasibility of new projects, and responding quickly and flexibly to them.

Conclusions: a new view

The collection, conservation and documentation of original objects and research on them are the essential foundations on which all museum services rest. *The road to Wigan Pier*? Audit Commission, 1991: 15

There is an almost total lack of publications on management and information for conservation. Yet only a few years ago, conservators ranked 'awareness of conservation needs by managers' as the most important factor affecting the preservation of the collections – even above improvements to stores or more conservation staff (Corfield *et al.*, 1989: 26). This is an outcome of the view that is still held by many museum managers and curators: that conservators are primarily there to apply treatment to remedy the consequences of neglect and insufficient care of the collections. The perception is matched among conservators

themselves, who see that many of them are only interested in practical conservation treatment, and much less in the real issues that affect collections preservation. Greater use of management information should greatly assist a holistic view of what needs to happen to preserve the collections. It should help museum managers to see what needs to be done, and conservators to perceive what their role should be.

Unless there is a coordinated information system, there is no means of knowing how staff time is spent, and no means of planning how resources should be applied to the preservation of the collections. Work will be responsive, undertaken in reaction to requests from individual curators. Developing the means of presenting meaningful information in an enlightening way requires considerable analysis and thought. As conservators begin to feel that they have more control over their work and that their efforts are part of a common plan their morale will rise, leading, we shall hope, to greater effectiveness.

Management information is a powerful new tool for conservation in the future. There is an unexpectedly wide range of techniques that we could adapt from general management. In understanding and describing the situation being studied, soft systems methodology has brought insights which have proved to be directly applicable to information systems analysis and design. Some operations research methods can be used to evaluate investments in preservation. Formal methods of strategic planning are highly applicable. A professional approach to presenting reports and information will mean that conservators' recommendations carry more weight. Finally, the area of performance measurement and indication can offer benefits for the management of conservation if used with due circumspection. The idea of collections conservation being achieved through management and monitoring should be promoted. This is at least as effective as is conservation through treating objects.

Future developments

One of the most crucial issues for collections preservation is how to create the political will to take greater account of the long-term functions of museums, to balance that for the more obvious short-term benefits of display and exhibition. Providing hard, quantified facts is almost the only effective way to do this. We need to construct a means of moving the political consensus in favour of the long-term objectives of preserving the collections as an information and inspiration database. This enterprise needs to be founded on the statutory functions of museums. It needs to call into play the measurable, factual standards and accountability mechanisms of performance indicators, the watchful eyes of the National Audit Office and the Audit Commission, the Museums and Galleries Commission's Standards, and the general push

for greater professionalism in museums. Each museum needs to develop clear, explicit strategies and plans for the collections, and to report information on progress regularly and publicly, based on factual information on what needs to be done. Standards and long-term plans are the only way to represent the needs of the largest, and crucial, group of museum users: those in the future.

References

Audit Commission (1991). *The road to Wigan Pier?* Audit Commission Local Government Report 1991, no. 3. London: HMSO.

Beer, S. (1985). *Diagnosing the system for organizations*. Chichester: John Wiley.

Checkland, P. (1981). *Systems thinking, systems practice*. Chichester: John Wiley.

Corfield, M., Keene, S. *et al.*, eds (1989). *The survey.* London, UKIC.

Handy, C. (1988). *Understanding voluntary organizations*. Harmondsworth: Penguin Books.

Imai, M. (1986). *Kaizen: the key to Japan's competitive success*. New York: Random House.

Land, F. F. (1985). Is an information theory enough? *The Computer Journal*, **28** (3), 211–15.

Land, F. F. and Kennedy-McGregor, M. (1987). Information and information systems: concepts and perspectives. In *Information analysis* (R. Galliers, ed.), Sydney, Australia: Addison-Wesley.

Michalski, S. (1990). An overall framework for preventive conservation and remedial conservation. In *ICOM Committee for Conservation, 9th Trienniel Meeting, Dresden, Preprints*. Marina del Rey, CA: Getty Conservation Institute/ICOM Conservation Committee.

Mintzberg, H. (1983). *Structure in fives*. New Jersey: Prentice Hall International.

Ohmae, K. (1982). *The mind of the strategist*. Harmondsworth: Penguin Books.

Peters, T. J. and Waterman, R. H. Jr (1982). *In search of excellence*. London: Harper and Row.

Rockart, J. F. and Delong, D. W. (1988). *Executive support systems: the emergence of top management computer use*. IL, USA: Dow Jones – Irwin.

Vickers, G. (1965). *The art of judgment*. London: Chapman & Hall.

Index